FAIR ISLE KNITTING

DEDICATION

To my husband, Trevor; my two sons, Jacob and Matthew; and my friend, Claerwen – thank you your continuous support, technical help, guidance, patience and encouragement throughout the time I have been working on this book.

ACKNOWLEDGEMENTS

My visits to my son in Glenelg near Skye, Scotland, and the exploration of its surrounding areas, played an essential part in the development and designing of several projects and swatches inside this book, inspiring me greatly through their sheer beauty and colours. In addition, my journeys to Scotland made me decide that traditional Scottish yarn was a must for knitting these same projects and swatches. I sourced Jamieson's of Shetland, and the owner Elaine and her family have gone out of their way to support me with a variety of yarns, for which I am extremely grateful.

I also really appreciate the donation of yarns and materials from Pete at Rooster yarns, Kathy at Wensleydale Longwool Sheep Shop, Erika at Erika Knight, Jenni and the staff at Fyberspates, Katie at Lang Yarns and Tom at KnitPro. Thank you.

I would also like to thank my pattern checker, Jemima Bicknell, for all her work on the patterns for this book.

Also a huge thank you to my editor Emily Adam, who has coped with my inconsistent computer skills, given me helpful hints and has always been a positive and encouraging presence throughout the two-and-a-half years I have been working on this book.

Finally, a big thank you to Katie French, who commissioned this book and supported me from the planning stage onwards, along with the rest of the team at Search Press who have aided in the publication and marketing of this book.

Monica Russel

FAIR ISLE KNITTING

A PRACTICAL & INSPIRATIONAL GUIDE

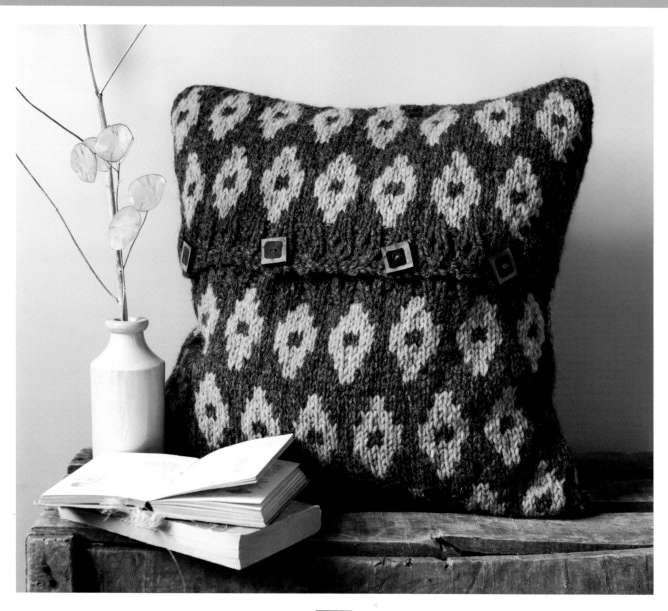

SEARCH PRESS

First published in 2019

Search Press Limited
Wellwood, North Farm Road,
Tunbridge Wells, Kent TN2 3DR

Photographs by Paul Bricknell (pages 21 (bottom right), 157),
Mark Davison (pages 13, 15, 18–19, 35 (top right), 50, 58–59,
62–65, 67–69, 100, 105, 107–109, 111–113, 115–121, 126),
Stacy Grant (pages 3, 21 (top), 48–49, 71–75, 77, 80–84, 87–89,
91, 93, 101–103, 128–129, 131, 133, 135, 137, 139–143, 145,
147, 150–153, 160–161, 163, 165–167, 169, 171, 173–175),
Roddy Paine Studios (pages 1, 7–9, 11, 14, 20, 22, 24–34, 35
(steps), 38–47, 51–57, 60–61, 66, 104, 122–123, 125, 127, 154–
156, 158–159) and Monica Russel (pages 6–17). The photograph
of wool on page 5 is courtesy of Jamieson's of Shetland.

Illustrations on page 32 by Jane Smith.

Photographs and design copyright
© Search Press Ltd. 2019.

Text copyright © Monica Russel, 2019.

ISBN: 978-1-78221-580-6

Suppliers

For details of additional suppliers, please visit the Search Press
website: www.searchpress.com

For the purchase of yarns, kits, books, other patterns, workshops
or further information about the author, please visit her website:
www.theknitknacks.co.uk

Metric and imperial measurements

The projects in this book have been made using metric
measurements, and the imperial equivalents provided have been
calculated following standard conversion practices. The imperial
measurements are often rounded to the nearest $\frac{1}{8}$in for ease of
use except in the rare circumstance; however, if you need more
exact measurements, there are a number of excellent online
converters that you can use.

CONTENTS

FAIR ISLE DESIGNS

INTRODUCTION

Fair Isle Knitting: A Practical & Inspirational Guide has something for every knitter. The patterns have both charts and written instructions to choose from, a variety of different colourways for many of the swatches and helpful hints and tips to support you with your project.

Fair Isle, named after the islands in the north-east of Scotland, is a traditional technique where two (occasionally three) colours of yarn are combined in each row. There are an infinite variety of patterns and colour combinations to discover with this technique, from the subtle and more traditional to the modern and (occasionally) gaudy! My colour inspiration comes from the Scottish Highlands, my brother's tapestries, our back garden in Sussex, UK and artists such as Hockney, Matisse and the Scottish colourists, amongst others.

This book has two main aims. Firstly to offer the knitter a large selection of designs, and I have included illustrations of motifs, borders and conventional Fair Isle designs using several colour combinations. All of these have been knitted in traditional Scottish yarns. The second aim is to demonstrate that Fair Isle can provide inspiration for rejuvenating or embellishing your favourite knitting patterns, from garments through to accessories and homeware. Fair Isle can transform a simple item into a thing of splendour. In the swatch galleries (see pages 50–69, 104–127 and 154–159) and the accompanying project pages (see pages 70–101, 128–151 and 160–175), you will find ideas for incorporating Fair Isle in whatever item you are knitting – from simple ones for the newer knitter to more challenging patterns for the more adept.

Fair Isle can be knitted in many thicknesses of yarn, be it 4-ply (fingering), DK (light worsted), aran (worsted) and chunky (bulky), and you can use any wool that fulfils your colour fantasies! I have included projects in this book that use all of these different weights, giving you the opportunity to see how versatile Fair Isle can be. If you choose to use a different yarn from the one stipulated in the pattern, please feel free to do so! However, always ensure that your tension (gauge) is adjusted accordingly (for more guidance on tension, please see page 26.)

I love designing Fair Isle because there is an element of surprise in every colour and pattern combination, which produces a unique piece of knitting every time.

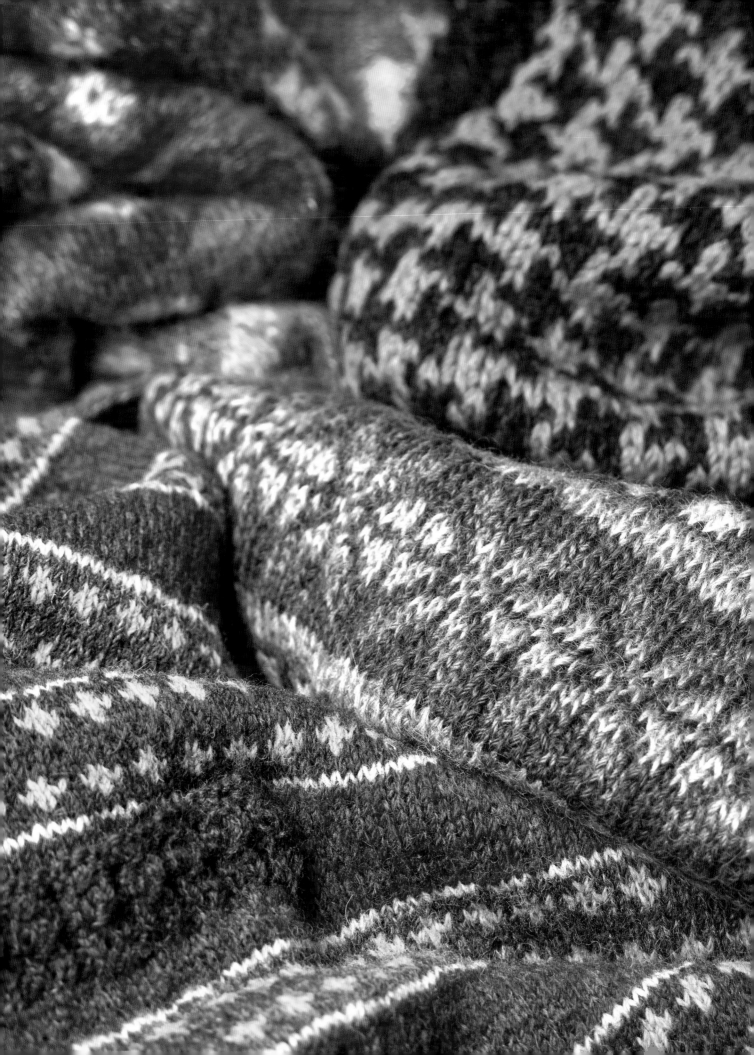

FAIR ISLE KNITTING:
A NEEDLE-SIZED HISTORY

Fair Isle knitwear is named after Fair Isle, one of the UK's most remote, inhabited islands in north Scotland. It is part of the group of isles known as the Shetland Isles, and lies about halfway between the Shetland mainland and Orkney. The island itself is very small, measuring only 4.8km (3 miles) long and 2.4km (1½ miles) wide, and has a population of just 68 people[†]. Fair Isle has two main claims to fame: the shipwreck of the Armada Flagship *El Gran Griffon* in 1588 and, of course, its vibrantly coloured, patterned knitwear.

Knitting started in the Shetland Isles around AD1500. One reason is that the Shetland sheep, specially bred to cope with the island's difficult conditions, produced an abundance of wool. The other reason the craft may have begun was for trade purposes: a piece of patterned knitting could be exchanged for fresh food and water from passing ships.

The original Fair Isle designs were copied and shared between crofts – fenced, arable land kept by tenant farmers. Yarn was hand spun, and could be left in its natural, unbleached state (known as 'undyed'). Other breeds of sheep inhabiting Fair Isle offered a small variety of colour, such as shaela's dark grey and sholmit's pale grey. Alternatively, fleece was dyed using plant or root sources on the island, such as madder (reds) or iris (yellows). Indigo (which produces blue to violet shades) was another popular dye that was frequently used and was bartered for from passing traders.

The women of Fair Isle knitted with 'wires' (the local name for double-pointed needles), aided with a knitting, or 'Makin', belt. This enabled the knitter to work while on the move. One end of the knitting needle was placed into the holder, which was fixed at the waist, and the right needle was held in position by the sheath; consequently, the knitter's right hand was free to handle the yarn more skilfully.

What was once hand-knitted by the Fair Isle women then developed into a major cottage industry from the late-sixteenth century. The initial items produced were coarse stockings, knitted underwear and gloves. By the mid-nineteenth century, more complex patterns were being developed for the knitwear. 'Crosses and lozenge-shaped hexagons [that] contain[ed] symbols, often of a religious nature, formed the basic Oxo pattern' which is still widely used today.[‡] The local environment and life on the island also formed inspiration for patterns such as ferns, anchors, ram's horns, flowers and hearts.

The form of stranded colour knitting affiliated with Fair Isle, in which two or more colours are used and worked simultaneously, developed after about 1910 and has become an increasingly

† *National Records of Scotland, 'Number of residents and households at individual island level, Census 2011', www.nrscotland.gov.uk, 2013 < https://tinyurl.com/y3mu6gsw>*

‡ *Elizabeth Riddiford, 'The history of Fair Isle knitwear', www.exclusivelyfairisle.co.uk, 2012 <https://tinyurl.com/y9werez9>*

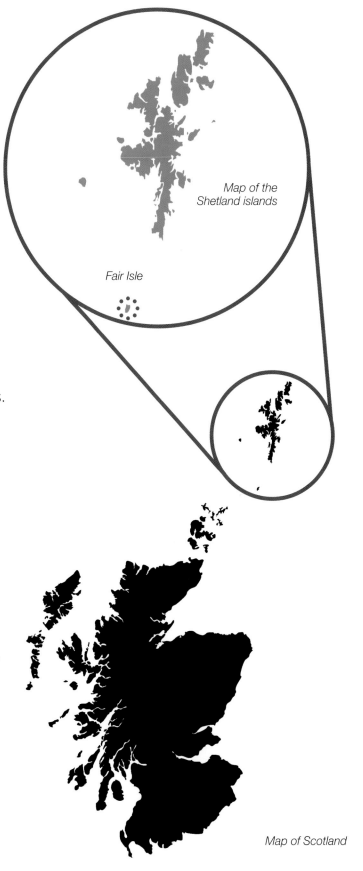

Map of the Shetland islands

Fair Isle

Map of Scotland

popular technique and design worldwide. In traditional Fair Isle designs two colours are used in every row with an average of four colours worked over a completed garment. Originally, blocks of patterns were rarely repeated. Fair Isle patterns then evolved, with motifs becoming more symmetrical: this symmetry created an invisible 'line' through the middle of a shape or motif, 'slicing' it in half to allow a repeated, decorative design. This resulted in continous, repeated patterns that were worked over an odd number of rows.

Fair Isle patterns were often categorized according to size, a system still used today. 'Peerie' (or 'small') were patterns usually five to seven rows long, worked as part of a more complex overall design. Border patterns were worked in bands, either once or multiple times as part of a simple or complex pattern repeat. Most traditional Fair Isle motifs are worked over fifteen to seventeen rows. An excellent example of how this pattern can be maintained to such an extent is the famous Oxo design (see page 50), where the crosses are used as a way of joining up patterns rather than as a separate decorative element.

Today the term 'Fair Isle' has become a generic one, and is used for any type of multicoloured knitwear. Although traditional Shetland yarn is still used, many items are knitted in modern yarns, examples of which can be seen in a number of patterns in this book.

YARNS

There are numerous yarns available, ranging from economic acrylics and bold coloured cottons to luxury hand-painted merino wools and soft alpaca fibres.

Traditionally 2-ply (laceweight) Shetland yarn was used for Fair Isle designs; this was because, once your item was complete, it would have nearly doubled in thickness due to the stranding of the yarn. Shetland yarn is also stickier than other yarns, and in stranded knitting these fibres will adhere together more easily – a useful quality especially for 'steeking' (a traditional method of cutting through stitches of a circular knitted item to create an opening), as the stickiness of the yarn prevents the cut stitches from unravelling.

When people first started knitting Fair Isle, they used natural colours taken from plants and minerals (see page 8); today, both vibrant and pastel colours are used for designs. When knitting your own designs, you could use solid colours or you could incorporate variegated yarn to add interest to a project. As with all types of knitting, cost can be a key factor and it is important to consider this when using many colours in a project.

Over the years I have knitted many Fair Isle projects and my preference is to use natural fibres, ranging from 4-ply (fingering) weight yarns through to aran (worsted) weight yarns – depending on the project. I find that using a 100 per cent wool enhances hand-knitted Fair Isle designs and is more in keeping with its traditional roots. Furthermore, if you are spending many hours working on a project, you want it to look and feel great, and good quality wool will leave you with a beautiful, professional finish. It is possible to knit a Fair Isle project in cotton, but it has less give than other yarns.

That said, yarn choice is completely up to the individual and you will need to bear in mind who the project is for or how it is to be used. For example, using a machine-washable yarn for a baby or toddler project might be more practical than a hand-wash variety; for an adult sweater or cardigan, a hand-wash yarn may give you a wider choice of yarns and colours.

Each yarn company has its own selection of yarns and colours too, which will impact your choice, These days you can mix and match equivalent fibres from different suppliers. However, take care that you check the tension (gauge) for each one to ensure they are the same – these are usually stated on the ball band.

SOME SAMPLE YARNS:

1 Fyberspates Cumulus 2-ply (laceweight) alpaca/silk: *this is a soft, luxurious, heavy laceweight yarn that's good for scarves, snoods, shawls (see pages 142–145) and delicate garments. Colours are very rich and blend well.*

2 Jamieson's Spindrift Shetland yarn: *described as a 2-ply but knits as a 4-ply (fingering) weight yarn, this type is used for the Shetland Dress (see pages 146–151). This brand has a great choice of colours that blend or contrast well together. This yarn is ideal for adult clothing, but this may be too itchy for children.*

3 Wensleydale DK (light worsted) weight 100% pure new wool: *type used for the Lerwick Waistcoat (see pages 132–137). A good yarn for adult projects in both plain or Fair Isle knitting.*

4 Jamieson's Shetland Marl: *textured chunky (bulky) weight yarn. Type used for the hats (see pages 70–75) and bag (see pages 138–141). Ideal for quick knits.*

5 Jamieson's Shetland Heather: *soft aran (worsted) weight yarn; ideal for textured knits.*

6 Lang Merino 150 4-ply (fingering) weight yarn, 100% virgin wool: *extremely soft, fine yarn that is machine-washable. Used for one of the colours in the child's dress (see pages 92–101).*

7 Koigu KPPPM 4-ply (fingering) weight merino yarn: *kaleidoscopic yarn that looks amazing on sweaters or socks.*

8 Manos del Uruguay Fino 4-ply (fingering) weight merino/ silk blend yarn: *luxuriously soft, tonal yarn.*

9 Jamieson's Spindrift Shetland yarn: *same as number 2 but in an alternative colour.*

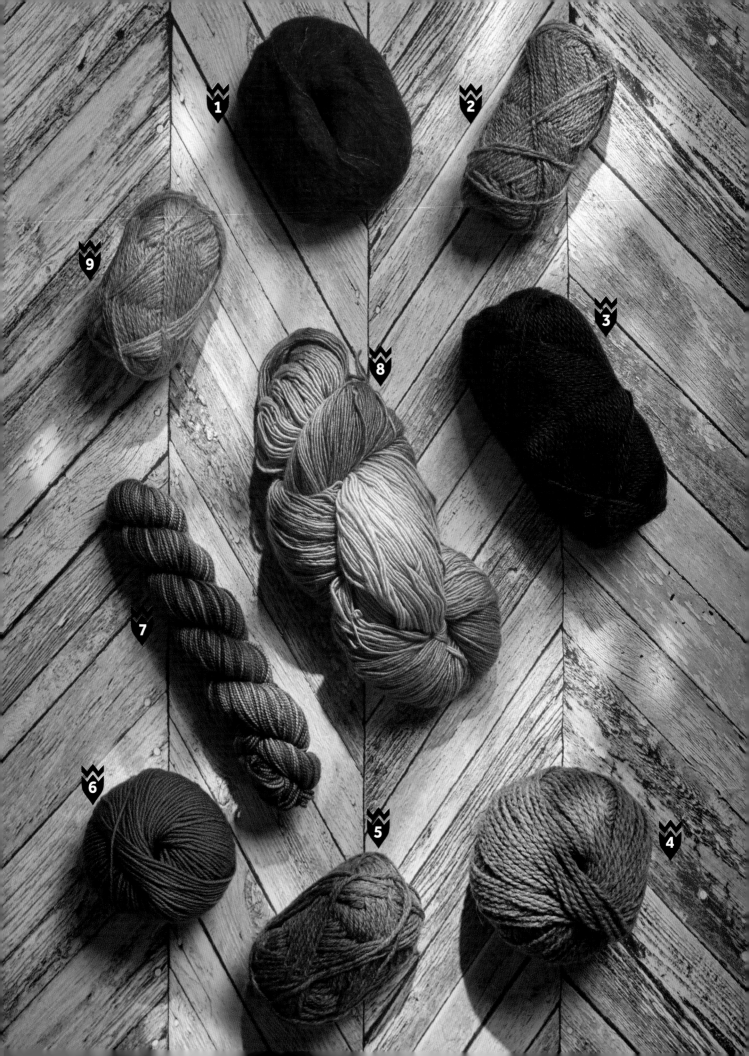

EQUIPMENT

Each project within the book will detail the specific size and type of knitting needles you will need, along with other particular requirements. However, the list below will be a useful guide for the key tools and materials you will need for Fair Isle knitting.

1. Knitting needles

A range of straight and circular knitting needles of various sizes are invaluable at the beginning of your knitting journey. These days there are a huge variety of knitting needles available in varying lengths and finishes, including types made from bamboo, metal, plastic or wood. The type you use is a matter of personal preference. For this book I have used a combination of carbonized steel and polished wooden needles; however, I prefer to use wooden needles most of the time as they are smooth but have just enough friction to stop the stitches sliding too readily along the needle. Wooden needles are also less affected by temperature – plastic needles can be difficult to work with in hot weather, as they can stick to your fingers! While some people find the clicking of steel needles distracting.

Circular needles are used to knit projects in the round, such as a hat, or for knitting large widths of yarn, such as a shawl (see pages 142–145) where you can easily fit large numbers of stitches on a needle and just work them back and forth as you would with straight needles. They come in all sizes and commonly in two types: those that are fixed in length, with a short needle tip at each end and a flexible cable in between the tips; or, those that have as interchangeable tips with a cable in the middle.

Double-pointed needles (or DPNs) are a traditional way of knitting in the round, and are extremely useful for finishing smaller circular knitting projects – such as the crown of a hat – when there are too few stitches to continue on circular needles. DPNs usually come in sets of five; four are used to 'hold' the project and the fifth is used to knit with.

KnitPro do an excellent range of needles to suit all budgets. I find them gentle on the hands and easy to grip. They also produce special needles called 'Cubics' (see opposite page, very bottom) that are designed to be more ergonomically friendly for those with rheumatism, as their square-like shape is easier to grip.

2. Tape measure

To measure your work for shaping and for checking your tension (gauge) in a tension square (see page 26).

3. Fabric (or thread) scissors

A small pair of sharp scissors is a vital tool. They are used for cutting yarn when changing colours, and trimming yarn tails after sewing up your completed knitting.

4. Tapestry needle

Essential for weaving in tails of yarn, sewing up seams and attaching additional embellishments (see pages 14, 42, 43, and 47).

5. Pins

Used to pin your work to a set measurement when blocking. They can also be used to hold separate pieces of knitting together when joining seams.

6. Stitch holder

Ideal for holding open stitches of knitted pieces while you continue to work on another part of your project, such as a neckline. Mainly used for garments.

7. Stitch marker

Used mostly for circular knitting to help denote the beginning of a new round. A loop of contrasting coloured scrap yarn can also be used to tie around the stitch when you are starting out.

8. Blocking board

A surface on which to block your knitted pieces. These vary, but I like to use interlocking foam mats by KnitPro. Not only does the foam make it easier to pin, but the interlocking feature means you can create a larger blocking surface – perfect for bigger garments or accessories – and store them away easily when they are not in use.

9. Paper scissors

For cutting out non-yarn or non-thread materials, such as card for tassels and pompoms.

Notebook & pen (not shown)

For keeping a record of your progress, these are essential for larger pieces of work. I also like to use mine to write down tensions for different yarns and to note completed rows.

Row counter (not shown)

To keep a record of a completed row.

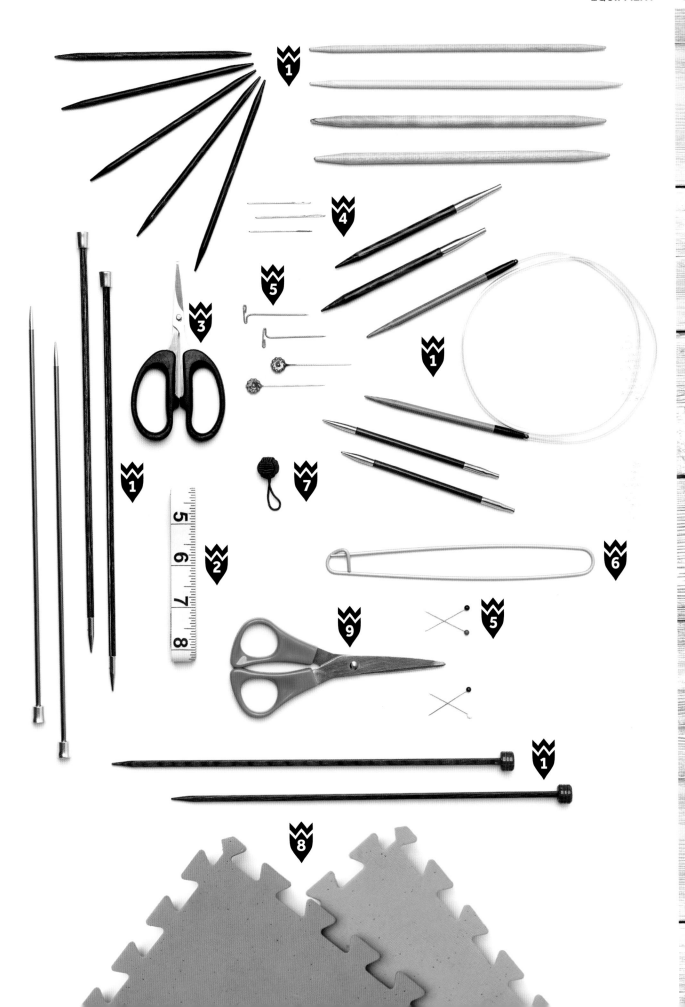

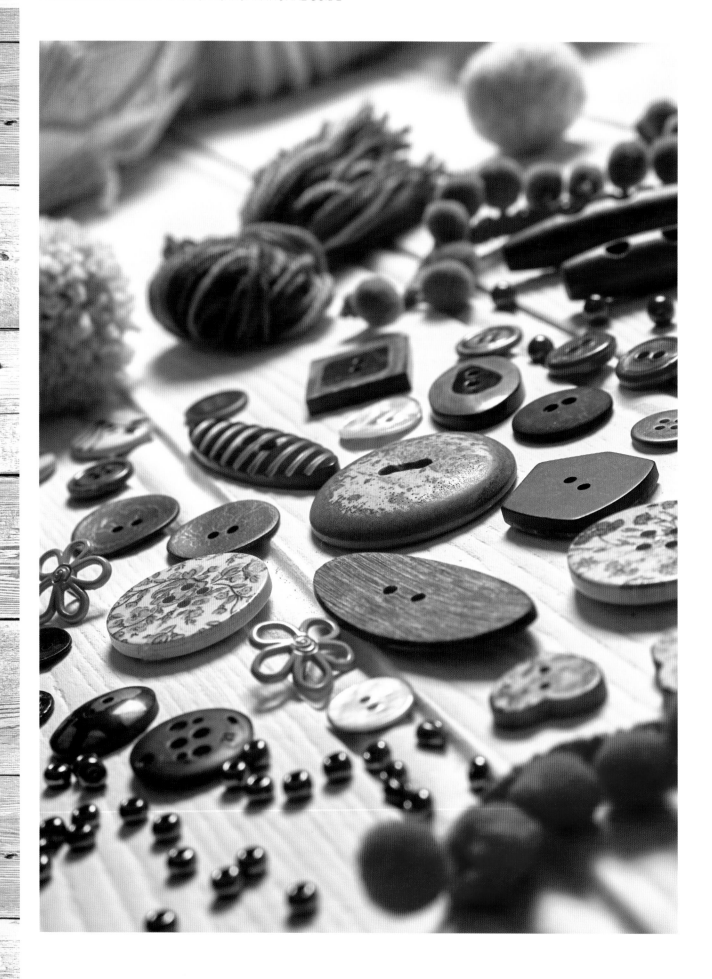

EMBELLISHMENTS

All crafters like to add special items or details to their work. You can make some of these yourself or buy them. There is a huge choice available nowadays, although budget plays a big part, it is always worth spending that bit extra to get items that will give your project a professional 'finishing touch'.

Buttons

Choosing buttons carefully for a buttoned knitted project is essential to the finished piece, and it is worth shopping around to find the perfect button for your project. The right button can really enhance an item you have made. I have a box where I store all sorts of buttons I have found and bought from around the world that I think would look fantastic on future designs. A helpful hint when sewing on buttons is to use the same yarn used to knit the project (see also page 43) At times this may mean you will need to separate the yarn strands, so that it is not to thick to go through both the eye of your needle and the holes in your button.

Beads

Beads come in various sizes, shapes and colours. They can either be sewn directly onto a piece of knitting (see page 42) or knitted directly into the item you are working on. Whatever beads you decide to use, make sure they are a size and shape that suits and fits your project and yarn. If the hole is the wrong size, the bead will either sit awkwardly or slide around. In addition, big beads can overwhelm a lighter-weight yarn; conversely, a small bead will get lost in a chunkier yarn. If necessary, test a bead on a scrap or tail of the same yarn you intend to use in your project, to see how it'll look.

Embroidery thread (floss)

As an alternative to yarn, embroidery thread (floss) can be used to sew and attach embellishments. Personally, I prefer to separate yarn for this purpose (see pages 42 and 43), but if your choice of yarn is difficult to separate – this is usually the case with synthetic fibres – a long length of embroidery thread (floss) that matches your knitting will work just as well.

Trims

Purchased lengths of trims can make a nice, decorative addition to a pillow edge or the top of the pocket. These have to be sewn on, either by hand or with a sewing machine, going slowly with the correct stitch length and using a walking foot if possible to help the knitting ease along.

Tassels

Tassel making is a very useful technique to have in your knitting repertoire. There are many uses for tassels, from attaching them to the ends of a scarf or the corners of a pillow cover to the top of a hat or even along the hem of a sweater! See my notes on how to make a tassel on pages 46 and 47.

Pompoms

A fun embellishment that looks lovely on lots of knitted items, from hats to bags!

A purchased pompom maker is a useful alternative to the traditional two pieces of cardboard. There are many different pompom makers in the market, so if you can it is worth playing around with different types to see which one appeals to you. In my opinion, the simpler the better; personally, I like to use the pompom makers by Prym: they separate and clip back together easily, and the maker itself does not move around too much when wrapping the yarn around the 'arches'. If you are not sure how often you will use your maker, you can start by making traditional cardboard makers first. I will show you how to do this on page 44.

Like knitting needles, it is good to have a range of maker sizes so that you can create suitably sized pompoms for all your projects. I have five different sizes – 25mm (1in), 35mm (1⅜in), 45mm (1¾in), 65mm (2⅝in) and 85mm (3⅜in). The largest size was used on the Fair Isle hats (see pages 70–75).

POMPOM MAKERS COLLECTION
Top: *clippable pompom makers by Prym.*
Middle-left: *homemade cardboard makers.*
Bottom: *rotating, unfoldable makers by Clover.*

COLOUR

I have always been influenced by colours when making my own designs. The colours for one of my first knitting projects were inspired by the heathers and bracken I saw when walking on the Isle of Skye, Scotland, on a visit to see my son. I found a local wool shop who stocked a yarn that reflected the colours I had seen; I then knitted a scarf from the same shades. It is now a constant reminder of the visit.

You can have terrific fun playing with colours, and what you see around you can provide you with all sorts of ideas for colour. I also find a visit to an art gallery is a fantastic place to influence my creativity – David Hockney's work has become a firm favourite of mine because of his use of colour.

However, when running my workshops, participants often comment that they rarely experiment and have difficulty choosing colours that are different to the ones stated in a pattern. My hope is that you use this chapter as an opportunity to discover colour and find new ideas.

The yarns used for this book were carefully chosen. Personally, I love muted colours with warm tones, but I am aware that each knitter has their own preferences; for this reason, I have endeavoured to use a wide range of colours throughout the swatch galleries later in this book, not only to suit a number of tastes but also to show how it is possible to work beyond your comfort zone and try new palettes. The knitted swatches and alternative colourways give an idea of how the different colour combinations work, and show you how a variation on colour can make the same pattern look completely different.

In the following section, I will give you a little information and guidance on how to understand colour and how to approach it when you start knitting your patterns, which I hope will be useful if you're struggling to put together your own colourways. However, see the advice here as just that: use it as a springboard for your own yarn 'mixes' and see what you can achieve with that extra confidence!

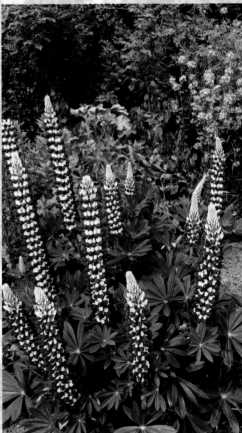

COLOURS IN NATURE
I took these photos on a trip to see my son, who lives in Scotland. You'll be amazed at the colours nature offers, from muted, cool shades of the sea and sky to the bold petals of the flowers, or the wings of a butterfly.

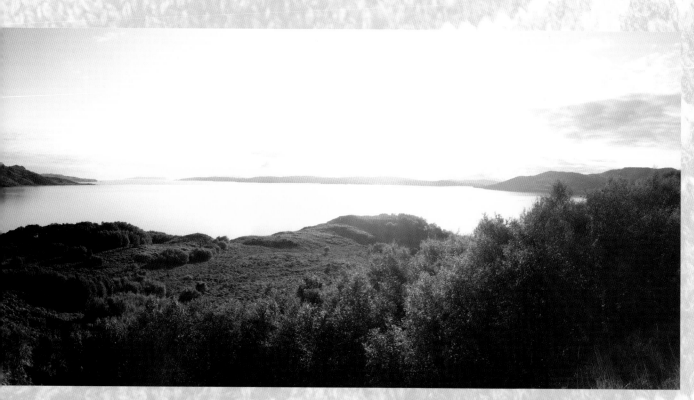

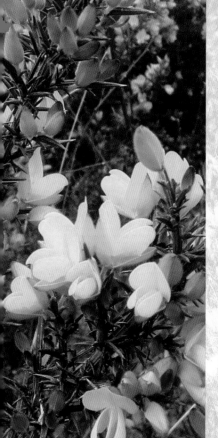

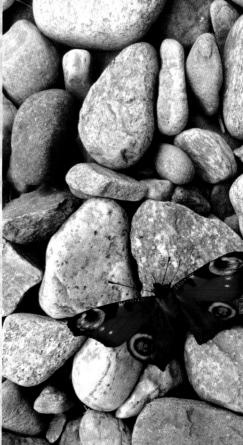

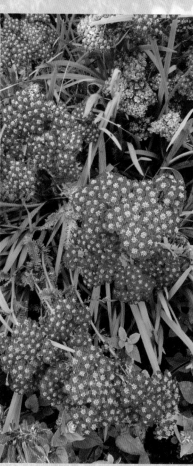

COLOUR THEORY

Never be afraid to play with colour, as you may be surprised by how different combinations work together! Some colours naturally blend together happily while others form more vibrant contrasts. By analyzing and understanding colour, you can recognize and decide what colours will 'work' well together early on, before you start knitting your Fair Isle patterns.

Throughout the swatch galleries I have provided one or two colour variations as charts in addition to the main swatch chart, to help you see what other colourways you could use for your patterns. However, I encourage you to play with different colours yourself using some of the information and advice below.

In a general sense, colours can be described as either warm or cool; for example, blues and greens are usually described as 'cool', whereas oranges and reds are 'warm'. These are usually a good starting point before exploring new colourways, as often the colours within their respective group naturally work with one another.

However, by understanding colour theory and using a colour wheel (such as the one on the right), we can break up the colours into simple groups, and use the theory behind them to help us put together more unusual but surprisingly harmonious colour combinations. Note that these are guidelines only, and colour combinations can vary according to the light and shade.

Primary colours

The primary colours are red, yellow and blue; they cannot be made from any other colour. By mixing these colours, using more or less of each one, you can make all other colours. Sometimes black and white are also called primary colours.

Secondary colours

The secondary colours are made by mixing two of the primary colours. These are green (yellow combined with blue), orange (yellow combined with red) and purple (red combined with blue).

Tertiary colours

Tertiary colours are combinations of primary and secondary colours. There are six tertiary colours: red-orange, yellow-orange, yellow-green, blue-green, blue-violet and violet-red.

Harmonious hues

Colours that sit next to each other on a colour wheel – such as blues and greens, yellows and oranges. These colours often blend well together; however, depending on the shade chosen (see below), the opposite effect can happen.

Complementary colours

These are colours that sit directly opposite each other in a colour wheel, for example, purple sits opposite yellow. These colours sharply contrast each other and can produce a 'wow effect' in a Fair Isle pattern.

Tints, tones and shades

A pure colour is called a 'hue'. Adding white to a hue makes a lighter version of the hue, called a 'tint'. Adding grey to a hue makes slightly darker, subtler, less saturated version of the colour; this is called a 'tone'. Adding black to a hue makes an even richer, darker version of itself – a 'shade'.

CHOOSING YOUR COLOUR SCHEME

Dark to light combination

If choosing lots of different colours sounds frightening to you, a simple way of starting to add more colour and interest to your knitting is to combine the different tints, tones and shades of a single colour.

For example, depending on whether the main colour of your knitting is cool or warm, adding a pure white (cool colour) or cream yarn (warm colour) as a border line or 'dot' within the pattern is a subtle way of adding interest to a simple colour scheme.

Complementary combination

Using complementary colours in a Fair Isle pattern makes a striking design. Here, just two colours – albeit ones that are equally bold – have given an otherwise simple pattern a vibrant appearance without it looking too garish.

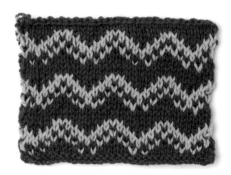

Subtle harmonious combination (with tint and tonal fun)

Pink and purple sit side by side very happily to form this famous Oxo pattern. As the pattern uses four colours and the pink and purple are tonal versions of themselves, I have added beige and cream – neutral, warm colours – to produce a subtle effect. The beauty of this combination is that their similar colour palette could offer the knitter an alternative colourway, using the same colours. Why not swap the pink with the purple? Or the pink with the white band?

When knitting patterns like Oxo, try knitting them in bold or subtle colours so that you can see the difference. A simple repeat pattern like this can be a good start to Fair Isle knitting.

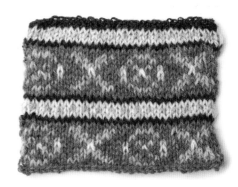

Bold harmonious combination

For the daring and the brave, combining your different colour palettes in a clever way can create unusual and inspiring designs that truly have the 'wow' factor.

It is important to note that a simple repeat pattern – such as the wave here – will stop a colourful design from looking dissonant and help to balance the piece. I would avoid working a complex design with a large mix of colours, as it will look too busy and discordant.

In this design, two strikingly different pairs of harmonious colour combinations are combined. To bring more cohesion to the swatch, both combinations are the pure, bold versions of themselves; in addition, a simple band of neutral colour – the black – is worked in between each pair, to break up the colours a little and allow them to be treated as separate panels.

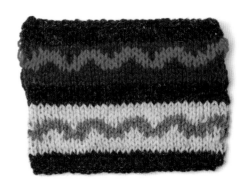

PLAYING WITH VARIATIONS

To show you how easy it is to create a unique design with different yarns or colours, I have provided some examples here. Use these as inspiration for your own colourways, but remember to consider the weight of your yarn before using it to knit one of the projects included later in this book.

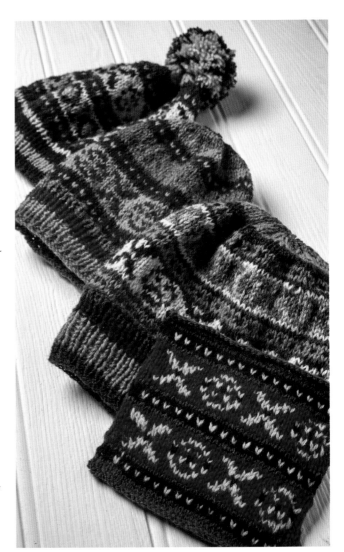

RIGHT

ONE PATTERN, FOUR COLOURWAYS

It is amazing to see how a simple colour change can transform a Fair Isle pattern. Here, I used the same traditional Oxo border (see page 50) to knit three hats, but in different colourways. They range from more muted shades (second from front) to a colour scheme with brighter colours (third from the front) and a colourway with stronger contrasts (back). As you can see, a pompom can add further interest to your design too! This was made with remaining ends of the same yarn.

BELOW, LEFT AND RIGHT

CHANGING THE LOOK WITH ALTERNATIVE YARNS

Sometimes, just changing the type of yarn can alter the look of your project. Here, I used the same animal motif seen on the pillow in this book (see pages 164–167) to knit another item, but this time used a variegated yarn for the background and cream bouclé yarn for the sheep, to add interest and texture.

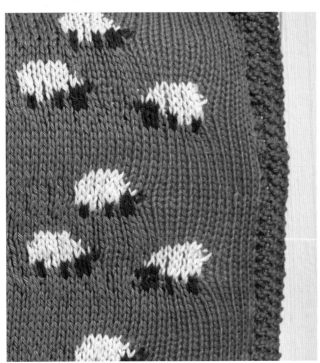

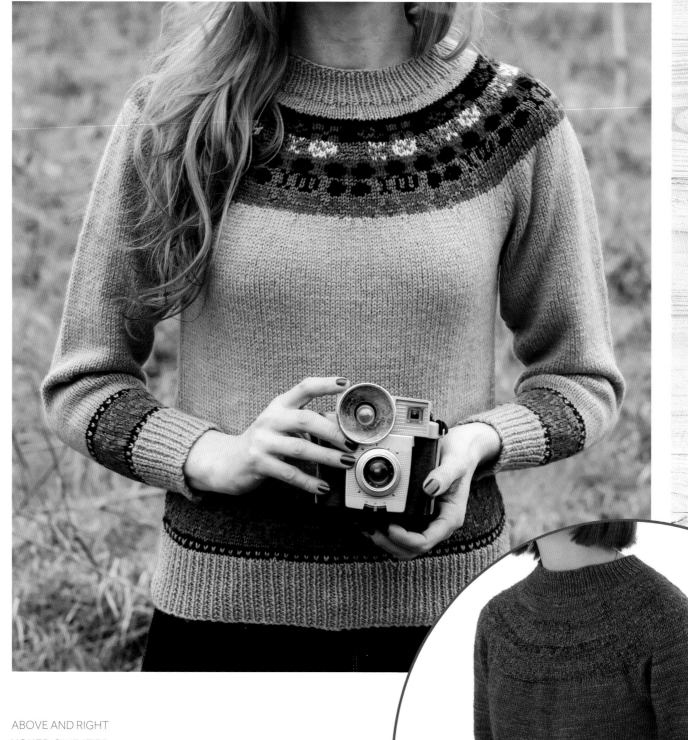

ABOVE AND RIGHT

YOKED SWEATER:
CHANGING THE COLOURWAY AND YARN

These sweaters are, in fact, the same! However, by using a different yarn and colour scheme, you can see how different a design can look. For the sweater on the right, I took the pattern from the original project (see pages 76–81) but kept the number of colours to a minimum, making the Fair Isle knitting slightly easier to do. I used a brown for the background colour, variegated blue for the main pattern and variegated sea green for the border in the middle of the blue bands.

Colour is a totally personal thing, and the choices you make with your yarns will be strongly influenced by what hues unconsciously speak to you. Some people find it hard to make their own decisions about colours for their project and opt for those given in the pattern, but it is worth thinking about the colours you naturally love and then looking at the basic colour rules to help you make your own combinations. Maybe the colour purple speaks to you, or yellow? Take a look at the colours that connect with them – harmonious or complementary – and discover an exciting palette you wouldn't have considered before!

All knitters have a stash of odd bits of yarn in different colours, so use these as an opportunity to experiment with colourways. Use some of these scraps to make small test swatches and then see if you can find combinations that work well for you. Don't be put off if you are not happy with the first swatch; just keep trying different colours until you hit on a 'mix' that you are happy with. These swatches can be reused too, added to your Fair Isle project as a border or central design for a scarf, shawl or blanket.

Visit your local yarn shop or a knitting show and see how the yarns or colours there are displayed. The stands and the knitting books they have on show provide plenty of inspiration.

Fashion is a good source of inspiration in both colour, patterning and texture, and many designers are not afraid to combine unique colourways and motifs. Flick through fashion books, catalogues or websites and see what you find. Take a look at the clothing choices of the people you see around you too! A friend, family member or even a stranger may have caught your eye with their outfit, and often the reason will be the colours they've chosen to partner together. Similarly, interior design can be a good place to find fresh ideas for colour and texture.

Different environments and seasons are good starting points too. For example, industrial areas in cities are often cool and grey in colour, with snatches of warm shades like orange and red thrown in – an usually rustic combination. The same scene can take on a whole new appearance in winter or summer, with splashes of either white or green. The countryside – filled with greens and bold colours – transforms across the seasons in even more distinctive ways than towns. Autumn and winter are especially beautiful times of the year to look for inspirational colours. Return to the same place at different times of the day too; a scene's colours in the morning look very different in the evening,

Art, of course, is a great place to look for colour schemes. A wander round a gallery or a flick through an art book or magazine will throw colours at you that you may not have dreamt of. Illustrated books are good sources too.

Food is an unconventional subject to look to for colour ideas, but the photography for it can be very inspirational: from the colours of the food itself to the dishes and table they're styled with, these can often be either striking or subtle colour schemes, thus suiting a wide variety of tastes.

My advice to you is don't be afraid to play with colour. Use these ideas as a springboard for your creativity and have fun! In time, you'll steadily gain confidence in making your own complex colourways.

NATURE IN YARNS

See how nature can inspire your yarn colours. From the coastline (top left), spring berries (top right) winter fruits (bottom left) and an autumn garden (bottom right), the places around us offer plenty of ideas for colour.

TECHNIQUES

Fair Isle knitting is a type of colourwork made by stranding two colours of yarn. Colours are frequently changed either within a set pattern or when beginning a new one to create a specific motif. The quickest way to change colour is to 'drop' the yarn you are not using and pick up the new one, and allow the old colour to 'strand' across the row at the back of the knitting as you continue to work. The stranding always takes place on the wrong side of your work, and it is advisable to do this every two to three stitches only to avoid long 'loops' that could become damaged or snagged. You will need to decide which colour yarn is kept on top – the first or the second colour – and keep this order consistent throughout the colour changing on that row.

Most stranded knitting with two colours is worked in stocking (stockinette) stitch on two straight needles; when working in the round, only a knit stitch is used.

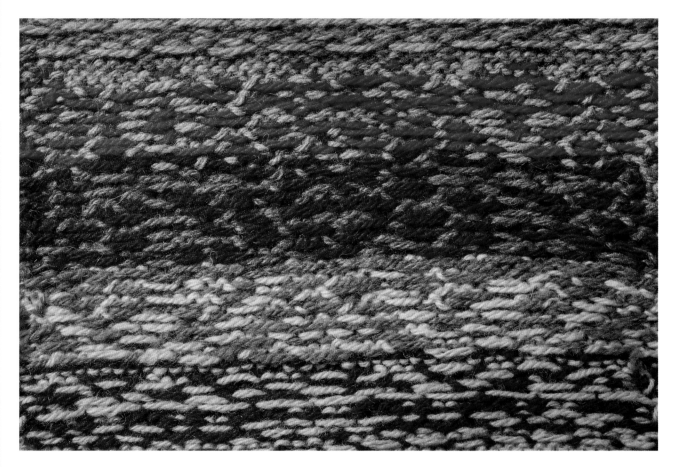

THE BACK OF FAIR ISLE

The wrong side (or back) of a swatch of a typical Fair Isle pattern.

Knitting a pattern with multiple colours means the unused yarn colours in the row are 'carried' across the back, creating 'strands' or 'loops' of yarn. The greater the distance between a particular colour and the pattern it belongs to, the larger the strand at the back of the work.

HOW TO HOLD THE YARN

As Fair Isle colourwork is about working with two (or, more rarely, three or even four) colours at a time, this means you need to pay attention to how you hold your yarns.

There are two common ways you can choose to hold the strands of yarn – just as in regular knitting. There is the English style, whereby the new, second colour that will be worked is introduced using the same hand you used to hold and work the first colour; the old, first colour is literally 'dropped' or simply held in the same hand. The other method you can use is the Continental style, whereby you hold both the old and new colours in your left hand (right hand, if you are left-handed) throughout your knitting, so that you can simply catch the held lengths yarn and knit (or purl) the colour into the knitting when needed – this will ensure the tension stays the same throughout too. The photographs below, and throughout this technique section, demonstrate the two styles from a right-hand knitting perspective.

Personally, I prefer to use the English method, and it is the way I have held my yarns throughout this techniques section. English style makes purling and slip stitching much easier. In addition, as Fair Isle is a pattern traditionally made with only two colours per row, you rarely need to carry more than one colour at a time, which makes dropping the old colour no problem at all.

YARN HELD IN ENGLISH STYLE
(ONE-HAND METHOD)

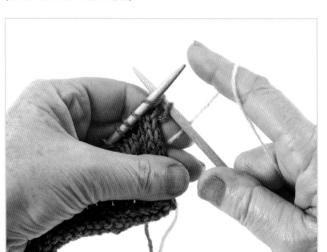

Right hand works in and knits the new, second colour (ecru); the old, first yarn (green) is dropped and left hanging at the back. The index finger on the right hand controls tension.

YARN HELD IN CONTINENTAL STYLE
(TWO-HAND METHOD)

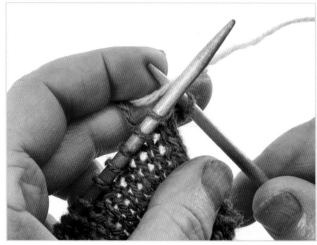

One hand (left here) holds the old and new yarn. The right needle simply picks up the necessary yarn when needed. The yarns are wrapped around one of the fingers (usually the index finger), which controls the tension.

TENSION (GAUGE)

Tension is the number of stitches and rows that the average knitter will achieve with a specific yarn, needle and knitting pattern. It is used to calculate measurements into a number of stitches and rows, and it is vital that these are accurate in order to achieve the measurements required for your finished knitted item. Furthermore, too tight or too loose a stitch can result in a distorted Fair Isle pattern that will affect the look of the overall design.

How you knit and hold the yarn will affect the tension. If you hold the yarn and knit more tightly, then the item will be smaller; conversely if you tend to hold the yarn loosely and have a relaxed knitting style, the finished piece will be larger.

All patterns will state a specific yarn to be used, but these can be substituted if the tension of the yarn is the same.

There are two tension measurements stated in the projects: the manufacturer's tension and my recommended tension for the specific pattern. Tension measurements given in a pattern are usually based on a swatch worked in stocking (stockinette) stitch measuring 10cm (4in) square. This is the stitch and measurement I have used throughout the book.

If you work fewer stitches than stated in the pattern it means that you are knitting too loosely; the answer will be to go down a needle size. Conversely, if there are more stitches than stated, then you will need to go up a needle size. Changing needles isn't something to worry about if it's something you need to do; I always tell my students that knitting is like travelling to a new destination – as long as you get there in the end, it doesn't matter how you do it!

When you have achieved the correct tension, you will be ready to knit your chosen pattern, and the finished size should match your chosen project.

How to measure

1. Cast on the appropriate number of stitches; this is usually 4–6 stitches more than those stated in the tension measurement.

2. Work in the stitch pattern specified for the number of rows required to make a row of knitting 10cm (4in) in length, plus four to six additional rows. Cast off loosely.

3. Block the swatch in the same way as you would for your finished project (see age 40–44).

4. Take your tape measure and count the number of stitches across your work within a 10cm (4in) length.

5. Use your tape measure once more to count the number of rows within 10cm (4in).

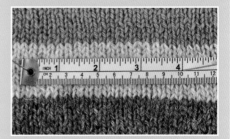

Measuring the number of stitches in a row.

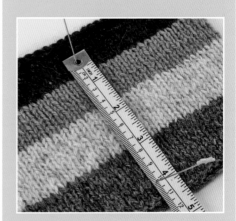

Measuring the number of rows.

>>>>>> **TIP** <<<<<<

A quick way of checking your tension is to move your work up and down the needle. If it moves smoothly along the needle, the tension is good. If it struggles to slide, the tension is too tight; conversely, if it slides too readily along the needle, the tension is too loose.

STARTING A NEW BALL OF YARN

The easiest way is to start a new ball of yarn is at the beginning of a row. You do this by simply knitting with the new ball and leaving the remaining length of yarn hanging. Both ends can then be sewn into the project later, either at the seam or woven into the wrong side of the piece of knitting.

This is the same for joining in new yarn when close to the end of a ball; just make sure you leave enough yarn for weaving in at the end.

FAIR ISLE KNITTING BASICS

Knit stitch

When you are ready to introduce your second colour, the new yarn is worked in as you would with joined-in yarn in regular knitting – albeit without the yarn slip-knotted onto the old yarn colour.

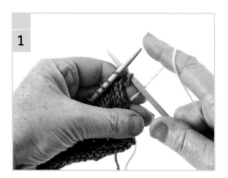

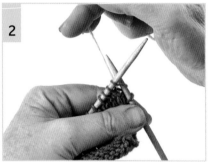

Work your last stitch in the first colour (green), then 'drop' it and lay it at the back of your piece. With a tail of approx. 10cm (4in), hold the new yarn colour between your third and middle finger on your left hand (right, if you are left-handed) to anchor it and create a little tension. With the yarn ball end, wrap it around your fingers as you would for the regular English method. Insert the right needle into the next stitch knitwise.

Wrap the new colour around the right needle, anti-clockwise.

Take the wrapped yarn through the stitch. Lift the stitch off the left needle onto the right needle. Your first stitch in the new colour has been made.

Purl stitch

Like the knit stitch, working Fair Isle purlwise follows the same principles as regular knitting. Fair Isle is rarely introduced purlwise, so more likely you will be picking up a 'hanging' length of the second colour from earlier on in the previous row. Then, simply work as you would for regular purl knitting. I have used a stranded sample of knitting here, so you can see how the new colour strands across the back.

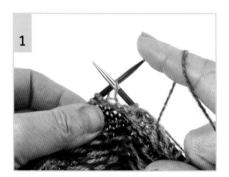

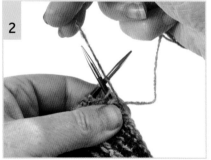

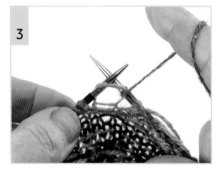

Pick up the second colour yarn and wrap it around your fingers to create the necessary tension. Enter the stitch purlwise.

Wrap the new colour around the right needle, anti-clockwise.

Take the wrapped yarn through the stitch. Lift the stitch off the left needle onto the right needle. Your purl stitch in the new colour has been made.

Stranding

The key feature of Fair Isle knitting is the stranding at the back of the work, made through the changing of yarn colours.

The number of stitches between each colour, along with the number of coloured yarns, determines how the yarns are stranded at the back. If the change between colours is three stitches or fewer, this is a simple process: you can drop the second colour and start working again with the first; the first colour will naturally strand at the back. However, if your pattern calls for four or more stitches between two colours, it is necessary to 'twist' the unused colour to anchor the loop of yarn to the back of the work, and ensure no large hanging strands are left on the wrong side. This is called 'carrying the yarn'.

THREE or FEWER stitches between colour changes

In this example, three stitches of green yarn have been worked. The pattern I am following states that pink is the next colour.

It is worth noting that, as the green will be immediately picked up after the pink, it is not necessary to completely drop it – simply clutching it lower down in your working hand will help keep it out of the way as you work in the second colour.

Note: here, the sample has been knitted knitwise. The technique is similar purlwise, but with the right needle inserted in front of the left on the wrong side of the work.

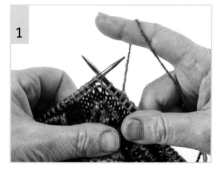

Insert your right needle into the next stitch. Carefully move the main colour (green) down from your index finger and clasp it against your palm with your third and fourth fingers. Pick up the second colour (pink).

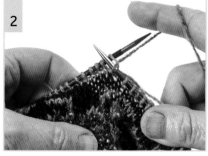

Work a knit stitch as usual (see also page 27 for guidance). As you can see, the second colour (pink) has naturally formed a strand across the back.

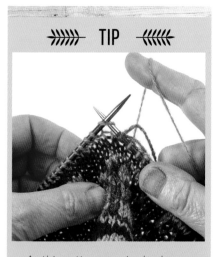

>>>>> TIP <<<<<

As this pattern required only one stitch of the second colour, and does not need to be picked up for several stitches, there is no need to hold it along with the green. Simply drop the yarn and pick up the main colour (green) once more and work as usual.

**FOUR or MORE stitches between colour changes –
yarn needs to be twisted or 'carried' between third and
fourth stitches**

Note: in order to see the twisting process more easily, the sample has
been knitted purlwise. The technique is similar knitwise, but with the
right needle inserted behind the left on the right side of the work.

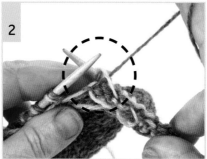

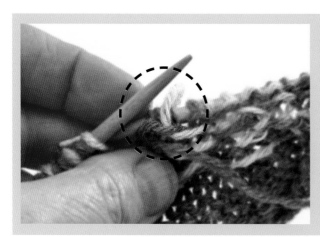

As you can see in the photo above there
are already three stitches made in the
first colour (green). The second colour
(ecru) won't be reintroduced for a while,
so it needs to be 'carried' across the
fourth stitch to prevent a large loop.

Lay the working yarn (green) over the
working needle. Then, take the colour
to be carried across (ecru) and lay it
over the top of the green. Pick up the
working yarn again.

Insert the needle into the stitch, and
wrap the working yarn anti-clockwise
around the needle. Continue to work
as usual.

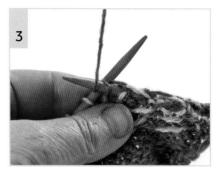

Here, you can see the working yarn (green) has twisted around
the unused yarn (ecru), locking it in place. You can continue to
work two to three stitches without twisting; more, and you will
need to twist and carry across the unused yarn once again.

⫸⫸⫸ TIP ⫷⫷⫷

An used colour is only carried across the back of the
work if it is to be reintroduced in the same row or the
following. If not, I suggest breaking the yarn, leaving a
long tail to weave in later. Then, simply cut off a new
length of the colour to reintroduce later when needed.

Introducing a third colour

Traditionally, Fair Isle uses only two different colours per row; this is because using numerous colours would create lots of overlapping 'strands' at the back of the work, which increases the chance of snagging. However, on occasion, a pattern will demand a third colour within the same row, especially if it has a detailed motif (such as Large Flower border on page 57 or Cherries border on page 68) or a complex pattern with 'highlights' (such as Lomond on pages 110 and 111).

In order to prevent long loops of the new yarn hanging at the back and getting in the way, twist it with the old yarn lengths with the new one once the first stitch has been worked, to lock it securely against the wrong side of the work.

Note: in order to see the twisting process more easily, the stages below have been worked purlwise. The technique is similar knitwise, but with the right needle inserted behind the left on the right side of the work.

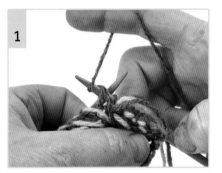

1

Drop the previous colour. Leaving a tail of yarn approx.10cm (4in) long, lay the new third colour (pink) against the working needle. Wrap it around the needle as anti-clockwise.

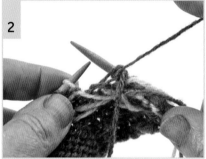

2

Work the first stitch and slide it from the left needle onto the right.

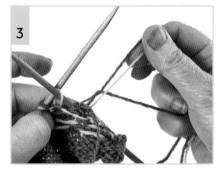

3

Now to twist! Twist the two other colours (green and ecru) used previously over the third colour. Note how the three yarns are clasped against my palm, with my index, middle and third fingers twisting and maintaining the tension.

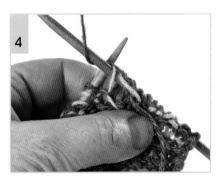

4

Continue to work. In this case, the green was the next working colour, and the pink and ecru yarns hanging. For the purposes of demonstration, these are hanging behind the needle, so you can see the twisted strands.

>>>))) **TIP** (((<<<

If the third colour is to be used one more time, simply knit/purl as usual (see also pages 28 and 29). If the third colour doesn't crop up until much later, it's worth breaking off the colour and weaving in the tail later.

>>>))) **TIP** (((<<<

If the third colour is used only once, it may not be necessary to use a whole ball. Instead, cut a set length of yarn approx. three times the length of your knitting, and introduce it to your knitting in the usual way.

Increasing

Making increases in Fair Isle is exactly the same as regular knitting; it just takes a few moments to get used to using two different colours! There are two different increases – 'Knit into Front and Back of the same stitch' (kfb) and 'Make 1' (or M1). With a regular increase, you knit into the same stitch to create another; with Make 1, you work an extra stitch between two stitches.

'Knit into Front and Back of the same stitch' (kfb)

The most visible of the increases, this leaves a small bump that can look similar to a purl stitch.

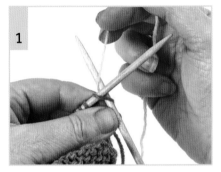

Insert the working needle into the stitch and wrap the yarn anti-clockwise around it.

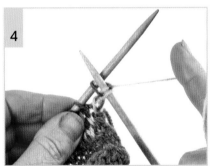

Take the wrapped yarn through the stitch as usual, but do not lift the stitch off the left needle.

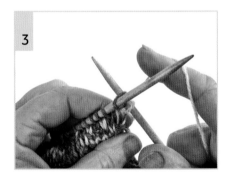

Instead, take the needle through the stitch again, this time through the back of the loop. Wrap the yarn around the needle once more.

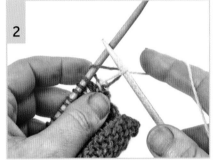

The stitch can now be lifted off the needle. As you can see, two stitches now sit on the working needle.

TIP

Increases are usually made on a knit row, rarely on a purl row.

'Make 1' (M1)

This particular technique forms an invisible increase, which is very useful for subtle shaping in knitted garments.

In between the stitch on the right needle and the stitch on the left needle, there is a horizontal 'bar' or 'thread' of yarn – you slide the left needle underneath this, to form the increase.

The direction in which you slide the needle under the bar will make the new stitch lean either to the left (needle enters from front to back) or to the right (from back to front). Unless the direction is noted in the pattern – usually as 'Make 1 Left (M1L) or 'Make 1 Right' (M1R) – either method could be used and is entirely your preference. I have used Make 1 Left below.

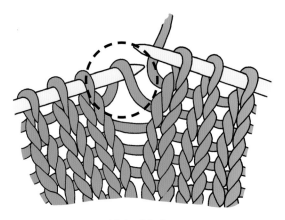
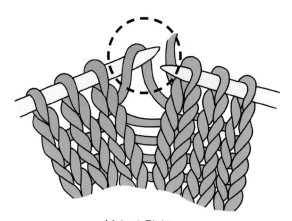

Make 1 Left *Make 1 Right*

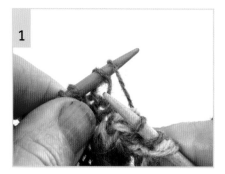

Using the left needle, slide the tip underneath the bar from front to back and slip it onto the left needle.

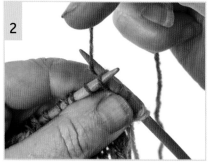

Continue to work a knit stitch as usual.

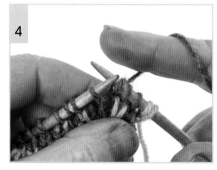

Slide the worked stitch onto the right needle. An extra stitch has now been made.

Decreasing

Like increases, making decreases in Fair Isle is exactly the same as regular knitting. Decreases can lean to the right or to the left, depending on the decrease you use. It is important to use the correct decrease for the knitted item, especially for highly shaped knitwear like garments as this ensures they fit properly.

The decrease that leans to the right is 'Knit Two Together' (k2tog) and the decrease that leans to the left is 'Slip one stitch, Slip one stitch, Knit' (SSK). K2tog and SSK are often paired together to create a balanced, symmetrical shape to the work on the right side of the work. Conversely, p2tog and SSP ('Slip one stitch, Slip one stitch, Purl') are paired to balance the piece on the wrong side of the work.

'Knit Two Together' (k2tog)

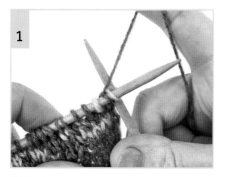

1

Slide the right needle through the loops of two stitches. Wrap the yarn around the needle anti-clockwise and continue to knit as usual.

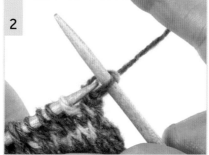

2

Lift the stitch onto the right needle. You will see the two stitches have been knitted together to form one stitch.

⟫⟫⟫ P2TOG ⟪⟪⟪

P2tog is worked exactly the same way as k2tog, except it is worked on a purl row and with the needle entering the stitches purlwise. It leaves you with the same result, creating a decrease leaning to the right on the right side of the work.

⟫⟫⟫ K2TOGTBL ⟪⟪⟪

K2togtbl is worked exactly the same way as k2tog, except you push the needle through the stitches back to front instead of front to back. This decrease serves a decorative purpose as well as a practical one, adding a subtle texture to the joined stitch.

'Slip stitch, Slip stitch, Knit' (SSK)

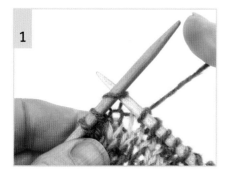

1

Slide one stitch off the left needle onto the right needle knitwise.

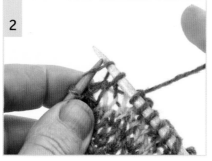

2

Slide another stitch off the left needle onto the right needle knitwise.

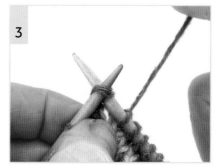

3

Take the left needle through both the back loops of the two slipped stitches that are sitting on the right needle. Knit as usual.

Fair Isle in circular knitting

Fair Isle knitted in the round is very similar to knitting flat; the only difference is whenever you knit a new colour into the item, it is essential that you twist the yarn with those of the older colours after working the first stitch, to avoid a hole appearing at the join.

 You can use either a circular needle or double-pointed needles (DPNs) to work your knitting. Circular needles are often the most popular, as you effectively knit as you would for a flat piece of knitting; however, for a small section of knitting, such as the tip of a hat, you will need to transfer your work onto DPNs as even the smallest of circular needles can be slightly too long for such a tight area. Knitting in the round is preferable for some projects as there will be no seam to sew up.

Circular needles

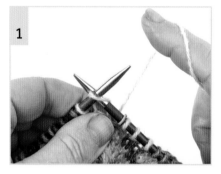

1

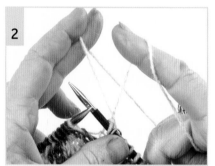

2

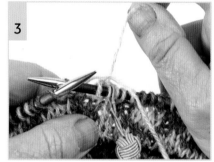

3

Knit the pattern in your first colour (pale blue) as usual. When you are ready to introduce a second colour, insert the needle into the stitch, wrap the new yarn (ecru) around the needle and work a single knit stitch as usual (see also page 27 for guidance).

Lift both ball end lengths of the two yarns and twist them together.

Continue to knit another stitch in the yarn colour stated in the pattern. Once this is done, pull the strand of the new yarn tightly, to ensure the new join is tight and the holes won't appear.

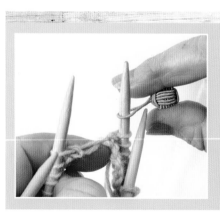

⇝⫸⫸⫸ TIP ⫷⫷⫷⫷⇜

Always ensure a stitch marker is placed at the beginning of a round before you work your first stitch, whether it's the first needle you will be working on with DPNs or the right side of a circular needle. This ensures the start and end of each round is consistent, and you always know where the round begins. A loop of contrasting coloured scrap yarn can also be used.

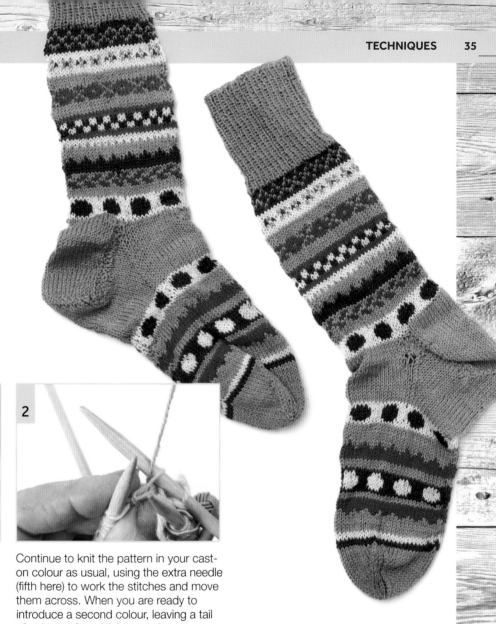

Double-pointed needles (DPNs)

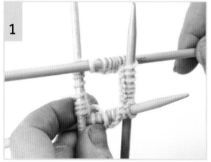

Prepare your needles for the round. The example here has 32 stitches, divided evenly across four needles by slipping the stitches (here, 8) onto each needle, one after the other.

Continue to knit the pattern in your cast-on colour as usual, using the extra needle (fifth here) to work the stitches and move them across. When you are ready to introduce a second colour, leaving a tail of at least 10cm (4in), wrap the new yarn around the needle and work a single knit stitch in the new colour.

Insert the working needle into the next stitch. Take the two coloured yarns in your hand.

Twist the two together. You can now continue to work a knit stitch.

READING THE CHARTS

You read a chart from bottom to top, the bottom being the beginning of the pattern and the top the end of it. When working with straight needles, the direction in which you read the squares on the chart indicates whether you knit or purl a row. Commonly, knit rows are odd numbered rows and the squares are followed from right to left. Conversely, purl rows are evenly numbered rows, and the charts are read from left to right.

When working in the round (for an item such as a hat or pair of socks), every row is knitted and the chart is read from right to left on every row.

 TIP

Charts for circular knitting are read in almost exactly the same way as those for straight needles; the only difference is that there are no purl rows, so all the even-numbered rows are knit rows too.

Chart example

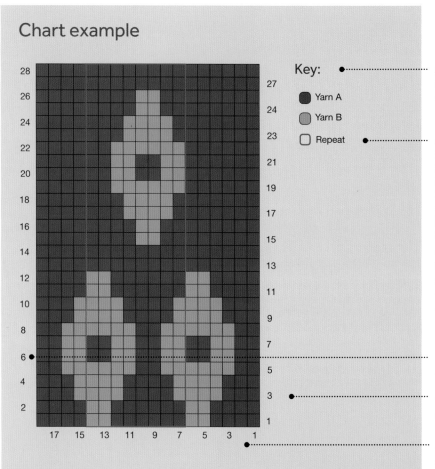

Key:

- Yarn A
- Yarn B
- Repeat

A **key** details what each colour square represents, along with other symbols necessary for the pattern.

A **pattern repeat** shows what stitches you need to work within a specific number of rows, in order to execute an accurate, repeated pattern motif. Once the beginning of the pattern has been established, work the stitches within the repeat box to create a consistent, continuous pattern across your knitwear.

For this chart, you work the first six stitches in the row to begin the pattern and then the stitches from columns 7–14 will allow a successful repeated motif.

Even-numbered row: purl row. Read the chart from left to right.

Odd-numbered row: knit row. Read the chart from right to left.

Number of stitches within a row needed to create the pattern

Row 1 (RS): k4A, k2B, * k6A, k2B, rep from * to last 4 sts, k4A.

Row 2 (WS): p4A, * p2B, p6A, rep from * to last 6 sts, p2B, p4A.

Written equivalent of chart, included whenever possible. These instructions will appear close to the chart.

Here is how they work, and relate to the chart:

Note the first row, read from right to left, begins with 'k4A'. This means 'knit 4 stitches with yarn A'.

If you have a look at the chart, the key indicates all brown squares are yarn A. See how row 1 of the chart has four brown squares? This is 'k4A'.

So, the next instruction 'k2B' means 'knit 2 stitches with yarn B'.

On row 2, read from left to right, you start the pattern in the same way – working 4 stitches in yarn A. However, because it is on an even-numbered row, this means you purl the stitches. So, the first four brown squares on row 2 mean 'p4A' – 'purl 4 stitches with yarn A'.

KNITTING ABBREVIATIONS

The list below details all the common abbreviations used in this book.

cm	centimetre(s)
cn	cable needle
cont	continue
dec	decrease(ing)
foll	following, or subsequent
in	inch(es)
k	knit
k2tog	knit two stitches together
kfb	knit into front and back of the same stitch (one stitch increase)
M1	make one stitch; pick up horizontal strand of yarn between st just worked and next st and knit it
m	metre(s)
p	purl
patt	pattern (in chart)
p2tog	purl two stitches together
PM	place marker
RS	right side
rem	remain(ing)
SSK	sl next 2 sts one at a time to right-hand needle knitwise, insert tip of left-hand needle through front loop of both sts and knit together
st(s)	stitch(es)
St st	stocking (stockinette) stitch
sl	slip stitch from one needle to another
tbl	through back loop
W&T	wrap and turn – *On a RS row:* with yarn in back, slip next st purlwise to right-hand needle. Bring yarn to front and slip st from right-hand needle back to left-hand needle. Bring yarn to back of work, then turn to work next short row with WS facing *On a WS row:* with yarn in front, slip next st purlwise to right-hand needle. Bring yarn to back and slip st from right-hand needle back to left-hand needle. Bring yarn to front of work, then turn to work next short row with RS facing
WS	wrong side
YO	yarn over needle; sometimes known as 'Yarn Forward or 'YF'
YF	yarn forward; sometimes known as 'Yarn Over' or 'YO'
yd	yard(s)
– (–:–:–––)	indicates different sizes, from the smallest to largest
–	sizing not applicable

YARN CONVERSIONS

The chart below shows the weights of yarn used in this book.

UK	US	Australia
2-ply	laceweight	-
3-ply	sock	3-ply
4-ply	fingering	5-ply
DK	light worsted	8-ply
aran	worsted	10-ply
chunky	bulky	12-ply

FINISHING

Cutting and weaving the yarn

Where multiple colours are used, I suggest you weave in yarns as you go along so you do not end up with an enormous amount of sewing in at the end of a project. Always leave a long tail of yarn at the end of your knitting, as this makes the sewing in easier (see also 'Starting a New Ball of Yarn' on page 26).

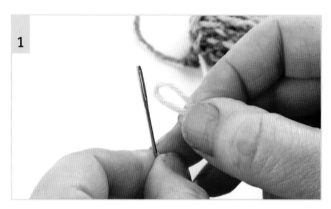

Cut your yarn, leaving a tail approx. 10cm (4in) long. Take your tapestry needle and thread the tail of yarn.

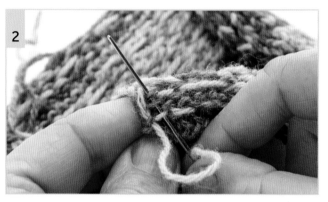

Take your tapestry needle through a few stitches at the back of your work, from bottom to top.

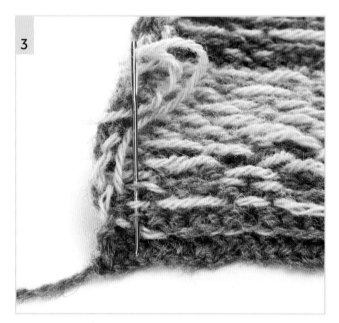

Take the tapestry needle through the next column of stitches the opposite way, from top to bottom.

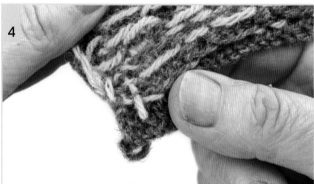

Repeat steps 2 and 3 several times until the yarn is secured. When finished, trim any excess yarn, leaving approx. 3mm (⅛in). This accomodates for yarn stretch.

Seaming your work – mattress stitch

I always use a mattress stitch to seam work, as I find it produces a flatter seam with an invisible edge.

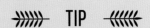
TIP
Sew the edges of each piece together as near the edges as possible to avoid a bulky seam.

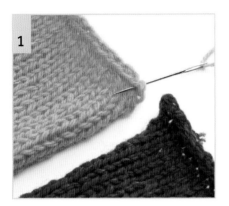

Lay out your flat pieces of knitting next to each other, right sides up with the bottom edges facing towards you. Thread a tapestry needle with a matching yarn three times the length of the seam you will be joining. Then, bring your threaded tapestry needle from the back of your work through to the front between the first two 'threads' of yarn that run horizontally in between your stitches, at the bottom edge of your work. (I like to begin with the knitted piece to the right and bring my needle to the front just above my cast-on edge.)

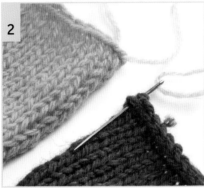

Then, take the tapestry needle between the first two 'threads' of yarn that run in between your knit stitches at the bottom edge of your other knitted piece.

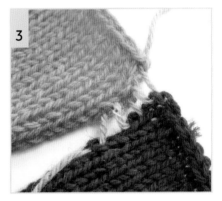

Return to the first piece of knitting. This time, take a close look at the edge of your piece you'll be seaming and gently tug it open a little. See how there are 'bars' of yarn, that form the knit stitches at the front? You'll be drawing the needle under these and then taking it under the 'bars' on the other knitted piece, in order to join the two together and create the first seam. Continue to sew together the two knitted pieces in this way, alternating back and forth and working upwards along the two edges. You'll see that the strand of yarn you threaded onto your needle becomes a ladder-like seam along the two edges.

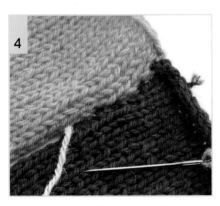

Picking up a 'bar' from each side of your work naturally draws the edges together, making your two knitted pieces appear as one piece of knitting. Continue right to the top, then cut and weave in the remaining yarn.

TIP
Depending on the gauge or thickness of the pieces, sometimes it is just as effective to pick up every other bar, rather than every bar.

TIP
If the seam doesn't naturally draw together, carefully pull the yarn to tighten – not too much, as the seam needs to be relatively elastic.

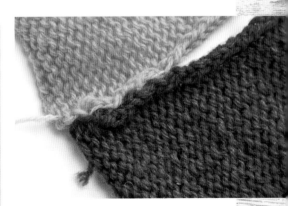

Mattress stitch from the back.

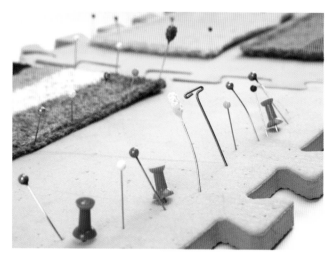

Blocking and pressing

Blocking and pressing your work is great for ensuring even stitches, relaxing the yarn and ensuring that your pieces of knitting match the size stated in the pattern (although it is worth noting that your tension (gauge) should be correct from the outset). Blocking will give a flat, finished look to most pieces of knitting, and make it easier to sew and seam them too.

There are different methods for blocking your pieces. For natural fibres, I always wet block or steam, but for synthetics a light spray with water is considered the best option. Pins should be placed approx. 2.5cm (1in) apart to hold work in place.

Unblocked piece.

Blocked piece.

You will need:

- Tape measure
- Blocking board or mat: I like to use interlocking foam mats
- Pins: you can buy special blocking pins for this process, but any old pins do just fine too! I like to use old dressmaking pins.
- Depending on your method:
 - **For wet blocking:** a towel and bowl of luke-warm water
 - **For spray blocking:** a spray bottle filled with cool water
 - **For steam pressing:** a steam iron or steamer

⋙ TIPS FOR BLOCKING ⋘

- Use the straight edges of the blocking mat to help you line up your piece of knitting, and ensure an even, straight edge to your work.

- Secure and pin one edge of your work at a time; this makes the pinning process quicker, as you don't have to keep adjusting the knitting.

- Smooth all seams and areas that are puckered as much as possible with your fingers.

Wet blocking

This is my preferred method of blocking – all it requires is a little bit of patience with the air-drying!

Immerse your pieces in luke-warm water until they are wet. Lift out each piece and gently squeeze out the excess water. Roll each piece in a towel to soak up most of the water.

Place each piece flat on a blocking board and shape it into the desired finished measurements – you can use your tape measure to help you do this, if you wish. Pin the piece securely in place.

Leave the pieces until they are completely dry. Gently remove the pins, being careful not to snag any stitches.

Spray blocking

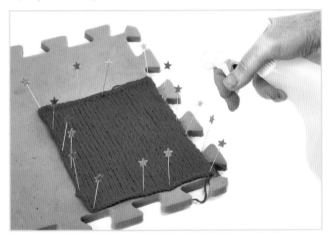

1 While your knitting is still dry, pin it to the blocking mat. Fill a clean spray bottle with cool water. Spray your entire knitted piece with water, until the piece is quite damp – feel the underside to make sure that the water is getting through.

2 Allow the piece to air-dry. When it is completely dry, gently remove the pins, being careful not to snag your stitches.

Steam pressing

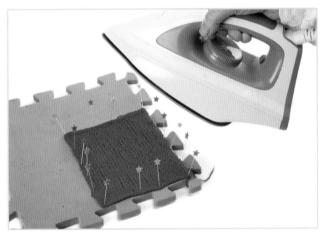

1 While your knitting is still dry, pin your piece to the blocking mat. Hold the steamer or steam iron an inch or more above the item, then steam the piece well. Move the iron slowly over the surface, but never allow it to touch the yarn; do not press.

2 After steaming, leave the piece undisturbed until it is completely cool and dry. When it is completely dry and cool, gently remove the pins, being careful not to snag your stitches.

EMBELLISHING

Embellishing your work with tassels, beads, pompoms or buttons can add a unique and sometimes practical touch to your finished piece of knitting.

Adding beads

Beads can add fun and glamour to a knitted item. There are lots of different methods out there for adding beads to your work; I prefer to sew mine in with a tapestry needle, as I would for buttons, as I find this simpler and often I have the needle threaded and ready to go after cutting and weaving my yarn!

You will need:

- Selection of beads
- Tapestry needle – make sure it will fit through the hole of your bead
- Fabric (or thread) scissors
- Separated yarn or embroidery thread (floss), to correspond with your design

→))))) TIP (((((←

Separating yarn is a simple process: simply tug on one of the strands you can see that make up the yarn, and gently pull on it, holding the other strand/s securely in your other hand. Some yarns are better than others for separating; cheaper, non-woolen yarns may snap, so it is always worth testing them first.

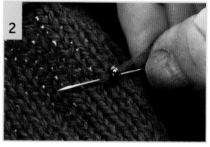

Thread your tapestry needle with separated yarn or embroidery thread (floss). Secure it to the inside of the garment or accessory with a knot or a few tiny stitches. Thread the yarn or thread (floss) through the hole of your chosen bead.

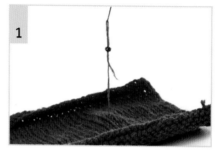

Take the needle from the front of the piece through to the back of the piece, over the left outer side of the bead, then up to the right outer side of the bead to secure it in place. To secure the other side of the bead, take the needle through the middle of the bead from the front of the piece to the back.

Bring the needle up through the knitted piece to where you would like next bead. Thread another bead onto the needle, and repeat step 2 as many times as you wish to add your beads.

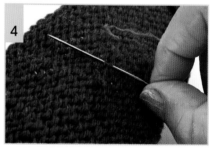

When you have finished stitching all your beads, take the needle through to the back of the work. Push it through the stitches of your last bead, and then work a couple of tiny stitches on either side before cutting away the yarn.

Adding buttons

Buttons are usually used for fastening garments or pillows, but they can also be used for embellishments. An example of this can be seen on the Croft Child's Dress (see pages 92–101). When using buttons on a garment, always mark out where you would like to place them before sewing them on. Using the same yarn as the one in the project ensures consistency, but note that it may need separating into single strands if it is too thick for your tapestry needle (see box opposite); otherwise, use embroidery thread (floss). There are many types of buttons available and it is worth spending a bit more to find the perfect one that will enhance your knitted project.

You will need:

- One button (or more, depending on your intention)
- Tapestry needle – make sure it will fit through the holes of your buttons
- Fabric (or thread) scissors
- Separated yarn or embroidery thread (floss), to correspond with your design

⟫⟫⟫ TIP ⟪⟪⟪

Mark the position for the button with a pin to ensure that it corresponds with the buttonhole or loop.

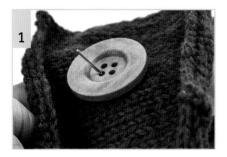

Thread your tapestry needle with separated yarn or embroidery thread (floss). Secure it to the inside of the garment or accessory with a knot or a few tiny stitches. Lay the button onto the front of your knitted item and take the needle through one of the holes to begin.

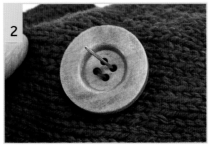

Stitch your button in place. If it is a two-hole button simply go up and down the holes a few times (usually three to four stitches in each hole). If it is a four-hole button, then make sure you are consistent with your stitching for all the buttons, either with two diagonal stitches, creating a cross, or by making two parallel stitches as I have done.

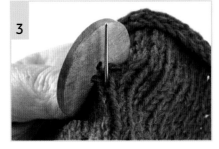

Once you have secured the button firmly, come up underneath the button with your threaded needle.

⟫⟫⟫ TO MAKE ⟪⟪⟪
A BUTTONHOLE & LOOP

A pattern will usually tell you how to make a buttonhole (as a standard, this is 'k2tog, YO, SSK'). To make a button loop, thread stranded yarn or embroidery thread (floss) through a tapestry needle then secure it to the inside of the garment or item with a knot where you want the button loop to start. Take the threaded yarn or thread (floss) up to the top of the fabric and form a loop slightly bigger than the button and stitch it to the edge of your knitting where you want the loop to end. Repeat this a few times, depending on how thick your yarn or thread (floss) is. Then, with the needle still threaded, work buttonhole stitch around the strands by taking the needle under the strands then, before pulling to tighten, poking the end through the loop made. Fasten off to finish.

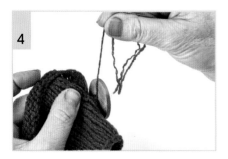

Wrap your yarn a few times around the stitches securing the button. This ensures that the button is held in place. Leave a little loop on the last turn.

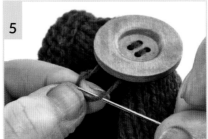

Take the threaded needle through the loop then pull to make a knot. Carefully cut away the excess. Repeat steps 1–5 with remaining buttons, if required.

Pompoms

You can either make a pompom maker, or purchase one from a shop. I will show you how to use both. Depending on the garment or accessory, you can make your pompom a small size for subtle fun, or extra large for a more audacious, quirky look! Have a play with winding different coloured yarns around your maker, to add texture and interest to your pompom.

Cardboard pompom maker

>>>>> **TIP** <<<<<

You could draw the inner hole freehand, instead of using a coin, but it is worth noting that the size of the inner hole determines the thickness of the pompom. If the hole is too big, it will make it difficult to tie off the pompom.

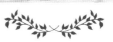

You will need:

- Two pieces of stiff card
- Tape measure/ruler and compass OR tumbler
- Small coin
- Paper scissors
- Fabric (or thread) scissors
- Tapestry needle
- Yarn, to correspond with your design

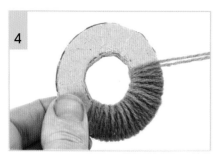

1

Use your tape measure/ruler to draw the diameter of the circle onto one of your pieces of card, and mark the centre point. Use this line and the compass to draw a circle. Alternatively, draw around a suitably sized tumbler. Repeat this on the other piece of card.

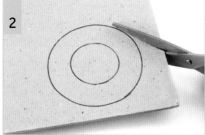

2

Draw a smaller circle in the centre of your card pieces. (I used a British two-pence coin, which is approx. 3mm (⅛in) in size.) Cut out both large circles and their centre circles. Lay one ring on top of the other to form your basic pompom maker.

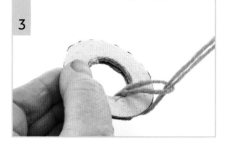

3

Fold your yarn in half and take the loop through the hole of your pompom maker from underneath. Pull the ends of your yarn through the loop to secure. This allows you to wrap doubled yarn around the card for faster wrapping!

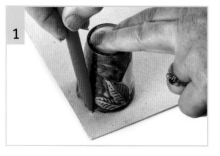

4

Start wrapping your yarn evenly around the card until there is no space left in the centre. Tying the yarn double earlier makes this process quicker! When the hole in the centre gets too small to wrap the yarn around with your fingers, thread the yarn onto a tapestry needle and complete the process.

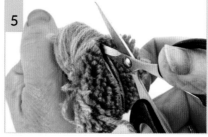

5

Carefully cut the yarn along the edge of the maker, in between the two pieces of card.

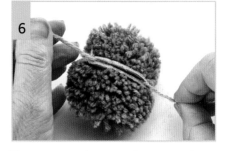

6

Tie some yarn between the two card circles, leaving a long tail of yarn to use for sewing with later. Cut the card with paper scissors, and then carefully pull out your pompom. Give it a 'hair cut' and trim it to make it evenly round.

Purchased pompom maker

There are many of these on the market and it is a matter of preference which one you use. I like to use a very simple one by Prym: it comes as a group of four 'arches', snapped together in pairs and then the yarn is wrapped around the arch of each pair.

This is how to use my maker, so do have a look at the instructions for your own type before you begin. However, the principle of bought makers is essentially the same for all types: the yarn is wrapped around each arch of the maker then the arches are brought together to make a ring. The two sides of the pompom are then joined by a length of yarn, tied around the open centre.

You will need:

- Chosen pompom maker
- Fabric (or thread) scissors
- Yarn, to correspond with your design

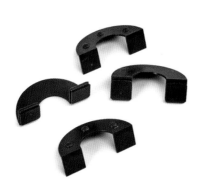

My pompom maker.

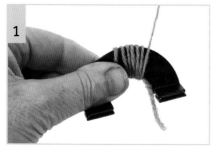

1 Leaving a little tail of yarn, start to wrap your yarn around one 'arch' of your maker until you reach your desired thickness (I like mine to be relatively thick, but make sure the indent of the arch is just visible). Repeat for the other arm.

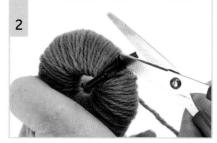

2 Bring together the two wound arms. Carefully cut through the middle of the wound yarn.

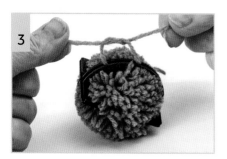

3 Tie a length of yarn around the middle of your pompom to secure then cut off the excess, although take care to leave a long tail of yarn to use for sewing with later.

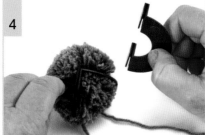

4 Carefully open up your pompom maker and remove the pompom. Give it a 'hair cut' and trim down to make it evenly round.

⫸⫸⫸ FELTED ⫷⫷⫷
POMPOMS

You can felt your pompoms too! Felted pompoms make lovely, subtle embellishments for your designs. You will need either felting wool or 100 per cent pure wool that is not machine washable; Shetland yarn is an ideal yarn type, as it's made of pure wool and is sticky.

Make a pompom approx. three times larger than the finished size required. Put the pompom in a gauze bag (such as one used for delicates). Place the bag inside the washing machine (you could add it to your normal washing load if you like).

Run a 40–60 degree Celsius (US medium to hot/100–140 degree Fahrenheit) wash. Remove your pompom from the bag and let it air-dry.

Tassels

Not only are these easy to make, tassels can add interest to a variety of knitting projects. Large tassels can perk up the corners of a pillow and the edge of a blanket; smaller tassels in fine yarn can be sewn along the bottom of a dress, or along the edge of a bordered collar, to add a contemporary, beautiful statement to a garment.

You will need:

- Cut card or a book, approx. the length of your desired tassel
- Fabric (or thread) scissors
- Yarn, to correspond with your design

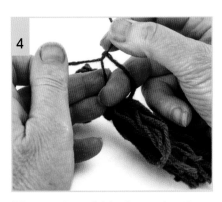

1 Wrap the yarn around your cut piece of card or a book. The number of times you wind the yarn around the card or book will determine the thickness of the tassel.

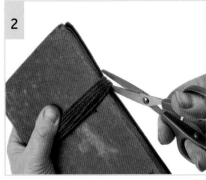

2 When happy with tassel thickness, cut through one end of your wound yarn then carefully remove from your card or book – you can pinch the uncut end to prevent the tassel from falling apart.

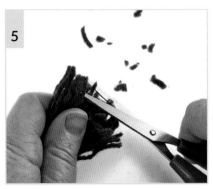

3 With another length of yarn tie your tassel a few centimetres (half an inch) down from the folded end of your tassel. Use the remaining length of the same yarn to cover and wrap the knot. Do this as many times as you wish.

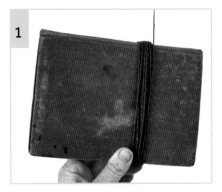

4 When you have finished wrapping, tie a final knot at the 'back' of your tassel. Cut away any excess yarn flush against the sides of the tassel.

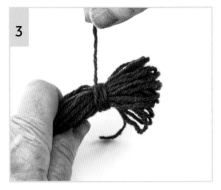

5 Trim the end of your tassel to neaten.

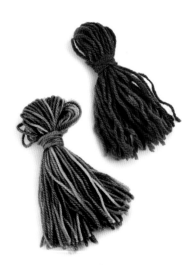

The finished tassel. Why not try using oddments of yarn to make a colourful, variegated tassel?

Attaching pompoms & tassels

Tassels

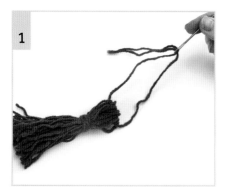

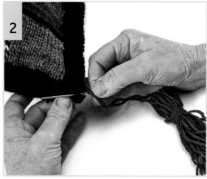

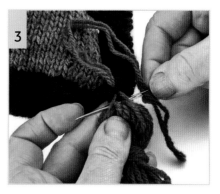

Thread the tapestry needle with a length of yarn, and take the needle through the tassel's loop. Thread the remaining end through the eye of the needle to double the yarn.

Take the needle under the 'thread' of yarn running between the stitches and bring it up through the knitted item, making sure both ends of the doubled yarn have come through. Depending on your yarn type and item, you may wish to secure your tassel by taking the needle through the item again.

Pull the yarn to draw the tassel close to the item. Take the needle through the loop of the tassel. Pull, tie a knot and then cut away the excess.

Pompoms

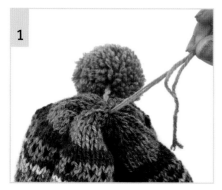

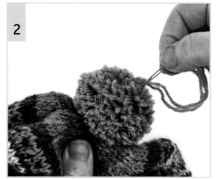

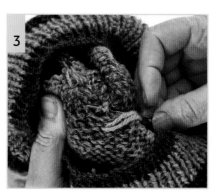

Thread the tapestry needle with the tail of yarn attached to the pompom. Take it under the 'thread' of yarn running between the stitches and bring it up through the knitted item

Pull the needle to draw the pompom close to the item. Take the needle up through the middle of the pompom from the bottom, and on the wrong side of the item, then take the needle back through the middle of the pompom, through to the wrong side of the item, to secure.

On the wrong side of the item work a few stitches to secure the pompom. Tie a knot, then cut the yarn flush against it to finish.

FAIR ISLE
BORDERS

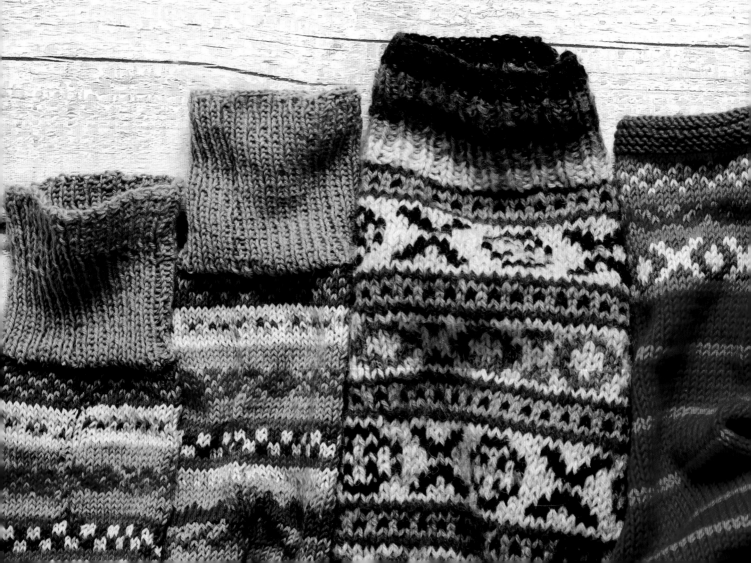

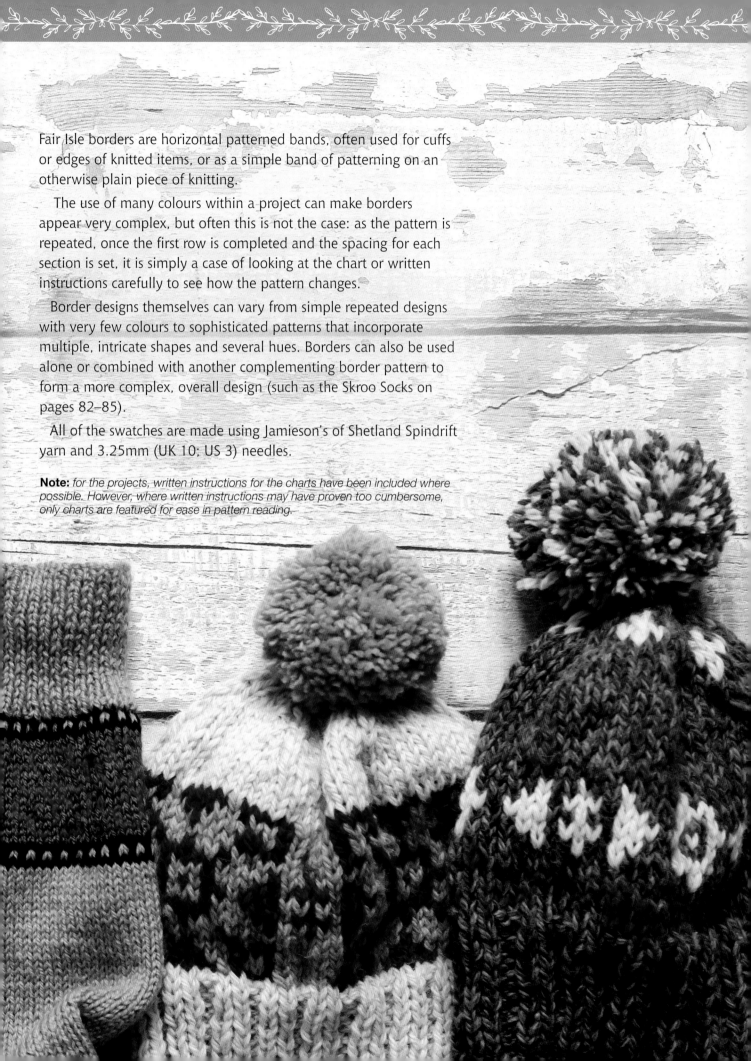

Fair Isle borders are horizontal patterned bands, often used for cuffs or edges of knitted items, or as a simple band of patterning on an otherwise plain piece of knitting.

The use of many colours within a project can make borders appear very complex, but often this is not the case: as the pattern is repeated, once the first row is completed and the spacing for each section is set, it is simply a case of looking at the chart or written instructions carefully to see how the pattern changes.

Border designs themselves can vary from simple repeated designs with very few colours to sophisticated patterns that incorporate multiple, intricate shapes and several hues. Borders can also be used alone or combined with another complementing border pattern to form a more complex, overall design (such as the Skroo Socks on pages 82–85).

All of the swatches are made using Jamieson's of Shetland Spindrift yarn and 3.25mm (UK 10; US 3) needles.

Note: *for the projects, written instructions for the charts have been included where possible. However, where written instructions may have proven too cumbersome, only charts are featured for ease in pattern reading.*

OXO

The most famous of the Fair Isle patterns, this could easily be used as an all-over design for a sweater, scarf or snood, as well as a border along the edge of a project. The pattern is over 16 stitches and 14 rows, with the 16-stitch pattern repeated twice across the row.

CHART

- ● Yarn A (Petrol)
- ● Yarn B (Admiral Navy)
- ● Yarn C (Canary Yellow)
- ● Yarn D (Cardinal)

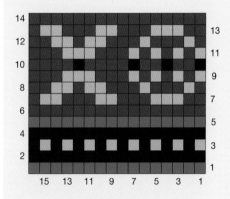

Row 1: using yarn A, knit.

Row 2: using yarn B, purl.

Row 3: * k1C, k1B, rep * to end.

Row 4: using yarn B, purl.

Row 5: using yarn A, knit.

Row 6: using yarn D, purl.

Row 7: k2D, k3C, k3D, k2C, k3D, k2C, k1D.

Row 8: p2D, p2C, p1D, p2C, p3D, p1C, p3D, p1C, p1D.

Row 9: k1C, k1D, k1C, k1D, k1C, k1D, k1C, k3D, k3C, k3D.

Row 10: p4D, p1B, p4D, p1B, p2D, p1B, p2D, p1B.

Row 11: as row 9.

Row 12: as row 8.

Row 13: as row 7.

Row 14: using yarn D, purl.

COLOUR VARIATION

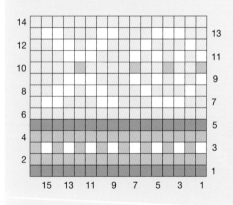

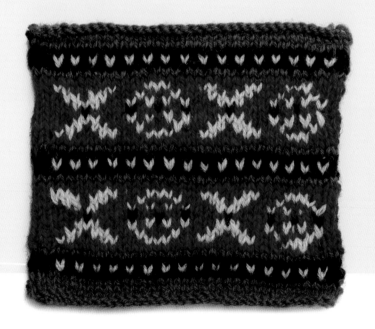

WAVES

This is a really simple border and therefore a good choice if you are new to Fair Isle knitting. It looks great when used to separate different sections of a larger, overall pattern. The pattern is worked over 16 stitches.

CHART

● *Yarn A (Birch)*
○ *Yarn B (Mooskit)*

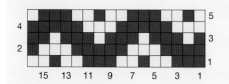

Row 1: k3A, k2B, k1A, k2B, k3A, k2B, k1A, k2B.

Row 2: p1A, p3B, p5A, p3B, p4A.

Row 3: k1A, k1B, k3A, k1B, k3A, k1B, k3A, k1B, k2A.

Row 4: p5A, p3B, p5A, p3B.

Row 5: k1A, k1B, k2A, k3B, k2A, k1B, k2A, k3B, k1A.

COLOUR VARIATIONS

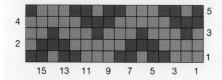

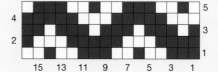

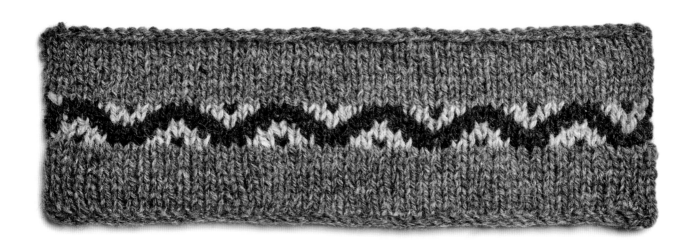

HEARTS

Hearts are always popular motifs and this border is a great choice for both adult and children's knitwear. When the pattern is repeated across a row, leave a 2-stitch space in between each heart. The pattern is repeated over 9 stitches.

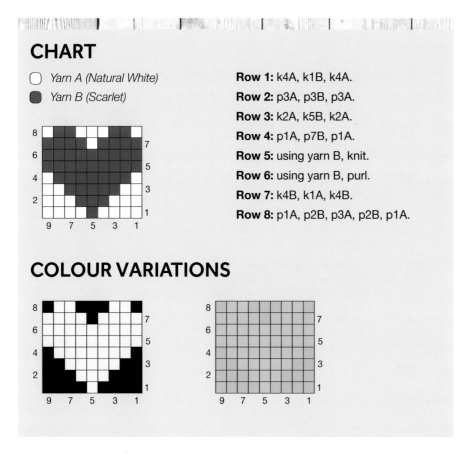

CHART

○ Yarn A (Natural White)
● Yarn B (Scarlet)

Row 1: k4A, k1B, k4A.

Row 2: p3A, p3B, p3A.

Row 3: k2A, k5B, k2A.

Row 4: p1A, p7B, p1A.

Row 5: using yarn B, knit.

Row 6: using yarn B, purl.

Row 7: k4B, k1A, k4B.

Row 8: p1A, p2B, p3A, p2B, p1A.

COLOUR VARIATIONS

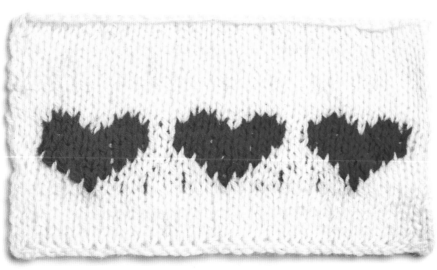

DANCING LADIES

This design is based on a traditional Scandinavian folk pattern.
It would be fun to use as a border for a sweater, hat or a child's dress.
This pattern is repeated over 23 stitches.

CHART

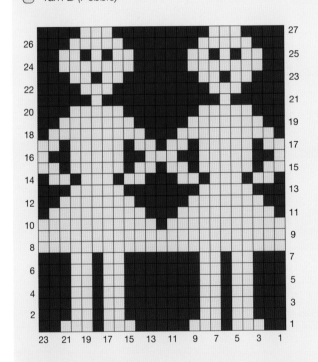

- ● Yarn A (Bramble)
- ○ Yarn B (Pebble)

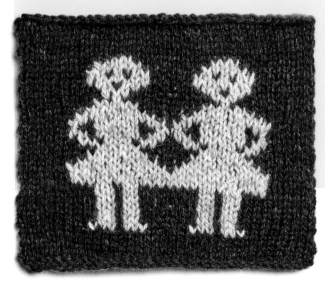

Row 1: k2A, k3B, k1A, k3B, k5A, k3B, k1A, k3B, k2A.

Row 2: p3A, p2B, p1A, p2B p7A, p2A, p1A, p2A, p3A.

Row 3: k3A, k2B, k1A, k2B, k7A, k2B, k1A, k2B, k3A, rep from * to end.

Rows 4 and 6: as row 2.

Row 5 and 7: as row 3.

Row 8: using yarn B, purl.

Row 9: using yarn B, knit.

Row 10: p11B, p1A, p11B.

Row 11: k1A, k9B, k3A, k9B, k1A.

Row 12: p2A, p7B, p5A, p7B, p2A.

Row 13: k3A, k5B, k7A, k5B, k3A.

Row 14: p1A, p2B, p1A, p3B, p1A, p2B, p3A, p2B, p1A, p3B, p1A, p2B, p1A.

Row 15: k2B, k1A, k5B, k1A, k2B, k1A, k2B, k1A, k5B, k1A, k2B.

Row 16: p1B, p2A, p5B, p2A, p3B, p2A, p5B, p2A, p1B.

Row 17: as row 15.

Row 18: p1A, p9B, p3A, p9B, p1A.

Row 19: k2A, k7B, K5A, K7B, K2A.

Row 20: p3A, p5B, p7A, p5B, p3A.

Row 21: k5A, k1B, k11A, k1B, k5A.

Row 22: p 4A, p3B, p9A, p3B, p4A.

Row 23: k3A, k2B, k1A, k2B, k7A, k2B, k1A, k2B, k3A.

Row 24: p2A, p7B, p5A, p7B, p2A.

Row 25: k2A, k2B, k1A, k1B, k1A, k2B, k5A, k2B, k1A, k1B, k1A, k2B, k2A.

Row 26: p3A, p5B, p7A, p5B, p3A.

Row 27: k4A, k3B, k9A, k3B, k4B.

LACE

This is a very pretty border and I can see it being used as a delicate accent to a knitting project. The pattern is knitted over 14 stitches.

CHART

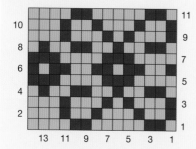

- Yarn A (Granny Smith)
- Yarn B (Cherry)

Row 1: k1A, k2B, k5A, k2B, k4A.

Row 2: p3A, p1B, p2A, p1B, p3A, p1B, p2A, p1B.

Row 3: k1B, k3A, k1B, k1A, k1B, k3A, k1B, k3A.

Row 4: p1A, p1B, p2A, p2B, p2A, p1B, p2A, p2B, p1A.

Row 5: k4A, k3B, k4A, k3B.

Row 6: p1B, p1A, p2B, p2A, p2B, p1A, p2B, p2A, p1B.

Row 7: as row 5.

Row 8: as row 4.

Row 9: as row 3.

Row 10: as row 2.

Row 11: as row 1.

COLOUR VARIATIONS

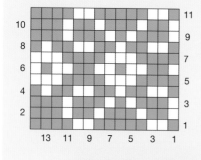

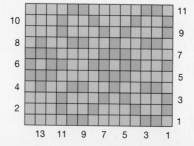

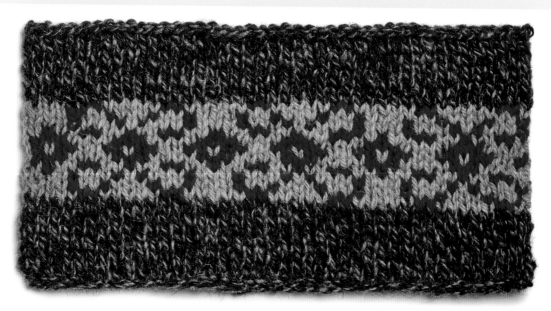

BRICKS

This is one of the smaller border designs that would add a touch of
fun to a simple garment. The pattern is knitted over 8 stitches.

CHART

● Yarn A (Coffee)
○ Yarn B (Lichen)

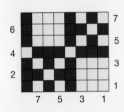

Row 1: k3A, k1B, k1A, k1B, k1A, k1B.

Row 2: p2B, p1A, p2B, p3A.

Row 3: as row 1.

Row 4: p1A, p3B, p1A, P3B.

Row 5: k1A, k1B, k1A, k1B, k3A, k1B.

Row 6: p1B, p3A, p2B, p1A, p1B.

Row 7: as row 5.

COLOUR VARIATIONS

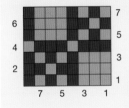 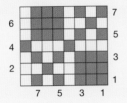

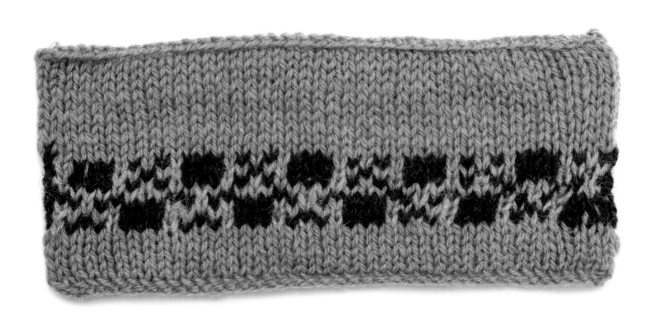

YARROW

This is a small, simple Fair Isle design that looks great in a variety of colours. If you are new to knitting Fair Isle, this would be a good starter pattern to develop your confidence in changing colours. The pattern repeat is over 6 stitches.

CHART

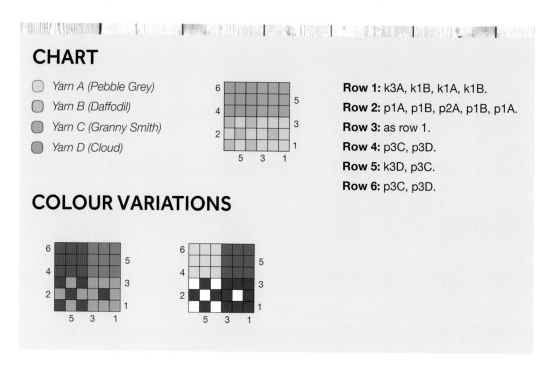

- Yarn A (Pebble Grey)
- Yarn B (Daffodil)
- Yarn C (Granny Smith)
- Yarn D (Cloud)

Row 1: k3A, k1B, k1A, k1B.

Row 2: p1A, p1B, p2A, p1B, p1A.

Row 3: as row 1.

Row 4: p3C, p3D.

Row 5: k3D, p3C.

Row 6: p3C, p3D.

COLOUR VARIATIONS

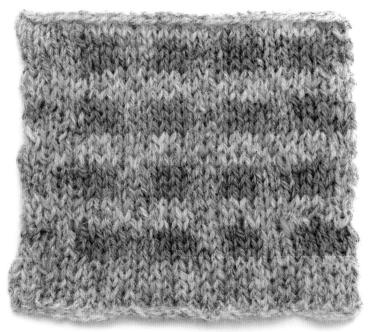

LARGE FLOWER

This is one of the larger borders in my collection of border designs. I have chosen traditional flower colours for the knitted swatch, but the pattern could equally be knitted in other colours for a more abstract effect. The pattern is repeated over 13 stitches.

CHART

- ● *Yarn A (Leaf)*
- ○ *Yarn B (Sand)*
- ● *Yarn C (Plum)*
- ● *Yarn D (Pumpkin)*

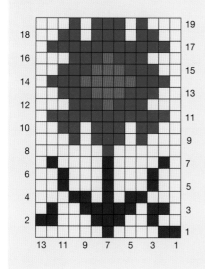

Row 1: k2A, k4B, k1A, k6B.

Row 2: p2A, p3B, p3A, p2B, p1A, p2B.

Row 3: k1B, k2A, k1B, k5A, k2B, k1A, k1B.

Row 4: p3B, p2A, p1B, p1A, p1B, p2A, p3B.

Row 5: k2B, k1A, k3B, k1A, k3B, k1A, k2B.

Row 6: p2B, p1A, p3B, p1A, p3B, p1A, p2B.

Row 7: k1B, k1A, k4B, k1A, k4B, k1A, k1B.

Row 8: p6B, p1C, p6B.

Row 9: k3B, k1C, k1B, k3C, k1B, k1C, k3B.

Row 10: p2B, p2C, p1B, p3C, p1B, p2C, p2B.

Row 11: k1B, k11C, k1B.

Row 12: p3B, p3C, p1D, p3C, p3B.

Row 13: k2B, k3C, k3D, k3C, k2B.

Row 14: p1B, p3C, p5D, p3C, p1B.

Row 15: as row 13.

Row 16: as row 12.

Row 17: as row 11.

Row 18: as row 10.

Row 19: as row 9.

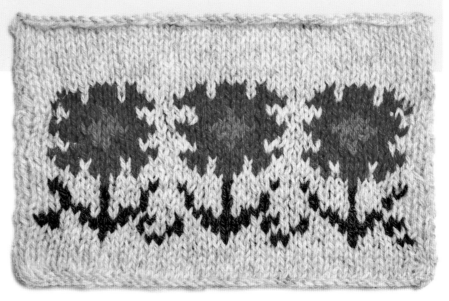

NET

I have used this border alongside others to form an overall design for the Croft Child's dress (see page 92–101); however, it would work well on its own too. The pattern repeat is over 10 stitches.

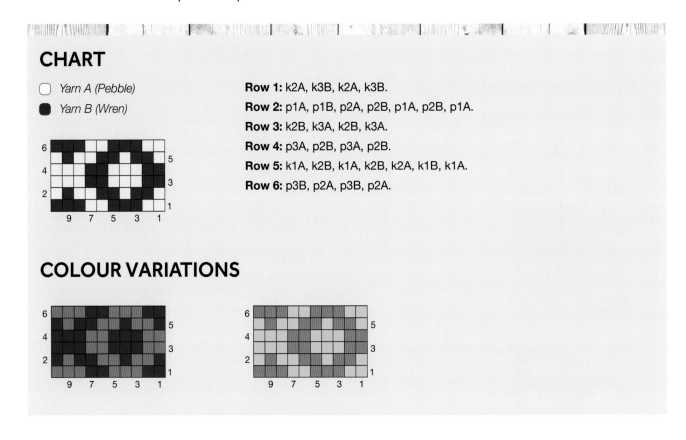

CHART

○ Yarn A (Pebble)
● Yarn B (Wren)

Row 1: k2A, k3B, k2A, k3B.
Row 2: p1A, p1B, p2A, p2B, p1A, p2B, p1A.
Row 3: k2B, k3A, k2B, k3A.
Row 4: p3A, p2B, p3A, p2B.
Row 5: k1A, k2B, k1A, k2B, k2A, k1B, k1A.
Row 6: p3B, p2A, p3B, p2A.

COLOUR VARIATIONS

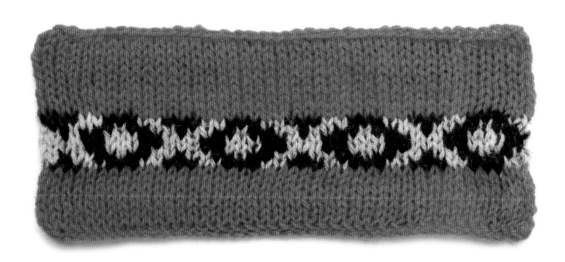

REGAL

As the name suggests, this border has an elegant feel to it that is reminiscent of medieval motifs. The pattern is knitted over 12 stitches.

CHART

● Yarn A (Birch)
○ Yarn B (Buttercup)

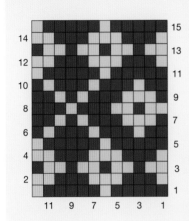

Row 1: k5A, k1B, k5A, k1B.

Row 2: p2B, p3A, p3B, p3A, p1B.

Row 3: k2B, k1A, k2B, k1A, k2B, k1A, k2B, k1A.

Row 4: as row 2.

Row 5: as row 1.

Row 6: p1A, p1B, p3A, p1B, p3A, p1B, p2A.

Row 7: k1A, k3B, k3A, k1B, k1A, k1B, k2A.

Row 8: p3A, p1B, p3A, p2B, p1A, p2B.

Row 9: as row 7.

Row 10: as row 6.

Row 11: as row 1.

Row 12: as row 2.

Row 13: as row 3.

Row 14: as row 2.

Row 15: as row 1.

COLOUR VARIATION

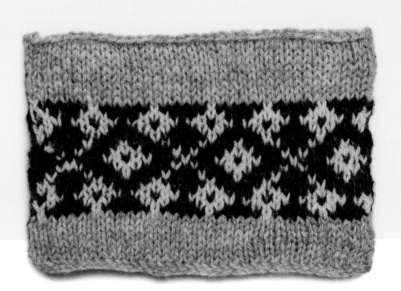

DAINTY FLOWER

This is one of my smaller designs that would make a lovely, delicate border for a dress, cardigan or sweater, or even as a repeated pattern for a pillow cover. The pattern is knitted over 12 stitches.

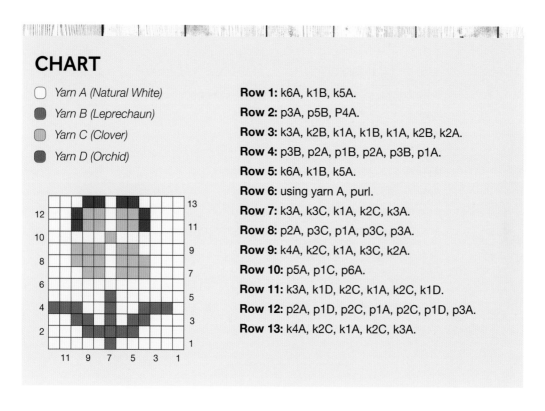

CHART

○ Yarn A (Natural White)
● Yarn B (Leprechaun)
○ Yarn C (Clover)
● Yarn D (Orchid)

Row 1: k6A, k1B, k5A.

Row 2: p3A, p5B, P4A.

Row 3: k3A, k2B, k1A, k1B, k1A, k2B, k2A.

Row 4: p3B, p2A, p1B, p2A, p3B, p1A.

Row 5: k6A, k1B, k5A.

Row 6: using yarn A, purl.

Row 7: k3A, k3C, k1A, k2C, k3A.

Row 8: p2A, p3C, p1A, p3C, p3A.

Row 9: k4A, k2C, k1A, k3C, k2A.

Row 10: p5A, p1C, p6A.

Row 11: k3A, k1D, k2C, k1A, k2C, k1D.

Row 12: p2A, p1D, p2C, p1A, p2C, p1D, p3A.

Row 13: k4A, k2C, k1A, k2C, k3A.

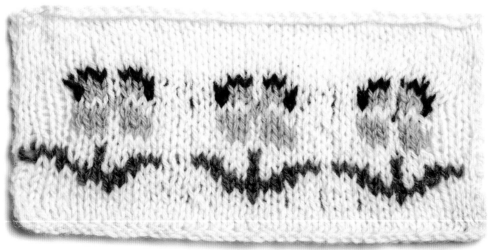

ANCHORS

This border has a nautical theme, and is a nod to the island culture of the Shetlands. I decided to use bold colours to allow the pattern to stand out, but subtler shades could be used instead. The pattern is knitted over 12 stitches.

CHART

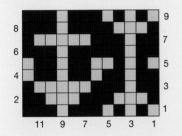

Yarn A (Daffodil)
Yarn B (Prussian Blue)

Row 1: k1A, k1B, k1A, k1B, k1A, k3B, k1A, k3B.

Row 2: p2B, p3A, p3B, p3A, p1B.

Row 3: k2B, k1A, k3B, k5A, k1B.

Row 4: p1A, p2B, p1A, p2B, p1A, p2B, p1A, p2B.

Row 5: k1A, k1B, k1A, k1B, k2A, k2B, k1A, k2B, k1A.

Row 6: p3B, p1A, p5B, p1A, p2B.

Row 7: k2B, k1A, k3B, k5A, k1B.

Row 8: p3B, p1A, p4B, p3A, p1B.

Row 9: as row 1.

COLOUR VARIATION

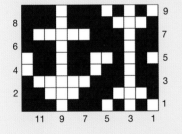

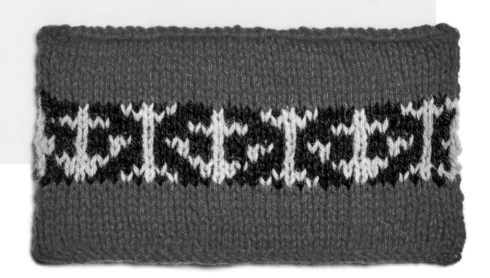

CROSSES & DIAMONDS

This design was integrated into my pattern for the Campion Yoked Sweater (see pages 76–81), which placed this and several other border patterns in a row together to form a long, repeated feature. For this reason, this border would make a great repeated row to separate larger Fair Isle patterns in an overall design. The pattern is repeated over 12 stitches.

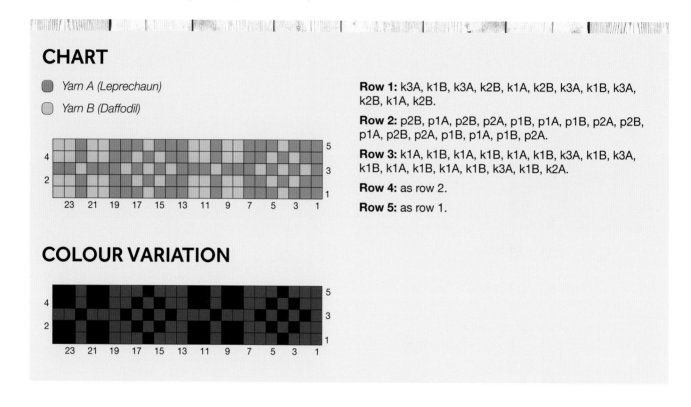

CHART

● Yarn A (Leprechaun)
● Yarn B (Daffodil)

Row 1: k3A, k1B, k3A, k2B, k1A, k2B, k3A, k1B, k3A, k2B, k1A, k2B.

Row 2: p2B, p1A, p2B, p2A, p1B, p1A, p1B, p2A, p2B, p1A, p2B, p2A, p1B, p1A, p1B, p2A.

Row 3: k1A, k1B, k1A, k1B, k1A, k1B, k3A, k1B, k3A, k1B, k1A, k1B, k1A, k1B, k3A, k1B, k2A.

Row 4: as row 2.

Row 5: as row 1.

COLOUR VARIATION

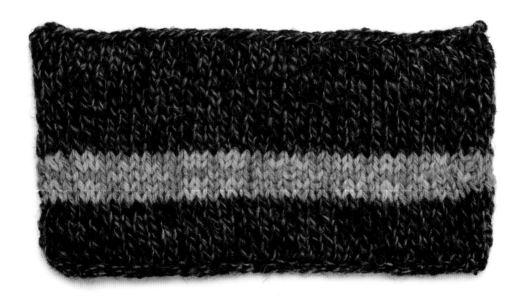

HAZEL

This small, nature-inspired border could easily be used on any item of knitwear. The potential for a wide range of colour variations is great, and would change the overall look of your item completely. The pattern is repeated over 10 stitches.

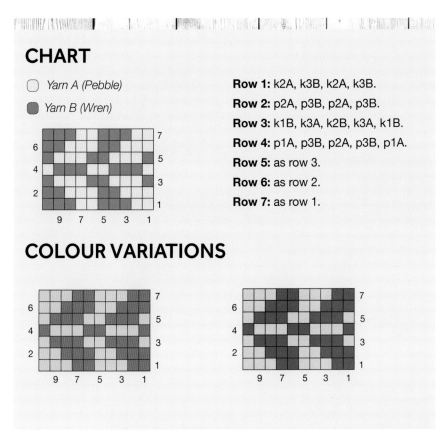

CHART

○ *Yarn A (Pebble)*

● *Yarn B (Wren)*

Row 1: k2A, k3B, k2A, k3B.

Row 2: p2A, p3B, p2A, p3B.

Row 3: k1B, k3A, k2B, k3A, k1B.

Row 4: p1A, p3B, p2A, p3B, p1A.

Row 5: as row 3.

Row 6: as row 2.

Row 7: as row 1.

COLOUR VARIATIONS

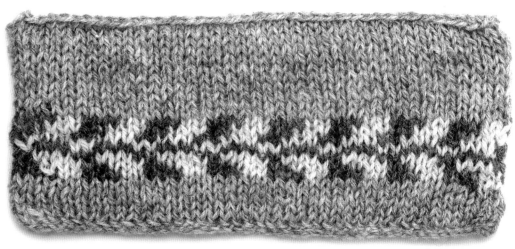

BUBBLES

This is one of the simpler borders, despite the fact that I have used four colours. The border would look striking used on its own as edging on a cuff, or in conjunction with another Fair Isle pattern to form a decorative yoke, for a sweater or cardigan. The pattern is repeated over 8 stitches.

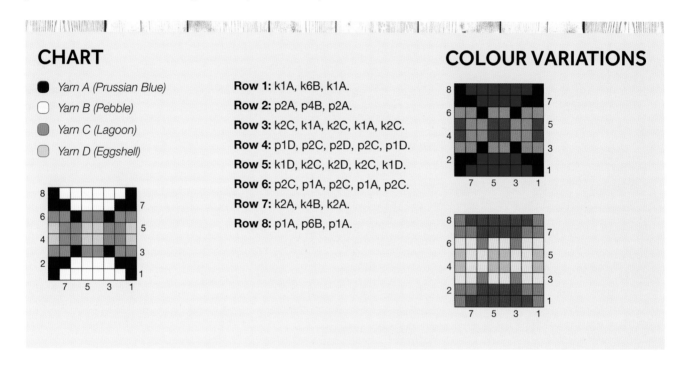

CHART

● Yarn A (Prussian Blue)
○ Yarn B (Pebble)
▨ Yarn C (Lagoon)
▨ Yarn D (Eggshell)

Row 1: k1A, k6B, k1A.
Row 2: p2A, p4B, p2A.
Row 3: k2C, k1A, k2C, k1A, k2C.
Row 4: p1D, p2C, p2D, p2C, p1D.
Row 5: k1D, k2C, k2D, k2C, k1D.
Row 6: p2C, p1A, p2C, p1A, p2C.
Row 7: k2A, k4B, k2A.
Row 8: p1A, p6B, p1A.

COLOUR VARIATIONS

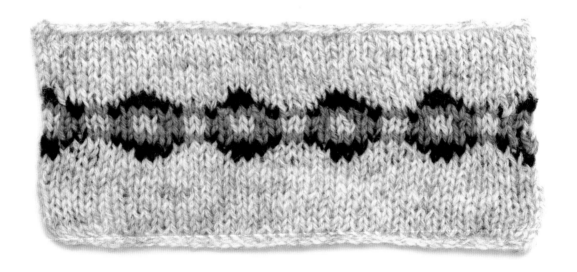

SIMPLE SNOWFLAKE

I chose this design as I thought it would look great as a border for a hat or sweater. The design has a definite wintry feel to it, so I have knitted it in traditional red and white, but the white yarn could be easily substituted for black or other striking shades. The pattern has a repeat of 17 stitches.

CHART

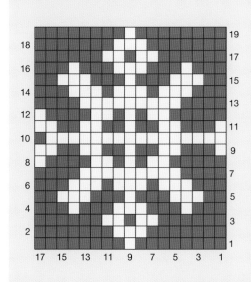

- Yarn A (Scarlet)
- Yarn B (Eesit/White)

Row 1: k8A, k1B, k8A.

Row 2: p7A, p3B, p7A.

Row 3: k6A, k2B, k1A, k2B, k6A.

Row 4: p3A, p1B, p3A, p3B, p3A, p1B, p3A.

Row 5: k2A, k3B, k3A, k1B, k3A, k3B, k2A.

Row 6: p3A, p3B, p1A, p3B, p1A, p3B, p3A.

Row 7: k4A, k9B, k4A.

Row 8: p1B, p4A, p2B, p1A, p1B, p1A, p2B, p5A.

Row 9: k1B, k3A, k2B, k2A, k1B, k2A, k2B, k2A, k2B.

Row 10: p1A, p16B.

Row 11: as row 9.

Row 12: as row 8.

Row 13: as row 7.

Row 14: as row 6.

Row 15: as row 5.

Row 16: as row 4.

Row 17: as row 3.

Row 18: as row 2.

Row 19: as row 1.

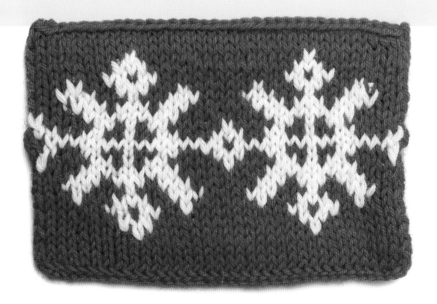

FRIENDSHIP

This border has an endearing faux naïve quality to it. The pattern is knitted over 21 stitches and is repeated twice in the knitted swatch.

CHART

⬤ *Yarn A (Moorit/Black)*

⬤ *Yarn B (Orchid)*

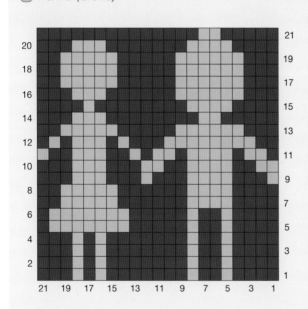

Row 1: k4A, k1B, k2A, k1B, k7A, k1B, k1A, k1B, k3A.

Row 2: p3A, p1B, p1A, p1B, p7A, p1B, p2A, p1B, p4A.

Row 3: as row 1.

Row 4: as row 2.

Row 5: k4A, k1B, k2A, k1B, k5A, k7B, k1A.

Row 6: p1A, p7B, p5A, p1B, p2A, p1B, p4A.

Row 7: k4A, k4B, k6A, k5B, k2A.

Row 8: p2A, p5B, p6A, p4B, p4A.

Row 9: k1B, k3A, k4B, k3A, k1B, k3A, k3B, k3A.

Row 10: p3A, p3B, p3A, p2B, p2A, p4B, p2A, p2B.

Row 11: k1A, k2B, k1A, k4B, k1A, k2B, k1A, k1B, k2A, k3B, k2A, k1A.

Row 12: p1A, p1B, p1A, p3B, p1A, p1B, p3A, p8B, p2A.

Row 13: k3A, k6B, k5A, k5B, k2A.

Row 14: p3A, p3B, p8A, p2B, p5A.

Row 15: k4A, k4B, k8A, k1B, k4A.

Row 16: p3A, p3B, p6A, p6B, p3A.

Row 17: k3A, k6B, k5A, k5B, k2A.

Row 18: p2A, p5B, p5A, p6B, p3A.

Row 19: as row 17.

Row 20: p3A, p3B, p7A, p4B, p4A.

Row 21: k5A, k2B, k14A.

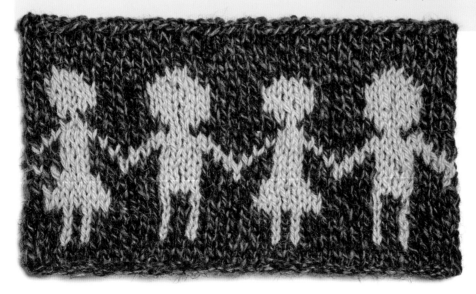

HEATHER

This border would look very pretty as a yoke or border for a cardigan or sweater. I have used different shades of pink but be adventurous and try out different colours using your stash of yarn. The pattern is repeated over 12 stitches.

CHART

○ Yarn A (White)
● Yarn B (Damask)
◌ Yarn C (Dog Rose)
● Yarn D (Cardinal)

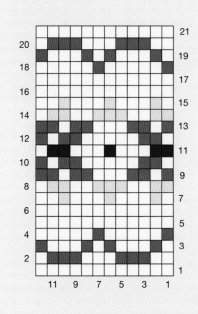

Row 1: using yarn A, knit.

Row 2: p1A, p3B, p3A, p3B, p2A.

Row 3: k1A, k1B, k3A, k1B, k1A, k1B, k3A, k1B.

Row 4: p5A, p1B, p5A, p1B.

Row 5: using yarn A, knit.

Row 6: using yarn A, purl.

Row 7: k1A, k1C, k3A, k1C, k3A, k1C, k2A.

Row 8: p1A, p2C, p2A, p3C, p2A, p2C.

Row 9: k1B, k1A, k2B, k3A, k2B, k1A, k2B.

Row 10: p1B, p1A, p2B, p5A, p2B, p1A.

Row 11: k2D, k3A, k1D, k3A, k2D, k1A.

Row 12: as row 10.

Row 13: as row 9.

Row 14: as row 8.

Row 15: as row 7.

Row 16: as row 6.

Row 17: as row 5.

Row 18: as row 4.

Row 19: as row 3.

Row 20: as row 2.

Row 21: as row 1.

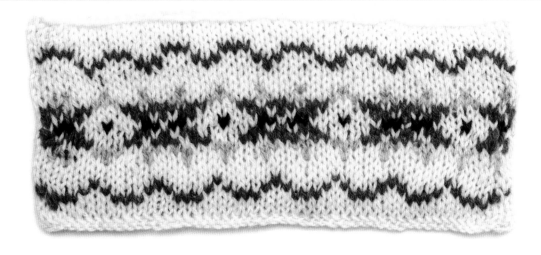

CHERRIES

This border design is broadly based on a branch of cherries. The pattern is more complex than the basic two-colour change, as a number of rows require the knitter to mix three different colours of yarn across a row. However, your efforts will be rewarded! This pattern is knitted over 14 stitches.

CHART

○ *Yarn A (Orchid)*

● *Yarn B (Madder)*

● *Yarn C (Birch)*

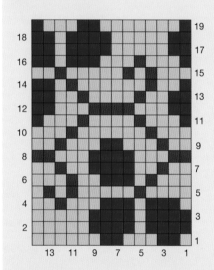

Row 1: k1A, k2B, k3A, k2B, k6A.

Row 2: p5A, p4B, p1A, p4B.

Row 3: k4B, k1A, k4B, k5A.

Row 4: p2A, p1C, p3A, p3B, p1A, p3B, p1A.

Row 5: k4A, k1C, k5A, k1C, k1A, k1C, k1A.

Row 6: p3A, p1C, p2A, p3B, p1A, p1C, p3A.

Row 7: k2A, k1C, k2A, k4B, k2A, k1C, k2A.

Row 8: p2C, p3A, p4B, p3A, p2C.

Row 9: k2A, k1C, k3A, k2B, k3A, k1C, k2A.

Row 10: p3A, p1C, p6A, p1C, p3A.

Row 11: k1B, k3A, k1C, k4A, k1C, k3A, k1B.

Row 12: p2B, p3A, p4C, p3A, p2B.

Row 13: k2B, k2A, k1C, k4A, k1C, k2A, k2B.

Row 14: p2B, p1A, p1C, p6A, p1C, p2A, p1B.

Row 15: k3A, k1C, k1A, k1C, k5A, k1C, k2A.

Row 16: p2B, p1A, p3B, p3A, p1C, p3A, p1B.

Row 17: k2B, k5A, k4B, k1A, k2B.

Row 18: p2B, p1A, p4B, p5A, p2B.

Row 19: k1B, k7A, k2B, k3A, k1B.

COLOUR VARIATION

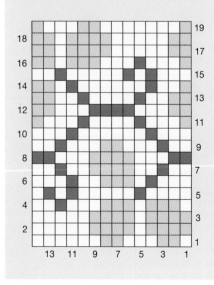

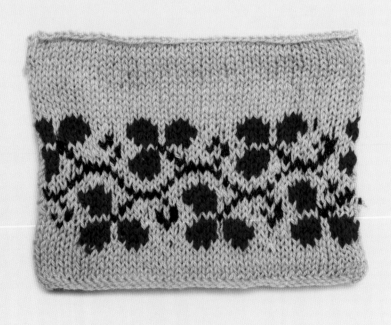

CHEQUERED

This design is made up from two separate patterns, placed together on a chart to create a larger design. I have chosen subtle colours for the knitted swatch but bold colours would work equally well. The pattern repeat is 24 stitches.

CHART

- ● Yarn A (Loganberry)
- ○ Yarn B (Wild Violet)
- ■ Yarn C (Charcoal)
- ○ Yarn D (Orchid)

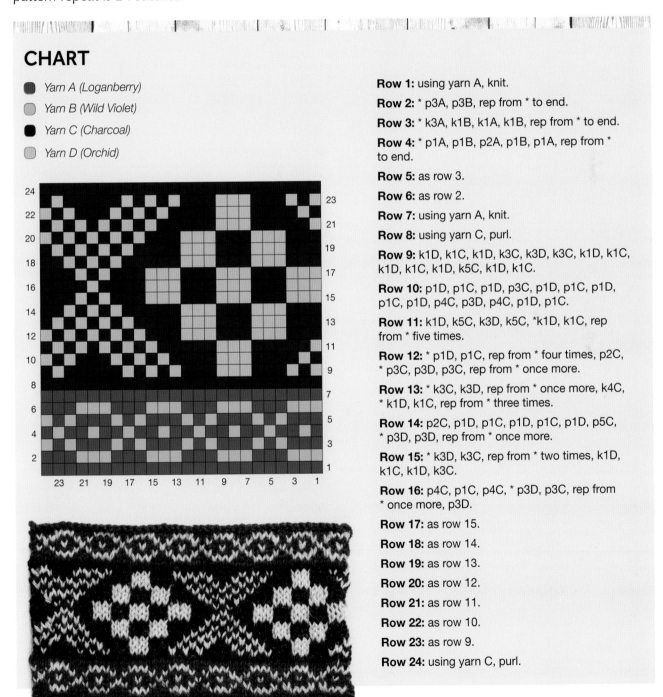

Row 1: using yarn A, knit.

Row 2: * p3A, p3B, rep from * to end.

Row 3: * k3A, k1B, k1A, k1B, rep from * to end.

Row 4: * p1A, p1B, p2A, p1B, p1A, rep from * to end.

Row 5: as row 3.

Row 6: as row 2.

Row 7: using yarn A, knit.

Row 8: using yarn C, purl.

Row 9: k1D, k1C, k1D, k3C, k3D, k3C, k1D, k1C, k1D, k1C, k1D, k5C, k1D, k1C.

Row 10: p1D, p1C, p1D, p3C, p1D, p1C, p1D, p1C, p1D, p4C, p3D, p4C, p1D, p1C.

Row 11: k1D, k5C, k3D, k5C, *k1D, k1C, rep from * five times.

Row 12: * p1D, p1C, rep from * four times, p2C, * p3C, p3D, p3C, rep from * once more.

Row 13: * k3C, k3D, rep from * once more, k4C, * k1D, k1C, rep from * three times.

Row 14: p2C, p1D, p1C, p1D, p1C, p1D, p5C, * p3D, p3D, rep from * once more.

Row 15: * k3D, k3C, rep from * two times, k1D, k1C, k1D, k3C.

Row 16: p4C, p1C, p4C, * p3D, p3C, rep from * once more, p3D.

Row 17: as row 15.

Row 18: as row 14.

Row 19: as row 13.

Row 20: as row 12.

Row 21: as row 11.

Row 22: as row 10.

Row 23: as row 9.

Row 24: using yarn C, purl.

PROJECT:
Simple Snowflake Hat

This hat uses a snowflake border design and is knitted in the round using chunky (bulky) yarn. It would make a quick weekend project. I have made the pompom in a single colour but it could equally be made using strands of all the colours in the hat.

Yarn

- Jamieson's Shetland Marl Chunky, or equivalent chunky (bulky) weight 100% pure wool yarn; 100g/132yd/120m; manufacturer's tension 15 sts x 22 rows on 6mm (UK 4; US 10) needles –
 - ~ 1 ball Ivory 343, or cream yarn (A)
 - ~ 1 ball Mantilla 517, or burgundy yarn (B)
 - ~ 1 ball Husk 383, or gold yarn (C)

Needles

- Two pairs of circular needles –
 - ~ 6mm (UK 4; US 10), 40cm (16in) long
 - ~ 6.5mm (UK 3; US 10½), 40cm (16in) long
- Five 6.5mm (UK 3; US 10½) DPNs
- Tapestry needle

Extras

- Pompom maker, or two pieces of card to make a pompom 9cm (3½in) in diameter
- Stitch marker

Pattern tension

16 sts x 18 rows on 6.5mm (UK 3; US 10½) needles

Completed size

To fit a head circumference of 50–57.5cm (19¾–22⅝in)

CHART

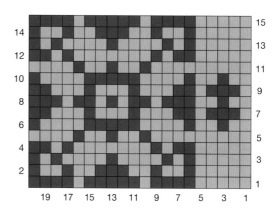

- ⬤ Yarn B (Mantilla 517, or burgundy)
- ◯ Yarn C (Husk 383, or gold)

Row 1: k5C, k4B, k1C, k5B, k1C, k4B.

Row 2: k5C, k1B, k2C, k1B, k2C, k3B, k2C, k1B, k2C, k1B.

Row 3: k5C, k1B, k1C, k1B, k4C, k1B, k4C, k1B, k1C, k1B.

Row 4: k5C, k2B, k1C, K1B, k7C, k1B, k1C, k2B.

Row 5: k9C, k1B, k2C, k1B, k2C, k1B, k4C.

Row 6: k2C, k1B, k2C, k1B, k4C, k5B, k4C, k1B.

Row 7: k1C, k3C, k1C, k2B, k3C, k1B, k3C, k1B, k3C, k2B.

Row 8: k2C, k1B, k2C, k3B, k1C, k2B, k1C, k1B, k1C, k2B, k1C, k3B.

Row 9: as row 7.

Row 10: as row 6.

Row 11: as row 5.

Row 12: as row 4.

Row 13: as row 3.

Row 14: as row 2.

Row 15: as row 1.

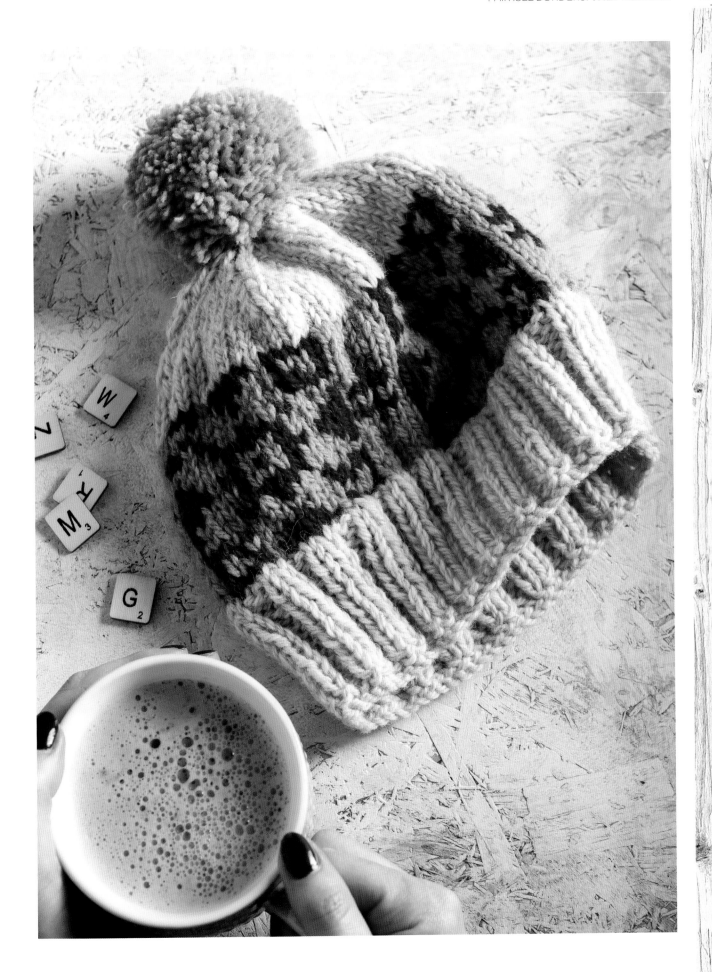

PATTERN

Using yarn A and 6mm (UK 4; US 10) needles, cast on 80 sts. Join in the round, being careful not to twist stitches. PM to denote beg of round.

Foundation round: knit each stitch tbl to end.

Rounds 1–12: * k2, p2, rep from * to end.

Change to 6.5mm (UK 3; US 10½) needles and yarn B.

Next round: following Chart or written equivalent and changing colour as indicated, work row 1 of Chart working 20-st repeat four times across the round.

Cont to work from Chart until row 15 is complete. Fasten off yarns B and C.

Change to yarn A and knit every round until hat measures 17cm (6¾in) from cast-on edge.

Decrease for crown (**Note:** change to DPNs when work becomes too tight on your circular needles):

Round 1: (k2tog, k8) eight times (72 sts).

Round 2: (k2tog, k10) six times (66 sts).

Round 3: (k2tog, k7, k2tog) six times (54 sts).

Round 4: knit to end.

Round 5: (k2tog, k5, k2tog) six times (42 sts).

Round 6: knit to end.

Round 7: (k2tog, k3, k2tog) six times (30 sts).

Round 8: knit to end.

Round 9: (k2tog, k1, k2tog) six times (18 sts).

Round 10: (k2tog) nine times (9 sts).

To make up

Cut yarn and thread through remaining sts. Pull up yarn tightly and fasten off. Weave in ends (see page 38).

Optional: make a large pompom (see page 44–45) and sew to top of the hat (see page 47).

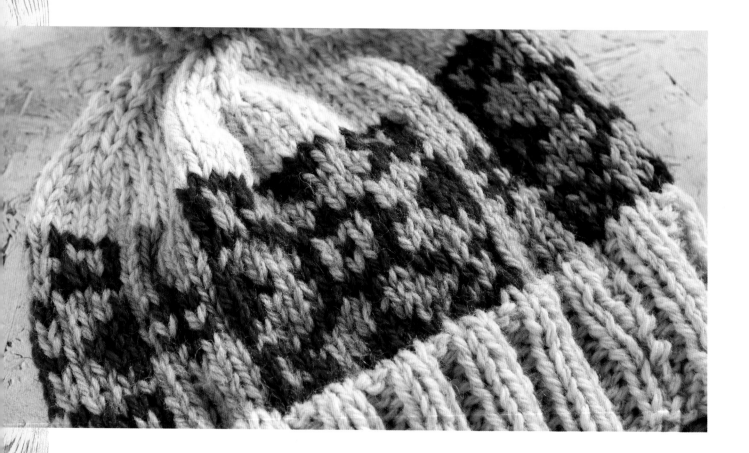

PROJECT:
Crowned Snowflake Hat

This hat is a more complex variation on the previous one, using three colours to create the main Fair Isle border and featuring an additional pattern around the top of the crown. The multicoloured pompom is a fun change too!

Yarn

- Jamieson's Shetland Marl Chunky, or equivalent chunky (bulky) weight 100% pure wool yarn; 100g/132yd/120m; manufacturer's tension 5 sts x 22 rows on 6mm (UK 4; US 10) needles –
 - ~ 1 ball Reef 2115, or flecked blue yarn (A)
 - ~ 1 ball Gingersnap 331, or dark orange yarn (B)
 - ~ 1 ball Natural White 104, or white yarn (C)

Needles

- Two pairs of circular needles –
 - ~ 6mm (UK 4; US 10), 40cm (16in) long
 - ~ 6.5mm (UK 3; US 10½), 40cm (16in) long
- Five 6.5mm (UK 3; US 10½) DPNs
- Tapestry needle

Extras

- Pompom maker or two pieces of card to make a pompom 9cm (3½in) in diameter
- Stitch marker

Pattern tension

16 sts x 18 rows on 6.5mm (UK 3; US 10½) needles

Completed size

To fit a head circumference of 50–57.5cm (19¾–22⅝in).

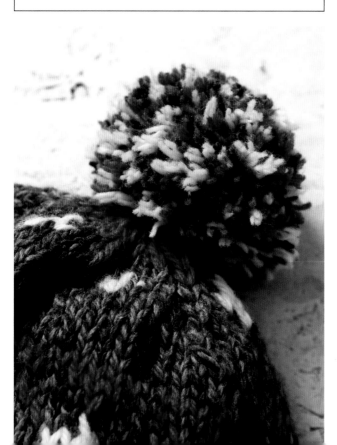

CHART A

- ● Yarn A (Reef 2115, or flecked blue)
- ● Yarn B (Gingersnap 331, or dark orange)
- ○ Yarn C (Natural White 104, or white)

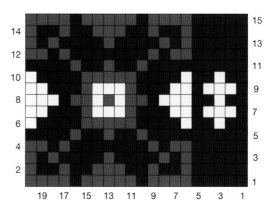

Row 1: k5A, k4B, k1A, k5B, k1A, k4B.

Row 2: k5A, k1B, k2A, k1B, k2A, k3B, k2A, k1B, k2A, k1B.

Row 3: k5A, k1B, k1A, k1B, k4A, k1B, k4A, k1B, k1A, k1B.

Row 4: k5A, k2B, k1A, k1B, k7A, k1B, k1A, k2B.

Row 5: k9A, k1B, k2A, k1B, k2A, k1B, k4A.

Row 6: k2A, k1C, k2A, k1C, k4A, k5B, k4A, k1C.

Row 7: k1A, k3C, k1A, k2C, k3A, k1B, k3C, k1B, k3A, k2C.

Row 8: k2A, k1C, k2A, k3C, k1A, k2B, k1C, k1B, k1C, k2B, k1A, k3C.

Row 9: as row 7.

Row 10: as row 6.

Row 11: as row 5.

Row 12: as row 4.

Row 13: as row 3.

Row 14: as row 2.

Row 15: as row 1.

CHART B

- ● *Yarn A (Reef 2115, or flecked blue)*
- ● *Yarn B (Gingersnap 331, or dark orange)*
- ○ *Yarn C (Natural White 104, or white)*
- ⊘ *K2tog in shade indicated*

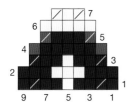

Row 1: * k2togA, k3A, k1C, k3A, k2togA, rep from * to end (54 sts).

Row 2: * k3A, k3C, k3A, rep from * to end.

Row 3: * k2togA, k2A, k1C, k2A, k2togA, rep from * to end (42 sts).

Row 4: * k1B, k5A, k1B, rep from * to end.

Row 5: * k2togB, k3A, k2togB, rep from * to end (30 sts).

Row 6: using yarn C, knit.

Row 7: *k2togC, k1C, k2togC, rep from * to end (18 sts).

PATTERN

Using yarn A and 6mm (UK 4; US 10) needles, cast on 80 sts. Join in the round being careful not to twist stitches. PM to denote beg of round.

Foundation round: knit each stitch tbl to end.

Rounds 1–12: * k2, p2, rep from * to end.

Change to 6.5mm (UK 3; US 10½) needles.

Next round: following Chart A and changing colour as indicated, work row 1 of Chart A working 20-st repeat four times across the round.

Cont to work from Chart A until round 15 is complete. Fasten off yarns B and C.

Cont in yarn A only and knit every round until hat measures 17cm (6¾in) from cast-on edge.

Decrease for crown (**Note:** change to DPNs when work becomes too tight on your circular needles):

Round 1: (k2tog, k8) eight times (72 sts).

Round 2: (k2tog, k10) six times (66 sts).

Next round: following Chart B or written equivalent and changing colour as indicated, work row 1 of Chart B six times across the round (54 sts).

Cont to work from Chart B until row 7 is complete.

Next round: (k2togC) nine times (9 sts).

To make up

Cut yarn and thread through remaining sts. Pull up yarn tightly and fasten off.

Optional: make a large pompom (see page 44–45) and sew to top of the hat (see page 47). I have used one strand of each colour to make the pompom a feature.

PROJECT:
Campion Yoked Sweater

This is a classic sweater knitted using a combination of neutral and vibrant colours. The main body is mostly worked on straight needles, then the yoke is worked in the round.

Yarn

- Erika Knight British Blue 100 DK yarn, or equivalent DK (light worsted) weight 100% pure wool yarn; 100g/240yd/220m; manufacturer's tension 22 sts x 30 rows on 4mm (UK 8; US 6) needles –
 - ~ 4(4:5:5) balls of Mrs Dalloway 604, or mustard yarn (A)
 - ~ 2 balls of Cymbeline 601, or black yarn (B)
 - ~ 2 balls of Ballet Russe 606, or bright pink yarn (D)
- Erika Knight British Blue DK yarn, or equivalent DK (light worsted) weight 100% pure wool yarn; 25g/60yd/55m; manufacturer's tension 22 sts x 30 rows on 4mm (UK 8; US 6) needles –
 - ~ 2 balls of Mr Bhasin 116, or teal blue yarn (C)
 - ~ 1 ball of Milk 100, or cream yarn (E)

Needles

- Two pairs of straight knitting needles –
 - ~ 3.5mm (UK 9/10; US 4)
 - ~ 4mm (UK 8; US 6)
- Two pairs of circular knitting needles (**Note:** you may find it helpful to have both lengths to hand, using the longer circular when joining the yoke and switching to the shorter needle as the yoke is decreased) –
 - ~ 3.5mm (UK 9/10; US 4), 60cm (24in) long
 - ~ 4mm (UK 8; US 6), 60–80cm (24–32in) long
- Tapestry needle

Extras

- Stitch markers
- Stitch holders

Pattern tension

23 sts x 28 rows on 4mm (UK 8; US 6) needles

Pattern notes

The upper Back is shaped with short rows using the wrap and turn method (W&T). See 'Knitting Abbreviations' on page 37 for instructions on how to do this.

Size chart

		SIZE 1	SIZE 2	SIZE 3	SIZE 4
TO FIT BUST	CM	81–86	91–97	102–107	112–117
	IN	32–34	36–38¼	40½–42	44–46
SLEEVE LENGTH	CM	44.5	44.5	44.5	45.5
	IN	17½	17½	17½	17⅞
BACK LENGTH	CM	55	56	58.5	60
	IN	21¾	22	23	23½

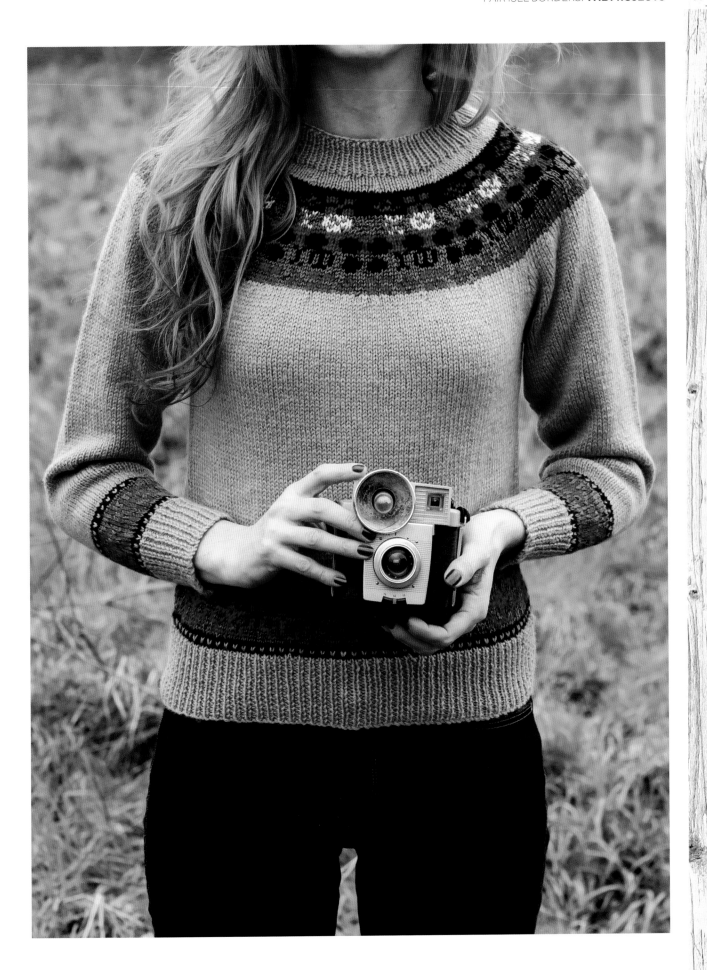

CHARTS

- ● Yarn B (Cymbeline 601, or black)
- ◉ Yarn C (Mr Bhasin 116, or teal blue)
- ◆ Yarn D (Ballet Russe 606, or bright pink)
- ○ Yarn E (Milk, or cream)
- ◹ K2tog
- ◻ No stitch

Chart A

Row 1 (RS): k3C, k3D, k1C, k3D, k2C.

Row 2 (WS): (p2C, p1D) three times, p3C.

Row 3: k1C, k3D, k2C, k1D, k2C, k3D.

Row 4: p1D, p2C, (p1D, p1C) twice, p1D, p2C, p1D, p1C.

Row 5: k1C, k1D, k3C, k3D, k3C, k1D.

Row 6: (p1C, p4D) twice, p2C.

Row 7: as row 5.

Row 8: as row 4.

Row 9: as row 3.

Row 10: as row 2.

Row 11: as row 1.

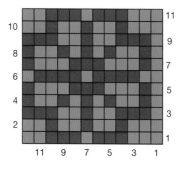

Chart B

Row 1: * k4C, k1D, k3C, k2D, k1C, k2D, k3C, k1D, k3C, k2D, k1C, k2D, rep from * to end.

Row 2: * k1C, k2togC, k1D, k1C, k1D, k2C, k2D, k1C, k2D, k2C, k1D, k1C, k1D, k2C, k2D, k1C, k2D, rep from * to end (1 st dec per repeat).

Row 3: * k1C, (k1D, k1C) twice, (k1D, k3C) twice, (k1D, k1C) twice, k1D, k3C, k1D, k2C, rep from * to end.

Row 4: * k2C, k1D, k1C, k1D, k2C, k2D, k1C, k2D, k2C, k1D, k1C, k1D, k2C, k2D, k1C, k2D, rep from * to end.

Row 5: * k3C, k1D, k2togC, (k1C, k2D) twice, k3C, k1D, k2togC, (k1C, k2D) twice, rep from * to end (2 sts dec per repeat).

Row 6: using yarn C, knit.

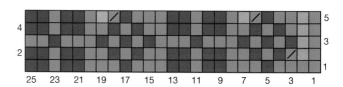

Chart C

Row 1: * k2C, k2B, k4C, k3B, k2C, k1B, k1C, k1B, k3C, k2B, k1C, rep from * to end.

Row 2: * k1C, k4B, k2C, (k1B, k1C) twice, k1B, k2C, k1B, k3C, k4B, rep from * to end.

Row 3: * k1C, k4B, k2C, (k1B, k1C) twice, k1B, k2C, k1B, k3C, k4B, rep from * to end.

Row 4: * k2C, k2B, k2Ctog, (k1C, k1B) three times, k2C, k1B, k2C, k2togC, k2B, k1C, rep from * to end (2 sts dec per repeat).

Row 5: * k7C, k3B, k2C, k1B, k1C, k1B, k5C, rep from * to end.

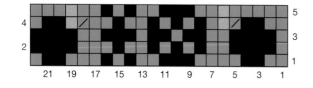

Chart D

Row 1: * k2D, (k3B, k4D) twice, k3B, k1D, rep from * to end.

Row 2: * k1D, (k5B, k2D) twice, k5B, rep from * to end.

Row 3: as round 2.

Row 4: * k2D, (k3B, k4D) twice, k3B, k1D, rep from * to end.

Row 5: * k2D, k2togD, k14D, k2togD, rep from * to end (2 sts dec per repeat).

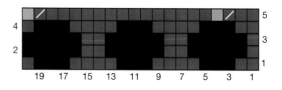

Chart E

Row 1: * k5C, k3E, k3C, k1E, k1C, k1E, k4C, rep from * to end.

Row 2: * k4C, (k1E, k1C) three times, k2C, k1E, k5C, rep from * to end.

Row 3: * k1C, k2togC, k1C, k2E, k1C, k2E, k2C, k3E, k1C, k2togC, k1C, rep from * to end (2 sts dec per repeat).

Row 4: * k3C, (k1E, k1C) three times, k2C, k1E, k4C, rep from * to end.

Row 5: * k2C, k2togC, k3E, k1C, k2togC, k1E, k1C, k1E, k3C, rep from * to end (2 sts dec per repeat).

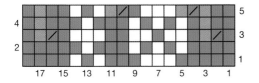

Chart F

Row 1: * k2B, k2D, k1B, k2D, k3B, k1D, k3B, rep from * to end.

Row 2: * k2B, k2D, k1B, k2D, k2B, k1D, k1B, k1D, k2B, rep from * to end.

Row 3: * k4B, k1D, k3B, (k1D, k1B) three times, rep from * to end.

Row 4: as round 2.

Row 5: as round 1.

Row 6: * (k2togB, k5B) twice, rep from * to end (2 sts dec per repeat).

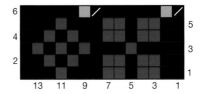

PATTERN

Back

Using 3.5mm (UK 9/10; US 4) needles and yarn A, cast on 86(98:110:122) sts.

Row 1 (RS): * k1, p1, rep from * to end.

Cont rep row 1 until work measures 7.5cm (3in), ending with a RS row.

Next row (WS): rep row 1 and at the same time inc 3 sts evenly across the row (89(101:113:125) sts).

Change to 4mm (UK 8; US 6) needles.

Next row (RS): using yarn B, knit.

Next row (WS): p2B * p1A, p1B, rep from * to last 3 sts, p3B.

Next row: using yarn B, knit.

Next row: using yarn C, purl.

Next row (RS): k2, work row 1 of Chart A 7(8:9:10) times, k3.

Next row (WS): p3, work next row of Chart A 7(8:9:10) times, p2.

Cont working from Chart A as established until row 11 of the chart has been completed.

Next row (WS): using yarn C, purl. Fasten off yarn C.

Next row (RS): using with yarn B, knit.

Next row: p2B, * p1A, p1B, rep from * to last 3 sts, p3B.

Next row: using yarn B, knit. Fasten off yarn B.

Using yarn A only, cont straight in St st until piece measures 33(33:33:34)cm / 13(13:13:13½)in from cast-on edge, ending with a WS row.

SHAPE ARMHOLES

Cast off 3 sts at beg of next 2 rows (83(95:107:119) sts).

Cont in St st and shape armholes as follows:

Next row (RS): k2tog, knit to last 2 sts, SSK (2 sts dec).

Work 3 rows in St st.

Repeat last 4 rows 1(3:3:3) more times (79(87:99:11) sts).

SIZES 1, 3 AND 4 ONLY

Next row (RS): k2tog, knit to last 2 sts, SSK (2 sts dec).

Next row: purl.

Repeat last 2 rows 1(–:1:2) more times (75(–:95:105) sts).

ALL SIZES AGAIN

Place rem 75(87:95:105) sts on stitch holder and set aside.

Front

Work as for Back.

Sleeves
MAKE TWO

Using 3.5mm (UK 9/10; US 4) needles and yarn A, cast on 48(52:56:56) sts.

Row 1 (RS): * k1, p1, rep from * to end.

Rep row 1 until rib measures 7.5cm (3in), ending with a RS row.

Next row (WS): rep row 1 and inc 2 sts evenly across the row (50(54:58:58) sts).

Change to 4mm (UK 8; US 6) needles.

Next row (RS): using yarn B, knit and at the same time inc 1 st at each end of the row (52(56:60:60) sts).

Next row: p2B, * p1A, p1B, rep from * to last 2 sts, p2B.

Next row: using yarn B, knit.

Next row (WS): using yarn C, purl.

Read the following section carefully as you'll be working two sets of instructions at the same time:

Next row (RS): using yarn C, k2(4:0:0), work row 1 of Chart A 4(4:5:5) times.

Next row (WS): using yarn C, p2(4:0:0), work next row of Chart A 4(4:5:5) times.

Cont working from Chart A as established until row 11 of the chart has been completed.

Next row (WS): using yarn C, purl. Fasten off yarn C.

Next row: using yarn B, knit.

Next row: p2B, * p1A, p1B, rep from * to last 2 sts, p2B.

Next row: using yarn B, knit. Fasten off yarn B.

Using yarn A only, cont working in St st until sleeve measures 44.5(44.5:44.5:46)cm / 17½(17½:17½:18)in from cast-on edge, ending with a WS row.

AT THE SAME TIME inc 1 st at each end of seventh row of Chart A then every foll sixth row until you have 76(82:88:92) sts, working increased sts with yarn C to end of Chart A, then in correct colour for row. When increases are complete, work straight to given length.

SHAPE ARMHOLES

Cast off 3 sts at beg of next 2 rows (70(76:82:86) sts).

Row 1 (RS): k2tog, knit to last 2 sts, SSK (2 sts dec).

Work 1(3:3:3) row(s) in St st.

Repeat these 2(4:4:4) rows 4(0:2:4) more times (60(74:76:76)sts).

SIZE 1 ONLY

Next row (RS): k2tog, knit to last 2 sts, SSK (58 sts).

Next row: p2tog, purl to last 2 sts, p2tog (56 sts).

SIZES 2, 3 AND 4 ONLY

Next row (RS): k2tog, knit to last 2 sts, SSK (2 sts dec).

Next row: purl.

Rep these 2 rows –(5:3:0) more times (–(62:68:74) sts).

ALL SIZES AGAIN

Place rem 56(62:68:74) sts on stitch holders.

Yoke

Using yarn A and 4mm (UK 8; US 6) circular needles, knit across 75(87:95:105) sts of Back, 56(62:68:74) sts of Left Sleeve, 75(87:95:105) sts of Front, 56(62:68:74)sts of Right Sleeve (262(298:326:358) sts).

Join to work in the round and PM to denote start of round.

DECREASE ROUND

Size 1: * (k19, k2tog) six times, k5, rep from * once more (250 sts).

Size 2: k10, * k2tog, k11, rep from * to last 2 sts, k2tog (275 sts).

Size 3: * (k0, k2tog) thirteen times, k7, rep from * once more (300 sts).

Size 4: (k9, k2tog) sixteen times, k4, k2tog, (k9, k2tog) sixteen times (325 sts).

ALL SIZES AGAIN

Remove marker, k11(3:6:23), PM to denote new start of round (this is to ensure that the charts are centred).

(**Note:** for Charts B to F, all rows are knitted, reading the chart from right to left.)

Next round: work row 1 of Chart B, working 25-st repeat 10(11:12:13) times across round.

Cont to work from chart as set until Chart B is complete, then work through Charts C to F (120(132:144:156) sts).

Using yarn B, knit 1 round.

Fasten off yarn B and cont in yarn A only.

Knit 1 round.

Shape the upper Back using short rows as follows:

Row 1 (RS): k34 (42:44:40), W&T.

Row 2 (WS): removing marker as you pass it, p44(48:52:56), W&T.

Row 3: k38(42:46:50), W&T.

Row 4: p32(36:40:44), W&T.

Row 5: k26(30:34:38), W&T.

Row 6: p20(24:28:32), W&T.

PM for new beginning of round.

Knit 1(1:2:2) rounds, picking up wraps and knitting them together with their st as you pass them.

SHAPE NECK

SIZE 1 ONLY

Round 1: * k10, k2tog, rep from * to end (110 sts).

Rounds 2 and 4: knit.

Round 3: * k16, k2tog, rep from * to last 2 sts, k2 (104 sts).

SIZE 2 ONLY

Round 1: * k9, k2tog, rep from * to end (120 sts).

Rounds 2 and 4: knit.

Round 3: * k13, k2tog, rep from * to end (112 sts).

SIZE 3 ONLY

Round 1: * k10, k2tog, rep from * to end (132 sts).

Rounds 2, 4 and 6: knit.

Round 3: * k20, k2tog, rep from * to end (126 sts).

Round 5: * k19, k2tog, rep from * to end (120 sts).

SIZE 4 ONLY

Round 1: * k11, k2tog, rep from * to end (144 sts).

Rounds 2, 4 and 6: knit.

Round 3: * k16, k2tog, rep from * to end (136 sts).

Round 5: * k15, k2tog, rep from * to end (128 sts).

ALL SIZES AGAIN

NECKBAND

Change to 3.5mm (UK 9/10; US 4) needles.

Next round: using yarn A, * k1, p1, rep from * to end.

Work in rib as set for 4cm (1½in).

Cast off.

To make up

Block each piece to your required measurements (see pages 40–41).

Join underarm, sleeve and side seams using mattress stitch (see page 39). Weave in any remaining ends (see page 38).

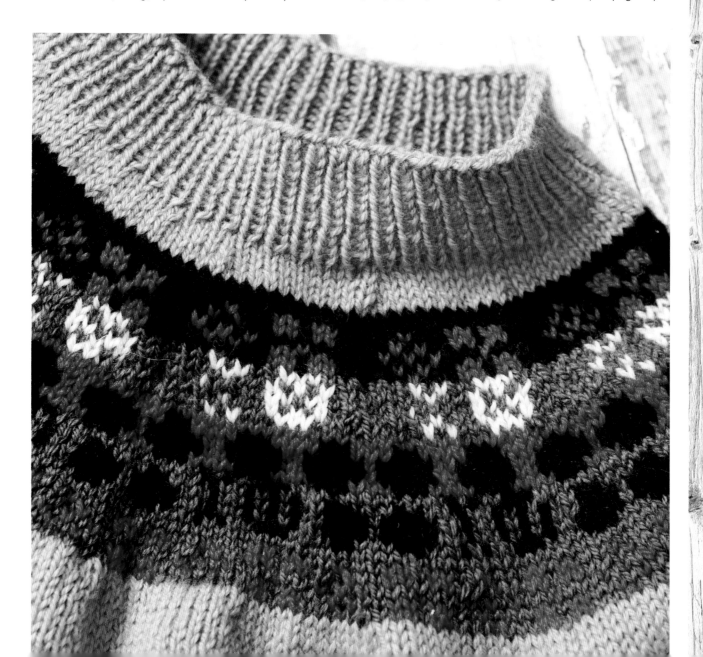

PROJECT:
Skroo Socks

These socks include lots of different Fair Isle borders to make them a fun yet practical addition to your wardrobe. This pattern is for the more skilled knitter who is used to knitting in the round, using five double-pointed needles (DPNs). When I made these socks, one of my DPNs was longer than the others, to mark the start of a round – that way, there was no need for a stitch marker. However, if you are new to working with DPNS, use five regular DPNs and a stitch marker to help you keep track of where you are.

Two sizes are listed, ladies and men (men are within brackets). In addition, the socks could be made longer or shorter in the leg if desired, simply by increasing or decreasing the number of rows after the rib.

Materials

- Socks Yeah! CoopKnits yarn 4-ply, or equivalent superwash 4-ply (fingering) weight sock yarn with merino/nylon blend; 50g/231yd/212m; manufacturer's tension 36 sts x 50 rows on 2.75mm (UK 12; US 2) needles –
 - ~ 1 ball of Peridot 114, or green yarn (A)
 - ~ 1 ball of Azurite 120, or blue yarn (B)
 - ~ 1 ball of Citrine 118, or yellow yarn (C)
 - ~ 1 ball of Quartz 122, or cream yarn (D)
 - ~ 1 ball of Carnelian 130, or rust red yarn (E)

Needles

- Four or five 2.75mm (UK 12; US 2) DPNs, 15cm (6in) long
- Tapestry needle
- Optional: one 2.7mm (UK 12; US 2) DPN, 20cm (8in) long

Extras

- Stitch marker

Pattern tension

32 sts x 38 rows on 2.75mm (UK 12; US 2) needles

Completed size

- Ladies –
 - ~ *Leg length:* 33cm (13in)
 - ~ *Foot cuff circumference:* 20cm (7⅞in)
- Men –
 - ~ *Leg length:* 33cm (13in)
 - ~ *Foot cuff circumference:* 23cm (9in)

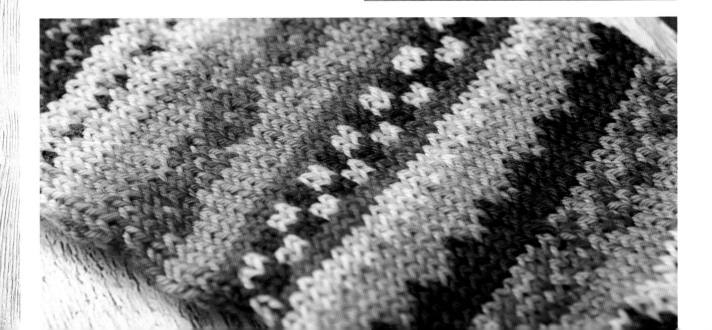

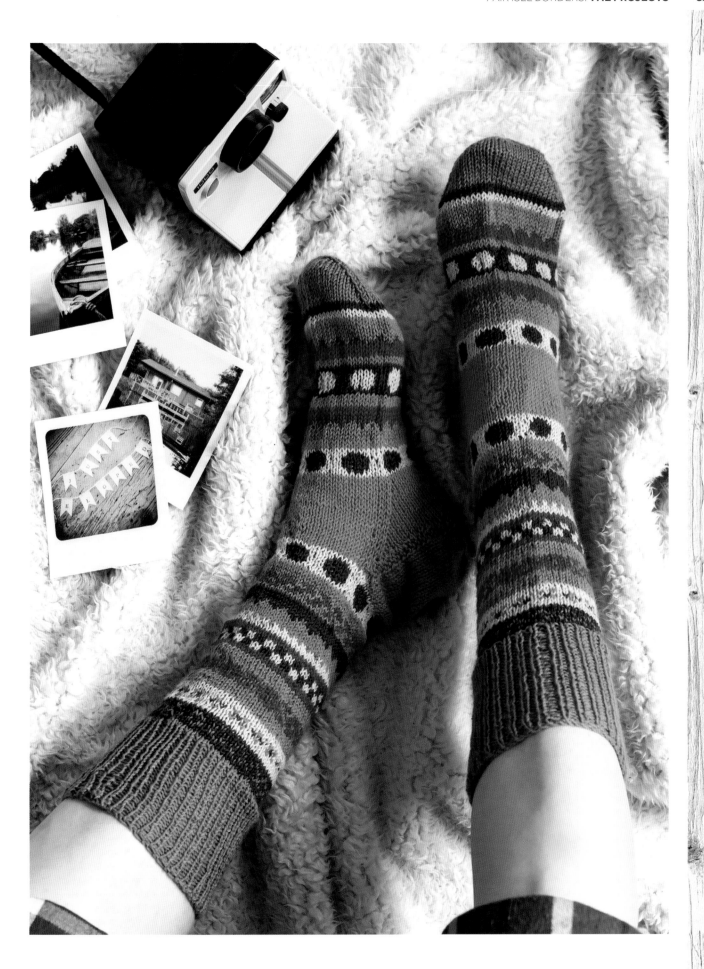

CHART

○ *Yarn A (Peridot 114, or green)* ○ *Yarn D (Quartz 122, or cream)*

● *Yarn B (Azurite 120, or blue)* ● *Yarn E (Carnelian 130, or rust)*

○ *Yarn C (Citrine 118, or yellow)*

Row 1: using yarn B, knit.

Row 2: * k3B, k1C, rep from * to end.

Row 3: * k1C, k1B, rep from * to end.

Row 4: * k1B, k1C, k3B, k1C, k2B, rep from * to end.

Row 5: as row 3.

Row 6: as row 2.

Row 7: as row 1.

Rows 8 and 9: using yarn D, knit.

Row 10: * k2D, k1C, k2D, k1C, k1D, k1C, rep from * to end.

Row 11: * k1D, k1B, k1D, k1B, k2D, k1B, k1D, rep from * to end.

Row 12: as row 10.

Row 13 and 14: using yarn D, knit.

Row 15 and 16: using yarn A, knit.

Rows 17 and 18: using yarn C, knit.

Row 19: * k2E, k1C, k3E, k1C, k1E, rep from * to end.

Row 20: * k1E, k1C, k5E, k1C, rep from * to end.

Row 21: * k1C, k3E, k1C, k3E, rep from * to end.

Row 22: as row 20.

Row 23: as row 19.

Row 24 and 25: using yarn C, knit.

Row 26 and 27: using yarn A, knit.

Row 28 and 29: using yarn E, knit.

Rows 30 and 31: * k2B, k2D, rep from * to end.

Rows 32 and 33: * k2D, k2B, rep from * to end.

Rows 34 and 35: using yarn E, knit.

Rows 36 and 37: using yarn D, knit.

Row 38: * k1C, k1D, rep from * to end.

Rows 39–41: using yarn C, knit.

Row 42: * k3C, k1B, rep from * to end.

Row 43: * k1B, k1C, k3B, k1C, k2B, rep from * to end.

Rows 44–46: using yarn B, knit.

Row 47: using yarn A, knit.

Row 48: * k1A, k2E, k2A, k2E, k1A, rep from * to end.

Row 49: * k2E, k2A, rep from * to end.

Row 50: * k2A, k2E, rep from * to end.

Row 51: * k1E, k2A, k2E, k2A, k1E, rep from * to end.

Row 52: using yarn A, knit.

Row 53 and 54: using yarn C, knit.

Row 55: using yarn D, knit.

Row 56: * k3D, k3B, k2D, rep from * to end.

Rows 57–59: * k2D, k5B, k1D, rep from * to end.

Row 60: as row 56.

Row 61: using yarn D, knit.

Rows 62 and 63: using yarn C, knit.

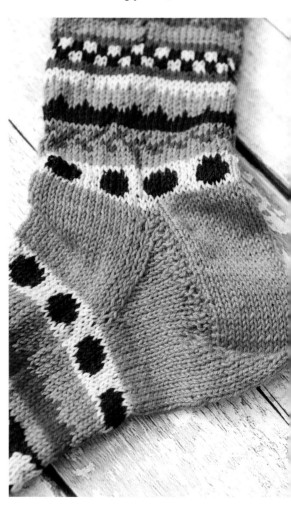

PATTERN
MAKE TWO

Using yarn A cast on 64(72) sts. Divide sts evenly across the three shorter needles and the one longer needle (or four 15cm/6in DPNs) and join to work in the round, being careful not to twist the sts.

(**Note:** if you are using a long needle alongside shorter needles, this will mark the start of the round. Otherwise, PM to mark start of round.)

Rounds 1–34: * k1, p1, rep from * to end.

Leg

Next round: changing colour as indicated, work row 1 of Chart, working 8-st repeat 8(9) times across the round.

Cont to work from chart until round 63 is complete.

Heel Flap

You will now be working on two needles in St st, using yarn C only.

Next row (RS): k16(18) turn.

Next row (WS): sl1, k2, p26(30), k3 (the additional sts come from the fourth (short) needle).

Next row: sl1, knit to end

Next row: sl1, k2, p26(30), k3.

Repeat the last 2 rows sixteen times more.

Turn Heel

Working across the heel flap sts only, cont as follows:

Row 1: sl1, k17(19), SSK, k1, turn.

Row 2: sl1, p5, p2tog, p1, turn.

Row 3: sl1, k6, SSK, k1, turn.

Row 4: sl1, p7, p2tog, p1, turn.

Row 5: sl1, k8, SSK, k1, turn.

Row 6: sl1, p9, p2tog, p1, turn.

Row 7: sl1, k10, SSK, k1, turn.

Row 8: sl1, p11, p2tog, p1, turn.

Row 9: sl1, k12, SSK, k1, turn.

Row 10: sl1, p13, p2tog, p1, turn.

Row 11: sl1, k14, SSK, k1, turn.

Row 12: sl1, p15, p2tog, p1, turn.

SMALLER SIZE ONLY

Row 13: sl1, k16, SSK, turn.

Row 14: sl1, p16 p2tog, p1, turn (18 sts).

LARGER SIZE ONLY

Row 13: sl1, k16, SSK, k1, turn.

Row 14: sl1, p17, p2tog, p1, turn (18 sts).

Row 15: sl1, k18, SSK, turn.

Row 16: sl1, p18, p2tog, turn (20 sts).

BOTH SIZES AGAIN

Next row: k9(10) and stop, do not turn.

Next row: using an empty needle, knit remaining 9(10) sts. With the same needle pick up and k15(17) sts along side edge of heel flap. This is now needle 1, with 24(27) sts.

Using an empty needle each time, knit across 16(18) sts from needle 2 and then 16(18) sts from needle 3.

Using an empty needle pick up and k15(17) sts along the side edge of heel flap, then across the remaining 9(10) sts. This is now needle 4, with 24(27) sts.

You'll have 80(90) sts total, divided across four DPNs. Return to working in the round.

Instep Shaping

Cont to use yarn C only and decrease to shape the instep as follows:

Round 1: knit to last 3 sts on needle 1, k2tog, k1. Knit across sts on needles 2 and 3, on needle 4, k1, SSK, knit to end of round (2 sts dec).

Round 2: knit.

Repeat rounds 1 and 2 using yarn C until 64(72) sts remain, ending with a round 2.

Foot

Rounds 1–9: work rows 55–63 from Chart.

Rounds 10–17: work rows 39–46 from Chart using yarn A instead of C, and yarn E instead of B.

Rounds 18–20: using yarn C, knit.

Rounds 21–29: work row 55–63 from Chart, using B as the background and D for the dot motif.

Rounds 30–37: as rows 39–46 from Chart, using yarn E instead of C, and yarn A instead of B.

Rounds 38–39: using yarn C, knit.

Rounds 40–41: using yarn D, knit.

Rounds 42–43: using yarn B, knit.

Cont in yarn A only and work straight in St st until foot reaches the base of big toe, or measures approx. 5cm (2in) less than desired foot length.

Shape Toe

Round 1: * knit to last 3 sts on needle 1, k2tog, k1; on needle 2, k1, SSK, knit to the end of the needle. Rep from * across needles 3 and 4 (4 sts dec).

Round 2: knit.

Rep these 2 rounds 5(6) more times (40(44) sts).

Rep round 1 a further 7(8) times (12 sts).

To make up

Cut yarn and thread through the remaining sts. Pull up yarn tightly and fasten off. Weave in any loose ends (see page 38).

PROJECT:
Jake's Sweater

Having knitted a hat as a Christmas present for my son, Jacob, I felt inspired and decided that I would knit him a sweater using the same colours and pattern. The colours were based on what I feel reflected Jacob's taste. The main pattern, the Oxo, is one of the most well-known and traditional Fair Isle motifs, and I have mixed this with simple borders.

Materials

- Jamieson's DK, or equivalent DK (light worsted) weight yarn made of 100% pure wool – ideally from Shetland sheep; 25g/82yd/75m; manufacturer's tension 25 sts x 32 rows on 3.75mm (UK 9; US 5) needles –
 - ~ 3(3:4:4) balls of Grouse 235, or variegated brown yarn (A)
 - ~ 3(3:3:4) balls of Twilight 175, or slate blue yarn (B)
 - ~ 2(3:3:3) balls of Nighthawk 1020, or green-blue yarn (C)
 - ~ 4(4:4:4) balls of Granny Smith 1140, or moss green yarn (D)
 - ~ 3(3:4:4) balls of Eggshell 768, or pale mint yarn (E)
 - ~ 4(4:5:5) balls of Pebble 127, or grey-cream yarn (F)

Needles

- Two pairs of straight knitting needles –
 - ~ 3.5mm (UK 9/10; US 4)
 - ~ 4.5mm (UK 7; US 7)
- Tapestry needle

Extras

- Stitch holders

Pattern tension

20 sts x 24 rows on 4.5mm (UK 7; US 7) needles

Size chart

		SIZE 1	SIZE 2	SIZE 3	SIZE 4
TO FIT CHEST	CM	91	96	101	106
	IN	36	38	39¾	41¾
ACTUAL CHEST	CM	93	101.5	110.5	118
	IN	36½	40	43½	46½
SLEEVE LENGTH	CM	47	48	48	49
	IN	18½	19	19	19¼
LENGTH TO SHOULDER	CM	61	63	64	65
	IN	24	25	25¼	25½
LENGTH TO UNDERARM	CM	38	39.5	39.5	40
	IN	15	15½	15½	15¾
UPPER ARM CIRCUM.	CM	44	45	47	49
	IN	17¼	17¾	18½	19¼

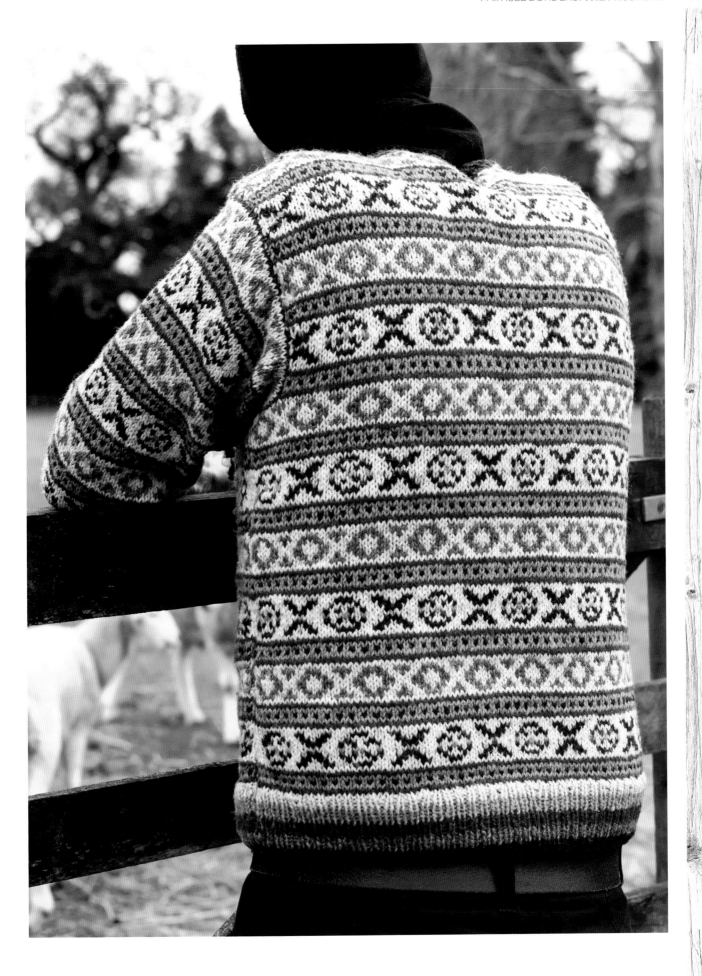

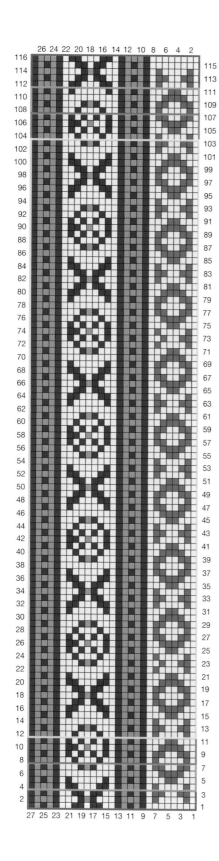

CHARTS

Note: each size in the Charts begins and ends at a different point in the pattern.

- 🔴 *Yarn A (Grouse 235, or variegated brown)*
- 🔵 *Yarn B (Twilight 175, or slate blue)*
- ⚫ *Yarn C (Nighthawk 1020, or green-blue)*
- 🟢 *Yarn D (Granny Smith 1140, or moss green)*
- ⚪ *Yarn E (Eggshell 768, or pale mint)*
- ⚪ *Yarn F (Pebble 127, or grey-cream)*
- ⚪ *Size 1 ONLY*
- ⚪ *Size 2 ONLY*
- ⚪ *Size 3 ONLY*
- ⚪ *Size 4 ONLY*

Chart A: Chest pattern

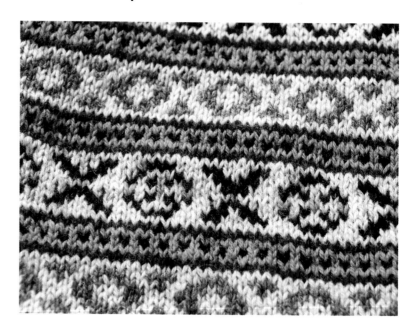

Chart B: Sleeve

Note: sleeve increases are not explicitly shown in the chart. Work increases in appropriate colour throughout, according to the pattern instructions, working M1 one stitch in from each edge. For example, if the second stitch of an increase row would be 'k1A', it should be worked as 'M1' with yarn A instead.

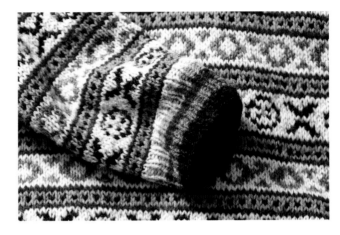

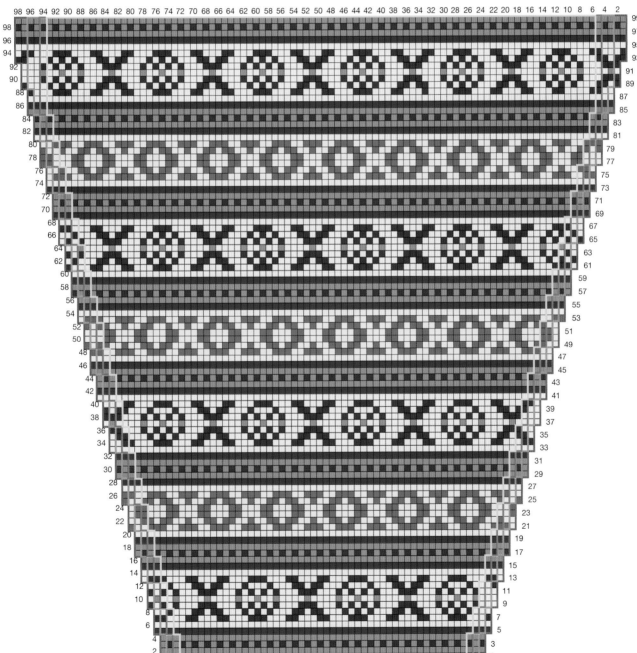

PATTERN

Back

Using 3.5mm (UK 9/10; US 4) needles and yarn A, cast on 78(86:94:102) sts.

Foundation row (WS): purl each st tbl to end.

Rows 1 and 2: using yarn A, * k1, p1, rep from * to end.

Rows 3–6: using yarn B, * k1, p1, rep from * to end.

Rows 7–10: using yarn C, * k1, p1, rep from * to end.

Rows 11–14: using yarn D, * k1, p1, rep from * to end.

Rows 15–17: using yarn E, * k1, p1, rep from * to end.

Row 18 (WS): using yarn E, work in 1x1 rib across 6(4:1:5) sts, M1, * work in 1x1 rib across 5(6:7:7) sts, M1, rep from * to last 7(4:2:6) sts, work in 1x1 rib to end (92(100:108:116) sts).

Change to 4.5mm (UK 7; US 7) needles.

Beginning and ending at the correct point for your size, work row 1 of Chart A.

Cont working from Chart A as set until row 27 is complete, then repeat rows 1–27 (noting that on the next and then every alternate rep of chart RS rows will become WS rows, and vice versa) until Back measures 38(39.5:39.5:40)cm / 15(15½:15½:16)in from cast-on edge, ending with a WS row.

SHAPE ARMHOLES

Cont in colourwork pattern as set throughout, casting off 10 sts at beg of next 2 rows (72(80:88:96) sts).

Work straight until Back measures 61(63:64:65)cm / 24(24½:25¼:25½)in, ending with a WS row.

SHAPE SHOULDERS

Next row (RS): cast off 7(8:9:10) sts, patt until there are 21(24:27:30) sts on right needle, cast off 16 sts, patt to end (49(56:63:70) sts).

Next row (WS): cast off 7(8:9:10) sts, patt to neck edge and turn, leaving rem sts on stitch holder and cont on these sts only for left side of neck (21(24:27:30) sts).

Next row (RS): cast off 5 sts, patt to end (16(19:22:25) sts).

Next row (WS): cast off 7(8:9:10) sts, patt to end. (9(11:13:15) sts).

Next row (RS): cast off 4 sts, patt to end (5(7:9:11) sts).

Cast off rem sts.

With WS facing rejoin yarn to held right side neck sts and complete to match left side, reversing shaping.

Front

Work as for Back until 22 rows fewer have been worked than the Back to beginning of shoulder shaping, ending with a WS row.

NECK SHAPING

Next row (RS): patt across 31(35:39:43) sts, cast off 10 sts, patt to end (62(70:78:86) sts).

Next row (WS): patt to neck edge and turn, leaving rem sts on a holder and cont on these sts only for right side of neck (31(35:39:43) sts).

Next row (RS): cast off 3 sts, patt to end (28(32:36:40) sts).

Next row (WS): patt to end.

Next row (RS): cast off 2 sts, patt to end (26(30:34:38) sts).

Repeat last 2 rows once more (24(28:32:36) sts).

Dec 1 st at neck edge of 5 foll alt rows (19(23:27:31) sts).

Work straight in patt until Front matches Back to beginning of shoulder shaping, ending with a RS row.

SHAPE SHOULDERS

Next row (WS): cast off 7(8:9:10) sts, patt to end (12(15:18:21) sts).

Next row: patt to end.

Repeat last 2 rows once more (5(7:9:11) sts).

Cast off rem sts.

With WS facing rejoin yarn to held left side neck sts and complete to match right side, reversing shaping.

Sleeves

Using 3.5mm (UK 9/10; US 4) needles and yarn A, cast on 38(40:42:44) sts.

Foundation row (WS): purl each st tbl to end.

Rows 1 and 2: using yarn A, * k1, p1, rep from * to end.

Rows 3–6: using yarn B, * k1, p1, rep from * to end.

Rows 7–10: using yarn C, * k1, p1, rep from * to end.

Rows 11–14: using yarn D, * k1, p1, rep from * to end.

Rows 15–17: using yarn E, * k1, p1, rep from * to end.

Row 18: using yarn E, work in 1x1 rib across 2(3:4:6) sts, * M1, work in 1x1 rib across 4 sts, rep from * to last 4(5:6:6) sts, work in 1x1 rib to end (46(48:50:52) sts).

Change to 4.5mm (UK 7; US 7) needles.

Beginning and ending at correct point for your size, work row 1 of Chart B.

Cont to work from Chart B, increasing 1 st at each end of every foll fourth row until there are 88(90:94:98) sts on needles, working the increase in colour indicated on chart (88(90:94:98) sts).

Work straight in patt as established until work measures 47(48:48:49)cm / 18½(19:19:19¼)in from cast-on edge.

(**Note:** Chart B includes a straight section without increases to help you establish the pattern, but you may need to work more or fewer rows to achieve the correct measurement.)

Cast off all sts loosely.

To make up

Join left shoulder seam using mattress stitch (see page 39).

NECKBAND

Using 3.5mm (UK 9/10; US 4) needles, with RS of work facing and yarn C, pick up and knit 42 sts across Back neck, and 70 sts evenly around Front neck (112 sts).

Using yarn C, work 2 rows in 1x1 rib.

Using yarn A, work 2 rows in 1x1 rib.

Using yarn B, work 2 rows in 1x1 rib.

Using yarn D, work 2 rows in 1x1 rib.

Cast off using yarn A.

Block each piece to your required measurements (see pages 40–41).

Use mattress stitch (see page 39) to join the following pieces: join right shoulder seam. Set in sleeves, carefully aligning the centre of the top edge of each sleeve with each shoulder seam. Join side and sleeve seams.

Weave in any remaining ends (see page 38).

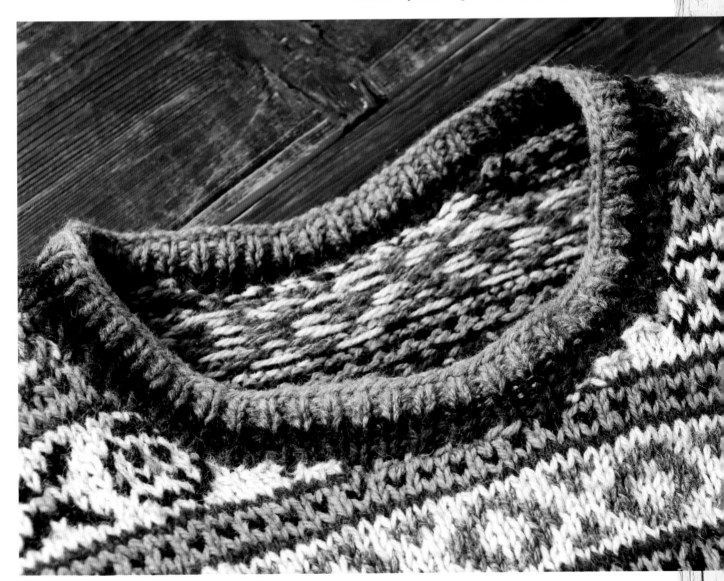

PROJECT:
Croft Child's Dress

This child's dress uses a combination of coloured knitting techniques, with the bluebird motif being applied both as a Fair Isle border and as Intarsia on the pockets. The bodice and sleeve borders have repeating Fair Isle patterns using bold colours to add fun to the dress. This will be a lovely project to work on as a gift for the special little girl in your life.

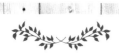

Yarn

- Lang Merino 150 4-ply yarn, or equivalent 4-ply (fingering) weight yarn made of 100% merino wool; 50g/198yd/150m; manufacturer's tension 27 sts x 37 rows on 3.25mm (UK 10; US 3) needles –
 ~ 1(2:2:2:2) balls of 0272, or deep turquoise yarn (A)
 ~ 3(4:4:4:5) balls of 0162, or cerise yarn (B)
 ~ 1 ball of 0029, or salmon yarn (C)
 ~ 1 ball of 0109, or light pink yarn (D)
 ~ 1 ball of 0116, or green yarn (E)
 ~ 1 ball of 0045, or mauve yarn (F)

Needles

- Three pairs of straight knitting needles –
 ~ 3mm (UK 11; US 2/3)
 ~ 3.25mm (UK 10; US 3)
 ~ 3.5mm (UK 9/10; US 4)
- Tapestry needle

Extras

- Two buttons
- Stitch holders
- Stitch markers

Pattern tension

23 sts x 28 rows on 3.25mm (UK 10; US 3) needles

Pattern notes

For the bird motifs (see Charts A and B on pages 96 and 97), strand the yarn not in use loosely across the WS of the work. Avoid long strands by twisting unused yarn colours with those in use every few stitches as you work (see page 29).

Size chart

		SIZE 1: 12-18 MONTHS	SIZE 2: 18-24 MONTHS	SIZE 3: 2-3 YEARS	SIZE 4: 3-4 YEARS	SIZE 5: 4-5 YEARS
ACTUAL CHEST	CM	57	62	65	72	78
	IN	22½	24½	25½	28¼	30¾
ACTUAL LENGTH TO SHOULDER	CM	41	45	50	56	64
	IN	16¼	17¾	19¾	22	25¼
ACTUAL SLEEVE LENGTH	CM	18	20	22	25	28
	IN	7	7⅞	8¾	10	11
LENGTH TO UNDERARM	CM	31	34	38	43	50
	IN	12¼	13½	15	17	19¾
UPPER ARM CIRCUM.	CM	18.5	20	21.5	24	26.5
	IN	7¼	7⅞	8½	9½	10½

CHARTS (FIRST SET)

- ⬤ *Yarn A (0272, or turquoise)*
- ⬤ *Yarn B (0162, or cerise)*
- ▨ *Yarn C (0029, or salmon)*
- ◯ *Yarn D (0109, or light pink)*
- ⬤ *Yarn E (0116, or green)*
- ⬤ *Yarn E (0045, or mauve)*

- ⌢ *Cast off*
- ◩ *SSK*
- ◪ *K2tog*
- ▢ *Repeat*

Chart D: Chest pattern (Size 1 ONLY)

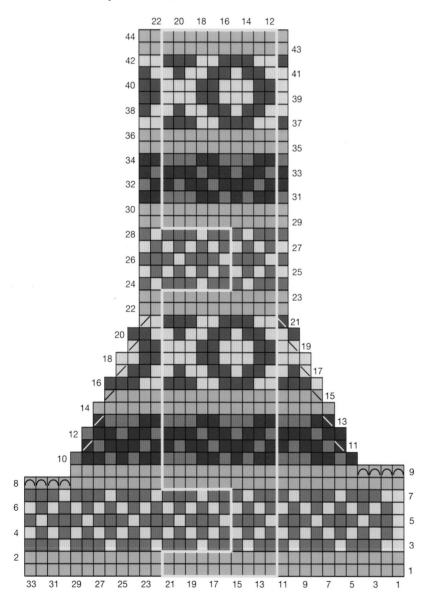

Chart C: Sleeves

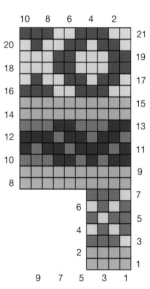

Chart D: Chest pattern (Size 2 ONLY)

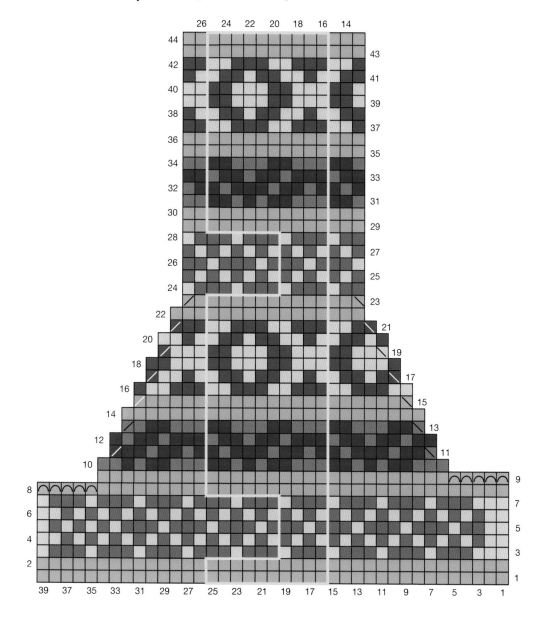

CHARTS (SECOND SET)

- ⬤ *Yarn A (272, or turquoise)*
- ⬤ *Yarn B (0162, or cerise)*
- ◐ *Yarn C (0029, or salmon)*
- ◯ *Yarn D (0109, or light pink)*
- ⬤ *Yarn E (0116, or green)*
- ◐ *Yarn E (0045, or mauve)*

- ◠ *Cast off*
- ◲ *SSK*
- ⊘ *K2tog*
- ◯ *Repeat*

- ◯ *Size 1 ONLY*
- ◯ *Size 2 ONLY*
- ◯ *Size 3 ONLY*
- ◯ *Size 4 ONLY*
- ◯ *Size 5 ONLY*

Chart A: Bordered hem

Chart B: Pocket (Sizes 4 and 5 ONLY)

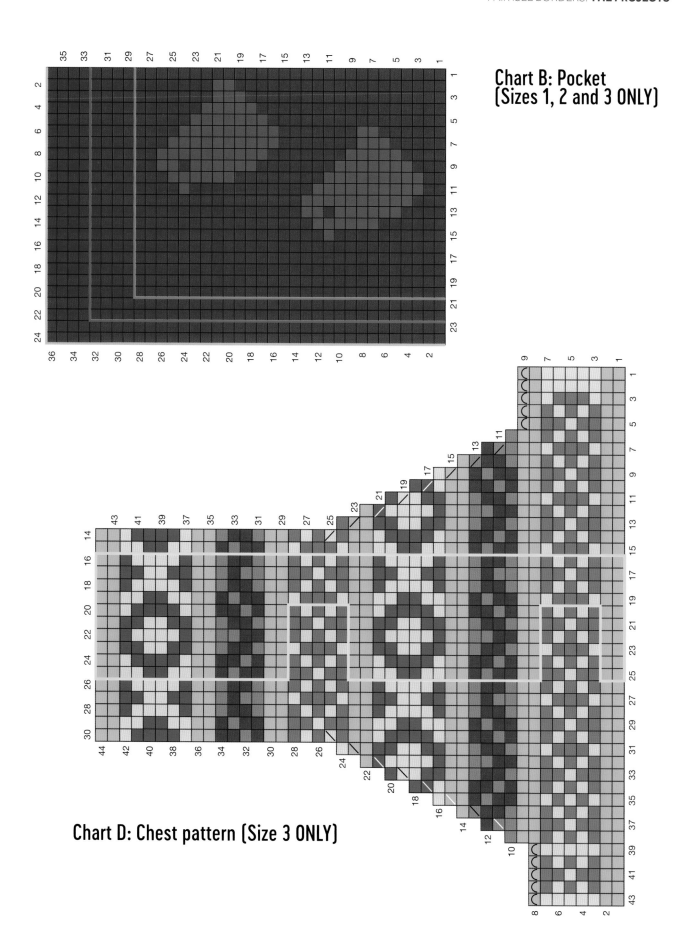

Chart B: Pocket
(Sizes 1, 2 and 3 ONLY)

Chart D: Chest pattern (Size 3 ONLY)

CHARTS (THIRD SET)

- 🔵 Yarn A (0272, or turquoise)
- 🔵 Yarn B (0162, or cerise)
- 🔵 Yarn C (0029, or salmon)
- ⚪ Yarn D (0109, or light pink)
- 🔵 Yarn E (0116, or green)
- 🔵 Yarn E (0045, or mauve)

- ⌒ Cast off
- ⟍ SSK
- ⟋ K2tog
- ⬜ Repeat

Chart D: Chest pattern (Size 4 ONLY)

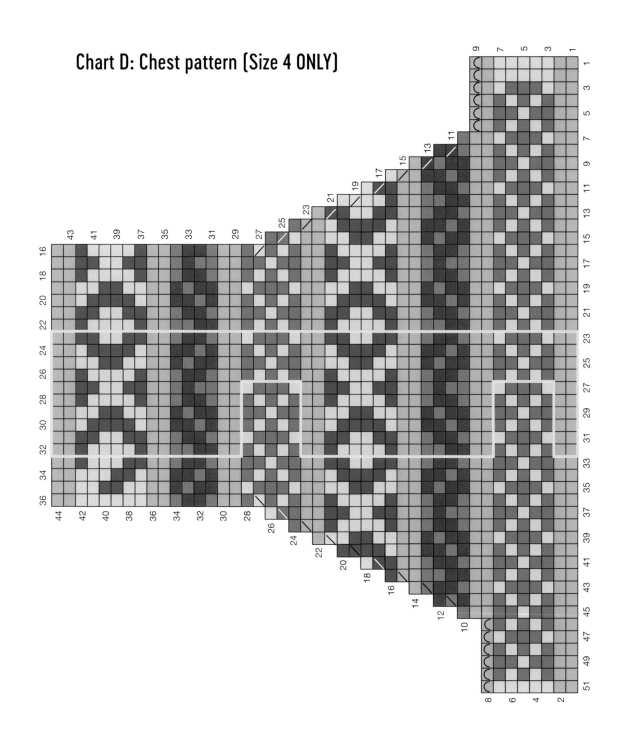

Chart D: Chest pattern (Size 5 ONLY)

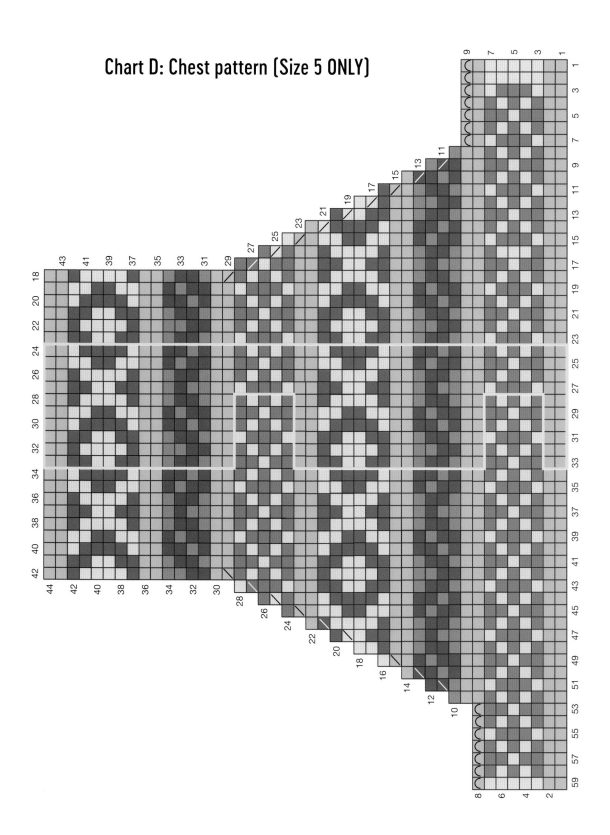

PATTERN

Back

Using 3mm (UK 11; US 2/3) needles and yarn A cast on 97(105:110:120:130) sts.

Knit 5 rows.

Fasten off yarn A.

Change to 3.25mm (UK 10; US 3) needles and yarn B.

Beginning with a RS knit row, work 6 rows in St st.

Following the correct instructions for your size, establish edge sts and Chart A as follows:

Row 1 (RS): k1(4:1:0:5)B, work row 1 of Chart A 8(8:9:10:10) times, k0(5:1:0:5)B.

Row 2 (WS): p0(5:1:0:5)B, work row 2 of Chart A 8(8:9:10:10) times, p1(4:1:0:5)B.

Cont as set, working next row of Chart A each time and maintaining edge sts as established until chart is complete. Fasten off yarn A.

Cont in St st using yarn B only until Back measures 28(31:35:40:47)cm / 11(12¼:13¾:15¾:18½)in from cast-on edge, ending with a RS row.

Dec row (WS): p2(2:2:3:4), [p2tog, p2] 23(25:26:28:30) times, p2tog, p1(1:2:3:4) (73(79:83:91:99) sts).

Fasten off yarn B.

Change to yarn C and work 2 rows in St st.

Change to 3.5mm (UK 9; US 4) needles.

Begin working from Chart B as follows:

Row 3 (RS): following correct chart for your size, work row 3 of Chart B to end.

Row 4 (WS): work next row of Chart B.

Cont working from Chart B as set until chart is complete. Armhole shaping is also complete (53(55:57:61:65) sts).

Cont in yarn B only, work in St st until Back measures 41(45:50:56:64)cm / 16¼ (17¾:19¾:22:25¼)in from cast-on edge, ending with a WS row.

SHAPE SHOULDERS

Cast off 12(12:13:14:15) sts at the beg of next 2 rows.

Place rem 29(31:31:33:35) sts on stitch holder for Back neck.

Front

Work as Back until Front measures 35(39:44:49:57)cm / 13¾(15¼:17¼:19¼:22½)in from cast-on edge, ending with a WS row.

LEFT FRONT SHOULDER

Cont to keep pattern correct according to Chart B as for Back and, at the same time, shape neck as follows:

Next row (RS): patt across 18(18:19:20:21) sts and turn to work on these sts only for left shoulder, leaving rem sts on a stitch holder.

Next row (WS): patt to end.

Next row (RS): patt to last 2 sts, k2tog (1 st dec).

Repeat the last 2 rows until 12(12:13:14:15) sts rem.

Work straight in pattern until the Front measures the same as the Back to shoulder shaping.

Cast off 12(12:13:14:15) sts.

RIGHT FRONT SHOULDER

With RS facing, leave centre 17(19:19:21:23) sts on a stitch holder for Front neck and rejoin yarn to rem 18(18:19:20:21) sts for right shoulder.

Next row (RS): patt to end.

Next row (WS): patt to end.

Next row (RS): SSK, patt to end (1 st dec).

Repeat the last 2 rows until 12(12:13:14:15) sts rem.

Work straight until the Front measures the same as the Back to shoulder shaping.

Cast off sts.

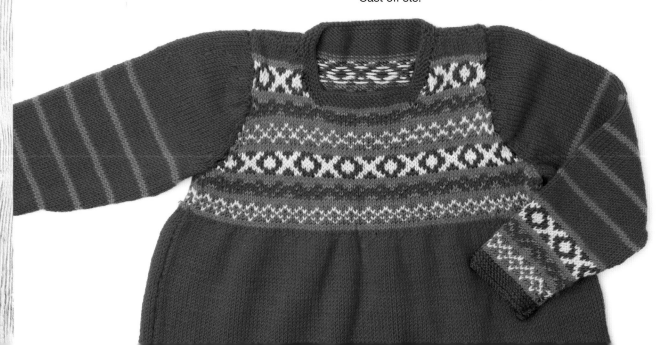

Sleeves
MAKE TWO

Using 3mm (UK 11; US 2/3) needles and yarn A cast on 36(38:40:44:48) sts.

Knit 5 rows.

Fasten off yarn A.

Change to 3.25mm (UK 10; US 3) needles.

(**Note:** read through the following section carefully before beginning as you will be working multiple instructions at the same time.)

Join yarn C and establish pattern as follows:

(**Note:** throughout charted section work edge sts (if any) in appropriate yarn for pattern – e.g. yarn C for rows 1 and 2, yarn E or D for rows 3–7, and so on. As you progress through the chart while increasing, you may not end with a full chart repeat – take care to keep pattern correct throughout on both RS and WS rows, using the chart as a guide.)

Row 1 (RS): k2(3:0:0:0), work row 1 of Chart C to last 2(3:0:0:0) sts, k2 (3:0:0:0).

Row 2 (WS): p2(3:0:0:0), work row 2 of Chart C to last 2(3:0:0:0) sts, p2(3:0:0:0).

Work rem 17 rows from Chart C as set, then work in stripe pattern and St st as follows: 2 rows with yarn C, 8 rows with yarn B.

At the same time, beginning on row 5 of Chart C, shape sleeve as follows, taking increased sts into pattern:

Inc row (RS): kfb, patt to last st, kfb (2 sts inc).

Rep Inc row every sixth row until you have 52(56:60:68:74) sts left.

Cont straight in pattern until sleeve measures 18(20:22:25:28)cm / 7(7¾:8¾:9¾:11)in from cast-on edge, ending with a WS row.

Fasten off yarn C and cont in St st with yarn B only.

SHAPE TOP

Cast off 4(5:5:6:7) sts at beg of next 2 rows (44(46:50:56:60) sts).

Next row (RS): knit.

Next row (WS): purl.

Next row: k2, SSK, knit to last 4 sts, k2tog, k2 (2 sts dec).

Next row: purl.

Rep last 4 rows until 38(40:42:48:50) sts rem.

Work 0(2:0:2:0) rows straight in St st.

Cast off 3 sts at beg of next 8(8:8:10:10) rows (14(16:18:18:20) sts).

Cast off sts.

Pockets
MAKE TWO

Using 3.25mm (UK 10; US 3) needles and yarn C, cast on 20(22:24:26:28) sts.

Following correct chart for your size and ending at point indicated on chart, work rows 1–28(32:36:40:44) of Chart D.

Change to 3mm (UK 11; US 2.5) needles and knit 4 rows.

Buttonhole row (RS): k8(9:10:11:12), k2tog, YO twice, SSK, k8(9:10:11:12).

Next row (WS): k9(10:11:12:13), knit through front of first YO and back of second YO, knit to end.

Knit 3 rows.

Cast off sts.

Neckband

Sew right shoulder seam using mattress stitch (see page 39).

With RS facing, using yarn B and 3.25mm (UK 10; US 3) needles, pick up and k15(15:17:17:19) sts down left side of Front neck, k17(19:19:21:23) sts from Front neck holder, pick up and k15(15:17:17:19) sts up right side of Front neck, k29(31:31:33:35) sts from Back neck holder (76(80:84:88:96) sts).

Knit 5 rows.

Cast off sts.

To make up

Block each piece to your required measurements (see pages 40–41).

Use mattress stitch (see page 39) to join the following pieces: join left shoulder and neckband seam. Sew sleeves into armhole carefully, easing them to fit. Join side and sleeve seams. Sew on pockets.

Sew on buttons behind pockets, opposite buttonholes (see page 43). Weave in any remaining ends (see page 38).

FAIR ISLE PATTERNS

Patterns are distinctive from the other categories of Fair Isle as they are designs created using a set number of stitches that are then repeated across a row. Often, they are made up of several small or large patterns to create an overall effect. Patterns are generally repeated a number of times within a project either using a single set of colours, or with the same pattern alternating between multiple, corresponding colourways to create an impressive effect.

All of the swatches are made using Jamieson's of Shetland Spindrift yarn and 3.25mm (UK 10; US 3) needles.

Note: *for the projects, written instructions for the charts have been included where possible. However, where written instructions may have proven too cumbersome, only charts are featured for ease in pattern reading.*

ELIZABETHAN ROSE

This pattern was inspired by a rose in our garden. I have used the
same design from the chart, albeit adapting the spacing slightly,
to make the rose shawl (see pages 142–145). For the swatch below,
I have repeated the main pattern once to the left and twice above.
The pattern repeat is 15 stitches and I have purled one row in yarn A,
in between the top and bottom repeats.

CHART

○ *Yarn A (Lichen)*

● *Yarn B (Copper)*

◐ *Yarn C (Leprechaun)*

○ *Yarn D (Mustard)*

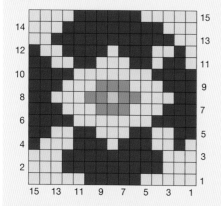

Row 1: k5A, k5B, k5A.

Row 2: p3A, p9B, p3A.

Row 3: k3A, k9B, k3A.

Row 4: p1B, p3A, p3B, p1A, p3B, p2A, p1B, p1A.

Row 5: k2B, k2A, k2B, k3A, k2B, k2A, k2B.

Row 6: p4B, p7A, p4B.

Row 7: k3B, k3A, k3C, k3A, k3B.

Row 8: p2B, p3A, p2C, p1D, p2C, p3A, p2B.

Row 9: as row 7.

Row 10: as row 6.

Row 11: k1A, k2B, k1A, k2B, k3A, k2B, k2A, k2B.

Row 12: p1B, p2A, p4B, p1A, p3B, p2A, p1B, p1A.

Row 13: k2A, k11B, k2A.

Row 14: as row 2.

Row 15: k5A, k6B, k4A.

COLOUR VARIATION

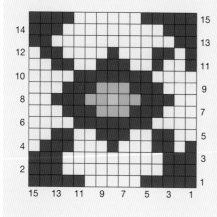

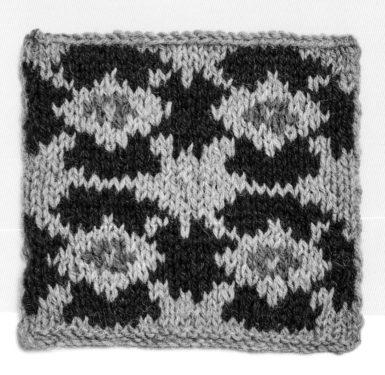

DOGTOOTH

This is classic design pattern, seen traditionally in woollen cloth, which I have adapted here for knitting. The 4-stitch pattern repeat makes it easy to place on many designs. The typical colours for dogtooth are black and white, but nowadays numerous two-colour combinations are put together to create incredibly striking, modern designs.

CHART

● Yarn A (Pumpkin)
● Yarn B (Rust)

Row 1: k2A, k1B, k1A.
Row 2: p1A, p3B.
Row 3: k1A, k3B.
Row 4: p2A, p1B, p1A.

COLOUR VARIATIONS

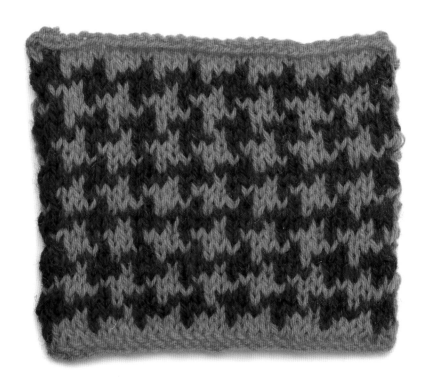

CAMPION

This pattern looks great as a multicoloured design, but if you wish yarns B to F could be just the one colour to create a simple two-colour design. The pattern is repeated over 29 stitches.

CHART

- ○ *Yarn A (Pebble)*
- ● *Yarn B (Prussian Blue)*
- ◑ *Yarn C (Scarlet)*
- ○ *Yarn D (Buttercup)*
- ● *Yarn E (Granny Smith)*
- ◑ *Yarn F (Tangerine)*

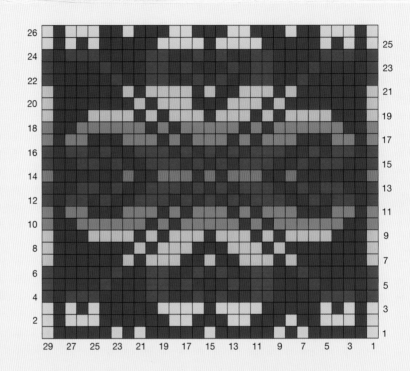

Row 1: k1A, k5B, k1A, k1B, k1A, k5B, k1A, k5B, k1A, k1B, k1A, k5B, k1A.

Row 2: p1A, p1B, p3A, p6B, p2A, p3B, p2A, p3B, p1A, p2B, p3A, p1B, p1A.

Row 3: k1A, k1B, k1A, k1B, k1A, k5B, k4A, k1B, k4A, k5B, k1A, k1B, k1A, k1B, k1A.

Row 4: p1C, p1B, p3C, p4B, p2C, p2B, p1C, p1B, p1C, p2B, p2C, p4B, p3C, p1B, p1C.

Row 5: k1C, k4B, k1C, k3B, k2C, k1B, k1C, k3B, k1C, k1B, k2C, k3B, k1C, k4B, k1C.

Row 6: p1C, p5B, p1C, p2B, p2C, p2B, p1C, p1B, p1C, p2B, p2C, p2B, p1C, p5B, p1C.

Row 7: k1D, k6B, k1D, k1B, k3D, k2B, k1D, k2B, k3D, k1B, k1D, k6B, k1D.

Row 8: p1D, p7B, p1D, p1B, p3D, p3B, p3D, p1B, p1D, p7B, p1D.

Row 9: k1D, k3B, k4D, k1B, k1D, k1B, k3D, k1B, k3D, k1B, k1D, k1B, k4D, k3B, k1D.

Row 10: p1E, p2B, p6E, p1B, p1E, p1B, p5E, p1B, p1E, p1B, p6E, p2B, p1E.

Row 11: k1E, k1B, k2E, k3B, k3E, k1B, k1E, k1B, k3E, k1B, k1E, k1B, k3E, k3B, k2E, k1B, k1E.

Row 12: p1C, p1B, p2C, p1B, p1C, p2B, p3C, p1B, p1C, p1B, p1C, p1B, p1C, p1B, p3C, p2B, p1C, p1B, p2C, p1B, p1C.

Row 13: k1C, k2B, k2C, k1B, k1C, k2B, k3C, k1B, k1C, k1B, k1C, k1B, k3C, k2B, k1C, k1B, k2C, k2B, k1C.

Row 14: p1F, p6B, p1F, p2B, p3F, p1B, P1F, p1B, p3F, p2B, p1F, p6B, p1F.

Row 15: as row 13.

Row 16: as row 12.

Row 17: as row 11.

Row 18: as row 10.

Row 19: as row 9.

Row 20: as row 8.

Row 21: as row 7.

Row 22: as row 6.

Row 23: as row 5.

Row 24: as row 4.

Row 25: as row 3.

Row 26: as row 2.

COLOUR VARIATION

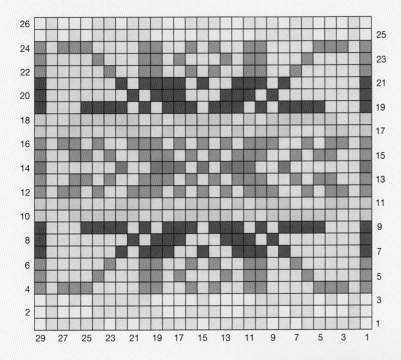

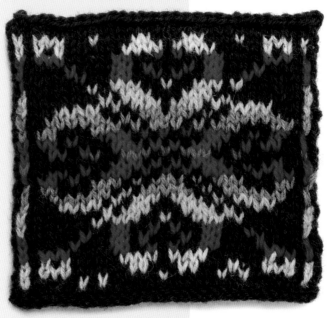

DOTTY

Dots are always fun, and they easily integrate with other small designs in Fair Isle knitting. I have used a single line in two of my designs, the Campion Yoked Sweater (see pages 76–81) and the Skroo Socks (see pages 82–85). Use scraps of yarn from your stash as an opportunity to go really wild with the colours! The pattern repeat is 7 stitches.

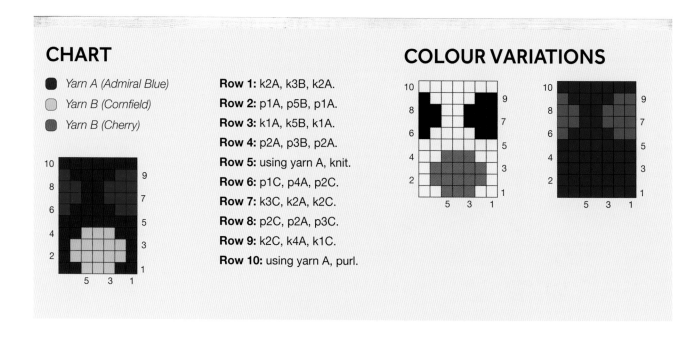

CHART

- ■ Yarn A (Admiral Blue)
- ◻ Yarn B (Cornfield)
- ◕ Yarn B (Cherry)

Row 1: k2A, k3B, k2A.
Row 2: p1A, p5B, p1A.
Row 3: k1A, k5B, k1A.
Row 4: p2A, p3B, p2A.
Row 5: using yarn A, knit.
Row 6: p1C, p4A, p2C.
Row 7: k3C, k2A, k2C.
Row 8: p2C, p2A, p3C.
Row 9: k2C, k4A, k1C.
Row 10: using yarn A, purl.

COLOUR VARIATIONS

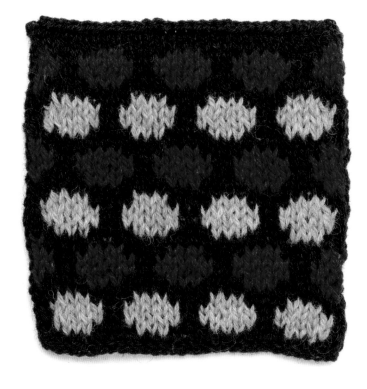

SHIELDS & CROSSES

I have chosen autumnal colours for this swatch as I think they work particularly well with the design. It has a pattern repeat of 12 stitches that I have then repeated three times across the row. The nine-row pattern is then repeated twice, with a row in yarn B in between each repeat.

CHART

- Yarn A (Pumpkin)
- Yarn B (Leprechaun)

Row 1: k1A, k3B, k1A, k3B, k1A, k3B.

Row 2: p2B, p1A, p1B, p1A, p3B, p1A, p1B, p1A, p1B.

Row 3: k2B, k1A, k3B, k2A, k1B, k2A, k1B.

Row 4: p3A, p1B, p3A, p1B, p1A, p1B, p1A, p1B.

Row 5: k1A, k3B, k1A, k3B, k1A, k3B.

Row 6: p3A, p1B, p3A, p1B, p1A, p1B, p1A, p1B.

Row 7: k2B, k1A, k3B, k2A, k1B, k2A, k1B.

Row 8: p2B, p1A, p1B, p1A, p3B, p1A, p1B, p1A, p1B.

Row 9: k1A, k3B, k1A, k3B, k1A, k3B.

COLOUR VARIATIONS

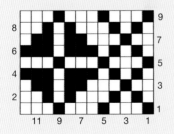

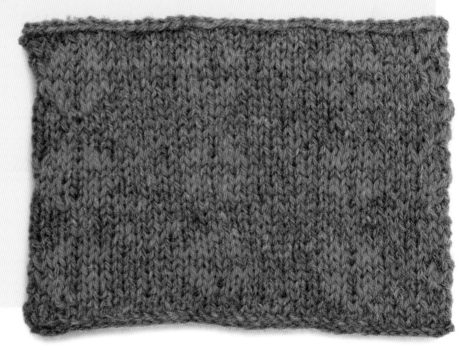

LOMOND

This is one of the more complex swatches as it combines many colours and more than one pattern. If this is a little challenging, the pattern could be simplified by reducing the number of colours used. This pattern would be great for an adult waistcoat, sweater or cardigan, but I would recommend waiting until you have fully mastered the technique of Fair Isle before approaching this particular pattern. You'll notice the smaller pattern design (rows 1–5) is repeated across 16 stitches, The overall pattern repeat is 24 stitches.

CHART

- ⬤ Yarn A (Pebble Grey)
- ⬤ Yarn B (Charcoal)
- ◯ Yarn C (Mist)
- ⬤ Yarn D (Damask)
- ⬤ Yarn E (Lomond)
- ⬤ Yarn F (Zodiac)
- ⬤ Yarn G (Petrol)

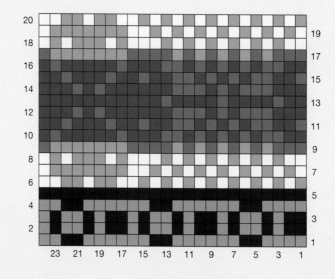

Row 1: k4A, k2b, * k6A, k2B, rep from * to last 2 sts, k2A.

Row 2: p1A, p1B * p2A, p1B, p1A, p2B, p1A, p1B, rep from * to last 6 sts, p2A, p1B, p1A, p2B.

Row 3: * k2B, k1A, k1B, k2A, k1B, k1A, rep from * to end.

Rows 4: p2A,* p2B, p6A, rep from * to last 6 sts, p2B, p4A.

Row 5: using yarn B, knit.

Row 6: p2C, p2D, p1C, p2D, p2C, (p1D, k1C) seven times, p1D.

Row 7: (k1C, k1D) seven times, k2C, k7D, k1C

Row 8: p1C, p1D, p1C, p3D, p1C, p1D, p3C, (p1D, p1C) six times, p1C.

Row 9: k3E, (k1D, k1E) five times, k3E, k7D, k1E.

Row 10: p1F, p1E, p5F, p1E, p3F, p2E, (p1F, p1E) four times, p1E, p2F.

Row 11: k1E, k2F, k2E, (k1F, k1E) three times, k1E, k2F, k1E, k2F, k1E, k3F, k1E, k2F.

Row 12: p3F, p1E, p1F, p1E, p6F, p3E, p1F, p1E, p1F, p3E, p3.

Row 13: k2G, k1E, k4G, k1E, k4G, k1E, k5F, k3G, k3F.

Row 14: as row 12.

Row 15: as row 11.

Row 16: as row 10.

Row 17: as row 9.

Row 18: as row 8.

Row 19: as row 7.

Row 20: as row 6.

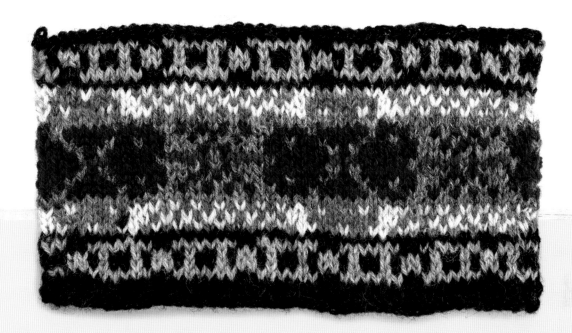

COLOUR VARIATIONS

Note: these variations feature fewer colours than the main design,
To the left, there are four shades; to the right there are five.

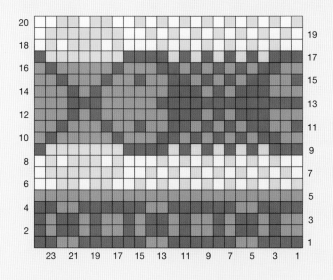

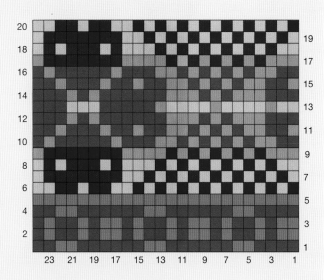

GORSE

This is one of the simpler Fair Isle patterns as the swatch is knitted in two colours. However, you could jazz up the design by changing colours with each pattern repeat. The pattern is repeated over 10 stitches.

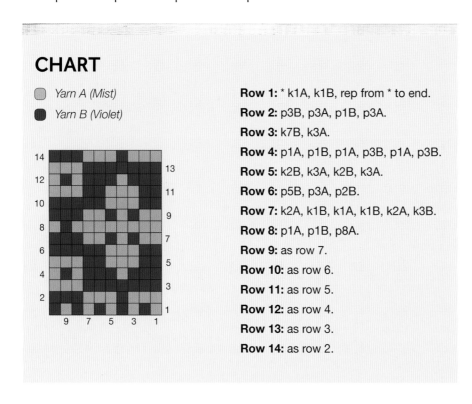

CHART

⬜ Yarn A (Mist)
⬛ Yarn B (Violet)

Row 1: * k1A, k1B, rep from * to end.

Row 2: p3B, p3A, p1B, p3A.

Row 3: k7B, k3A.

Row 4: p1A, p1B, p1A, p3B, p1A, p3B.

Row 5: k2B, k3A, k2B, k3A.

Row 6: p5B, p3A, p2B.

Row 7: k2A, k1B, k1A, k1B, k2A, k3B.

Row 8: p1A, p1B, p8A.

Row 9: as row 7.

Row 10: as row 6.

Row 11: as row 5.

Row 12: as row 4.

Row 13: as row 3.

Row 14: as row 2.

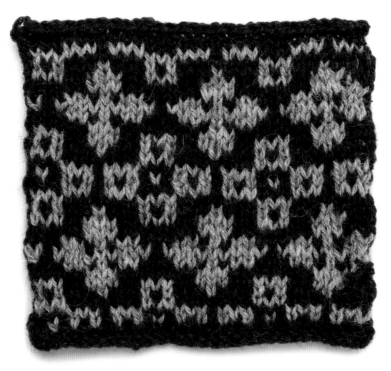

SEEDS

This is a simple Fair Isle pattern that can be used as an overall design on any item. Colours can be bold or subtle depending on how much you would like the design to show up. I have used this chart as part of my Skroo Sock design (see pages 82–85), in which several patterns have been put together. The pattern repeat is 4 stitches.

CHART

○ Yarn A (Sky)
○ Yarn B (Wild Violet)

Row 1: using yarn A, knit.

Row 2: * p1B, p3A, rep from * to end.

Row 3: * k1B, k1A, rep from * to end.

Row 4: p2A, p1B, p3A, p1B, p1A.

Row 5: as row 3.

Row 6: as row 2.

Row 7: using yarn A, knit.

COLOUR VARIATIONS

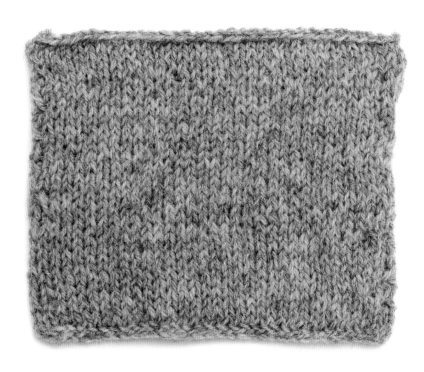

IROQUOIS

This Fair Isle design has three separate patterns worked together, and really shows how versatile Fair Isle designs can be: as long as the different multiples of stitches fit together across a row, you can combine different patterns to create a unique design. In this pattern, they go together easily as the largest section is multiples of 18 stitches, then there is a 9-stitch pattern repeat for the middle section, and finally a 3-stitch pattern repeat for the smallest section. They all work together, as the 36-stitch swatch shows. To break up the different parts, I have used three different colours.

CHART

🔴 Yarn A (Scarlet)

⚪ Yarn B (Leprechaun)

⚫ Yarn C (Peacock)

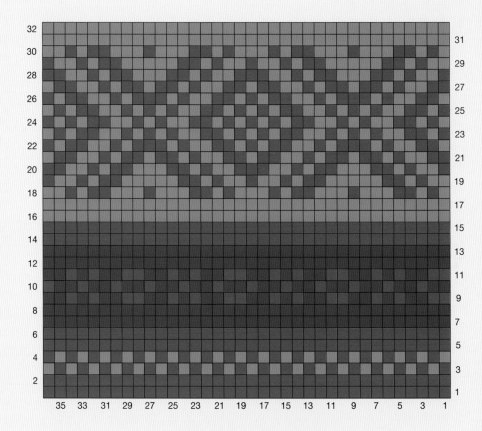

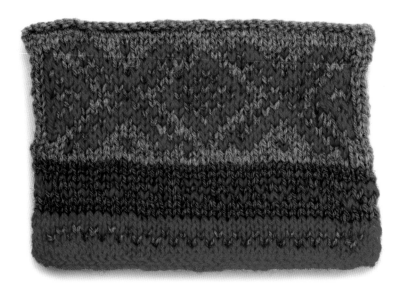

Row 1: using yarn A, knit.

Row 2: using yarn A, purl.

Row 3: * k1A, k1B, rep from * to end.

Row 4: * p1A, p1B, rep from * to end.

Row 5: using yarn A, knit.

Row 6: using yarn A, purl.

Row 7: using yarn C, knit.

Row 8: using yarn C, purl.

Row 9: * k2A, k2C, k1A, k1C, k1A, k2C, rep from * to end.

Row 10: * p1A, p2C, rep from * to end.

Row 11: * k2A, k2C, k1A, k1C, k1A, k2A, rep from * to end.

Row 12: using yarn C, purl.

Row 13: using yarn C, knit.

Row 14: using yarn A, purl.

Row 15: using yarn A, knit.

Row 16: using yarn B, purl.

Row 17: using yarn B, knit.

Row 18: * p2B, p1A, p1B, p2A, p3B, p1A, p3B, p2A, p1B, p1A, p2B, rep from * to end.

Row 19: * k2B, k1A, k1B, k2A, k5B, k2A, k1B, k1A, k2B, k1A, rep from * to end.

Row 20: * p2A, p2B, p1A, p1B, p2A, p3B, p2A, p1B, p1A, p2B, p1A, rep from * to end.

Row 21: * k2A, k2B, k1A, k1B, k2A, k1B, k2A, k1B, k1A, k2B, k2A, k1B, rep from * to end.

Row 22: * p1A, p1B, p2A, p2B, p1A, p1B, p3A, p1B, p1A, p2B, p2A, p1B, rep from * to end.

Row 23: * k1A, k1B, k2A, k2B, k1A, k1B, k1A, k1B, k1A, k2B, k2A, k1B, k1A, k1B, rep from * to end.

Row 24: * p1A, p1B, p1A, p1B, p2A, p2B, p1A, p1B, p1A, p2B, p2A, p1B, p1A, p1B, rep from * to end.

Row 25: as row 23.

Row 26: as row 22.

Row 27: as row 21.

Row 28: as row 20.

Row 29: as row 19.

Row 30: as row 18.

Row 31: as row 17.

Row 32: as row 16.

RIPPLE

This Fair Isle pattern is one of the larger ones in this book and would be great for sweaters, bags or a waistcoat. A small, simple border pattern could be added above and below to add greater interest. The pattern repeat is 30 stitches.

CHART

⬤ Yarn A (Copper)

◯ Yarn B (Sand)

⬤ Yarn C (Admiral Blue)

⬤ Yarn D (Plum)

⬤ Yarn E (Apple Green)

◯ Yarn F (Scotch Broom)

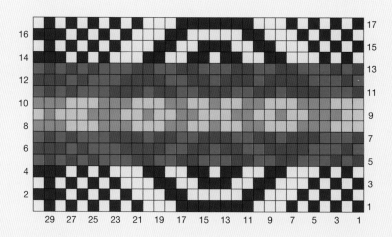

Row 1: (k1A, k1B) four times, k2B, k7A, k3B, (k1A, k1B) five times.

Row 2: p3A, (p1B, p1A) three times, p3B, p2A, p5B, p2A, p3B, (p1A, p1B) three times.

Row 3: (k1A, k1B) three times, k2B, K2A, k2B, k3A, k2B, k2A, k3B, (k2A, k2B) four times.

Row 4: p3A, p1B, p1A, p1B, p1A, p3B, p2A, p2B, p2A, p1B, p2A, p2B, p2A, p3B, p1A, p1B, p1A, p1B.

Row 5: k1C, k1D, k1C, k3D, k2C, k2D, k2C, k3D, k2C, k2D, k2C, k3D, (k1C, k1D) three times.

Row 6: p3C, p1D, p1C, p3D, p4C, p2D, p2C, p1D, P2C, p2D, p4C, p3D, P1C, p1D.

Row 7: k1C, k3D, k3C, k1D, k2C, k2D, k3C, k2D, k2C, k1D, k3C, k3D, k1C, k1D, k1C, k1D.

Row 8: p3E, p3F, p3E, p3F, p2E, p2F, p1E, p2F, p2E, p3F, p3E, p3F.

Row 9: k2F, k3E, k2F, k1E, k2F, k2E, k3F, k2E, k2F, k1E, k2F, k3E, k3F, k1E, k1F.

Row 10: as row 8.

Row 11: as row 7.

Row 12: as row 6.

Row 13: as row 5.

Row 14: as row 4.

Row 15: as row 13.

Row 16: as row 2.

Row 17: as row 1.

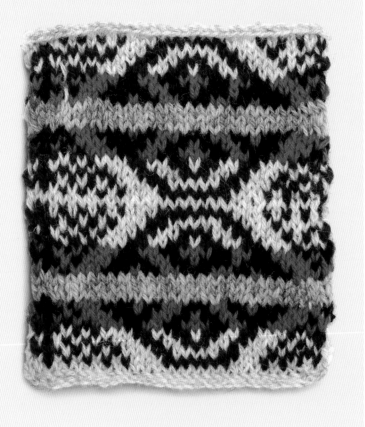

NAVAJO

This pattern was inspired by a Navajo print. It is worked on a multiple of 16 stitches and is knitted onto a background that is worked in colour A. For this swatch, I have repeated the pattern once, both to the left and above.

CHART

● Yarn A (Leprechaun)
○ Yarn B (Scotch Broom)
● Yarn C (Copper)
● Yarn D (Cobalt)

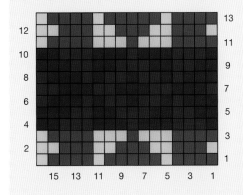

Row 1: k4A, k1B, k5A, k1B, k4A, k1B.

Row 2: p2B, p3A, p2B, p3A, p2B, p3A, p1B.

Row 3: k4A, k3B, k1A, k3B, k4A, k1B.

Row 4: p2C, p3D, p3C, p1D, p3C, p3D, p1C.

Row 5: k2C, k2D, k2C, k3D, k2C, k2D, k3C.

Row 6: p1D, p3C, p1D, p1C, p2D, p1C, p2D, p1C, p1D, p3C.

Row 7: k1D, k3C, k2D, k3C, k2D, k3C, k2D.

Row 8: as row 6.

Row 9: as row 5.

Row 10: as row 4.

Row 11: as row 3.

Row 12: as row 2.

Row 13: as row 1.

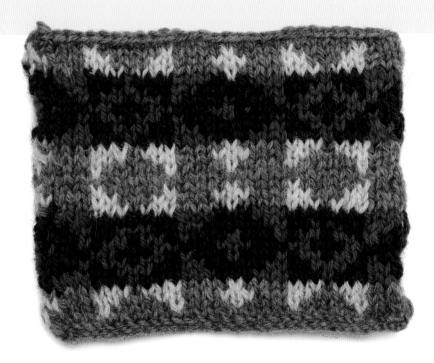

THISTLE

This swatch uses four colours to give it a vibrant feel. After completing the eleven rows of the chart, I have knitted one row in the background colour, then placed the pattern in the right place for a repeat. The pattern repeat is 16 stitches.

CHART

○ Yarn A (Scotch Broom)

● Yarn B (Rosemary)

● Yarn C (Plum)

○ Yarn D (Dog Rose)

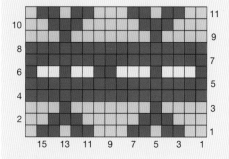

Row 1: k2A, k2B, k1A, k2B, k3A, k2B, k1A, k2B, k1A.

Row 2: p2A, p3B, p5A, p3B, p3A.

Row 3: k4A, k1B, k7A, k1B, k3A.

Row 4: p2C, p1B, p1C, p1B, p3C, p1B, p5C, p1B, p1C.

Row 5: k2B, k5C, k2B, k1C, k1B, k3C, k1B, k1C.

Row 6: p1B, p2D, p1B, p2D, p2B, p3C, p1B, p3C, p1B.

Row 7: as row 5.

Row 8: as row 4.

Row 9: as row 3.

Row 10: as row 2.

Row 11: as row 1.

COLOUR VARIATION

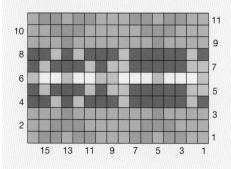

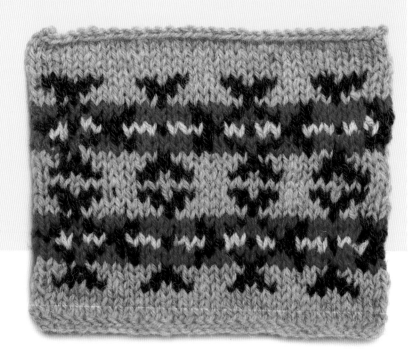

FAROE

This is a simple Fair Isle pattern, inspired by the Danish islands that sit north of the Shetland Isles. It could be easily worked in the other two colours of your choice. The pattern repeat is 6 stitches.

CHART

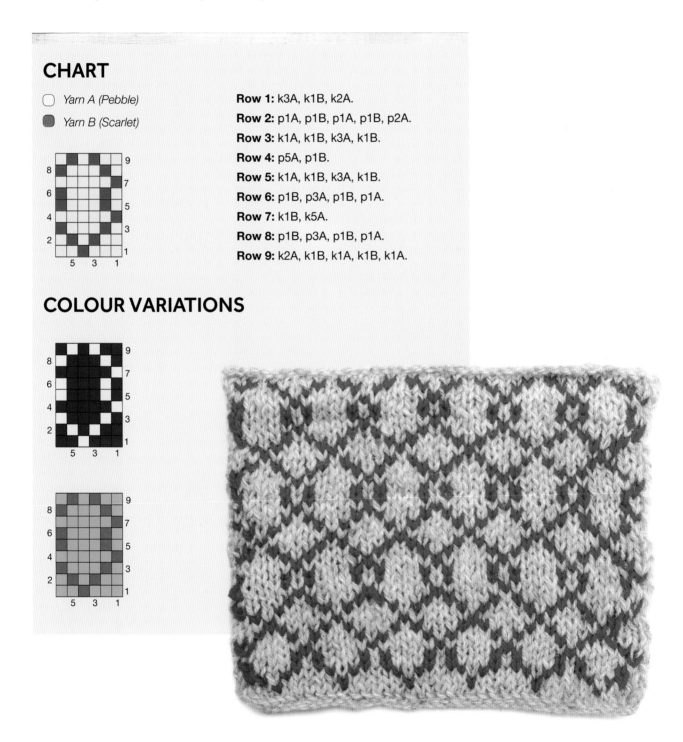

○ Yarn A (Pebble)
● Yarn B (Scarlet)

Row 1: k3A, k1B, k2A.

Row 2: p1A, p1B, p1A, p1B, p2A.

Row 3: k1A, k1B, k3A, k1B.

Row 4: p5A, p1B.

Row 5: k1A, k1B, k3A, k1B.

Row 6: p1B, p3A, p1B, p1A.

Row 7: k1B, k5A.

Row 8: p1B, p3A, p1B, p1A.

Row 9: k2A, k1B, k1A, k1B, k1A.

COLOUR VARIATIONS

BLOOM

This is one of the larger Fair Isle patterns in the book. It would be great on its own, or in between repeating bands of a corresponding border pattern in different colours. The pattern repeat is 36 stitches.

CHART

● Yarn A (Cobalt)
○ Yarn B (Eggshell)

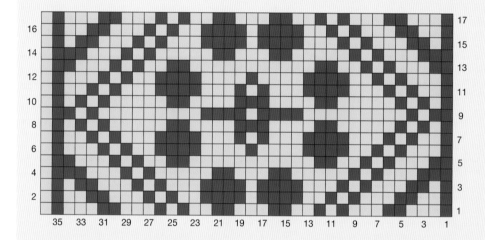

Row 1: k1A, k3B, k2A, k3B, k1A, k1B, k1A, k2B, k2A, k3B, k2A, k2B, k1A, k1B, k1A, k3B, k2A, k3B, k1A, k1B.

Row 2: p1B, p1A, p2B, p2A, p3B, p1A, p1B, p1A, p2B, p4A, p1B, p4A, p2B, p1A, p1B, p1A, p3B, p2A, p2B, p1A.

Row 3: k1A, k1B, k2A, k3B, k1A, k1B, k1A, k3B, k4A, k1B, k4A, k3B, k1A, k1B, k1A, k3B, k2A, k1B, k1A, k1B.

Row 4: p1B, p3A, p3B, p1A, p1B, p1A, p5B, p2A, p3B, p2A, p5B, p1A, p1B, p1A, p3B, p3A.

Row 5: k2A, k3B, k1A, k1B, k1A, k2B, k2A, k11B, k2A, k2B, k1A, k1B, k1A, k3B, k2A, k1B.

Row 6: p1B, p1A, p3B, p1A, p1B, p1A, p2B, p4A, p4B, p1A, p4B, p4A, p2B, p1A, p1B, p1A, p3B, p1A.

Row 7: k1A, k2B, k1A, k1B, k1A, k3B, k4A, k3B, k1A, k1B, k1A, k3B, k4A, k3B, k1A, k1B, k1A, k2B, k1A, k1B.

Row 8: p1B, p1A, p1B, p1A, p1B, p1A, p5B, p2A, p4B, p3A, p4B, p2A, p5B, p1A, p1B, p1A, p1B, p1A.

Row 9: k2A, k1B, k1A, k9B, k4A, k1B, k4A, k9B, k1A, k1B, k2A, k1B.

Row 10: as row 8.

Row 11: as row 7.

Row 12: as row 6.

Row 13: as row 5.

Row 14: as row 4.

Row 15: as row 3.

Row 16: as row 2.

Row 17: as row 1.

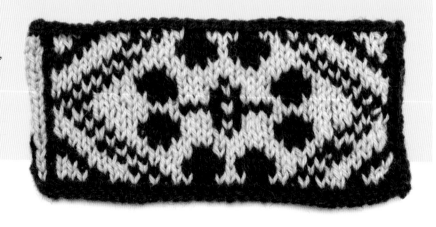

STARS & CROSSES

This pattern reminds me of an Aztec design, especially in the colours of the swatch. I think it would be a great pattern for a pillow cover or a poncho.

CHART

○ *Yarn A (Ivory)*
● *Yarn B (Charcoal)*
● *Yarn C (Madder)*
● *Yarn D (Copper)*

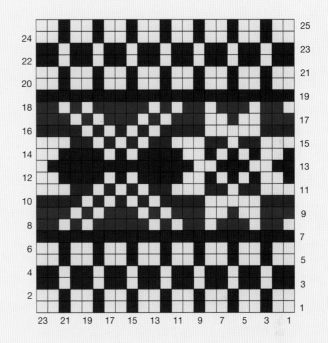

Row 1: * k2A, k1B, rep from * to last 2 sts, k2A.

Row 2: * p2A, p1B, rep from * to last 2 sts, p2A.

Row 3: * k2B, k1A, rep from * to last 2 sts, k2B.

Row 4: * p2B, p1A, rep from * to last 2 sts, p2B.

Row 5: as row 1.

Row 6: as row 2.

Row 7: using yarn B, knit.

Row 8: p2C, p1A, p2C, p1A, p5C, p1A, p1C, p1A, p2C, p1A, p3C, p1A, p2C, p1A.

Row 9: k3C, k2A, k1C, k2A, k3C, k1A, k1C, k1A, k3C, k1A, k1C, k1A, k3C.

Row 10: p4D, p1A, p1D, p1A, p1D, p1A, p1D, p1A, p4D, p5A, p3D.

Row 11: k3A, k2D, k1A, k2D, k3A, k2D, k1A, k1D, k1A, k1D, k1A, k2D, k3A.

Row 12: p2B, p4A, p1A, p1B, p1A, p4B, p2A, p1B, p1A, p1B, p1A, p1B, p2A, p1B.

Row 13: k2B, k2A, k3B, k2A, k11B, k1A.

Row 14: as row 12.

Row 15: as row 11.

Row 16: as row 10.

Row 17: as row 9.

Row 18: as row 8.

Row 19: as row 7.

Row 20: as row 2.

Row 21: as row 1.

Row 22: as row 4.

Row 23: as row 3.

Row 24: as row 2.

Row 25: as row 1.

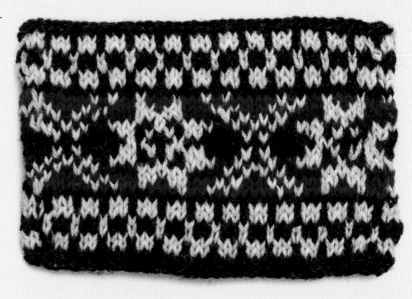

SWORD

I decided to use muted colours for this swatch, with the idea of it forming an overall pattern for a waistcoat or sweater design. The pattern is knitted over 22 stitches. When repeating the eleven rows, the first row is removed after the initial working of the chart, to repeat the overall pattern effectively.

CHART

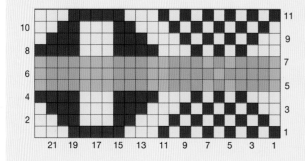

- ● Yarn A (Lomond)
- ○ Yarn B (Eggshell)
- ◐ Yarn C (Lichen)
- ◑ Yarn D (Dewdrop)

Row 1: k1A, k1B, k1A, k1B, k1A, k1B, k1A, k1B, k1A, k1B, k1A, k3B, k5A, k3B.

Row 2: p2B, p2A, p3B, p2A, p3B, p1A, p1B, p1A, p1B, p1A, p1B, p1A, p1B, p1A, p1B.

Row 3: k2B, k1A, k1B, k1A, k1B, k1A, k1B, k1A, k3B, k3A, k3B, k3A, k1B.

Row 4: p4A, p3B, p4A, p3B, p1A, p1B, p1A, p1B, p1A, p3B.

Row 5: k1C, k3D, k1C, k1D, k1C, k3D, k2C, k3D, k3C, k3D, k1C.

Row 6: p1C, p3D, p3C, p3D, p2C, p4D, p1C, p4D, p1C.

Row 7: as row 5.

Row 8: as row 4.

Row 9: as row 3.

Row 10: as row 2.

Row 11: as row 1.

Cont repeating rows 2–11 only to create a larger pattern.

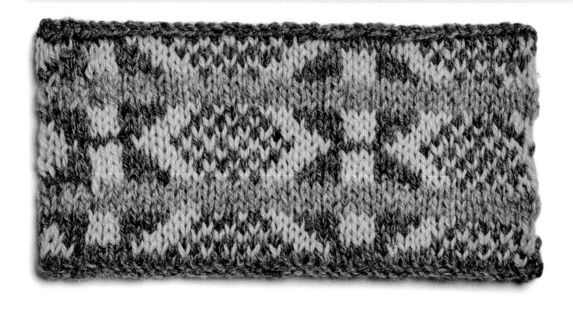

DOCKS

I once used this as an overall pattern for a beret. As it is relatively small, it could be used in virtually any knitting project. In the knitted swatch below, the nine rows are repeated once with a row of purl before the next pattern repeat. The pattern repeat is 14 stitches.

CHART

- ● *Yarn A (Birch)*
- ● *Yarn B (Wren)*
- ○ *Yarn C (Eesit/White)*

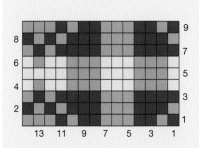

Row 1: k1A, k1B, k2A, k3B, k2A, k1B, k1A, k3B.

Row 2: p1A, p1B, p1A, p1B, p3A, p3B, p3A, p1B.

Row 3: k4A, k3B, k4A, k1B, k1A, k1B.

Row 4: p1C, p1B, p2C, p3B, p3C, p3B, p1C.

Row 5: k1C, k3B, k3C, k3B, k4C.

Row 6: as row 4.

Row 7: as row 3.

Row 8: as row 2.

Row 9: as row 1.

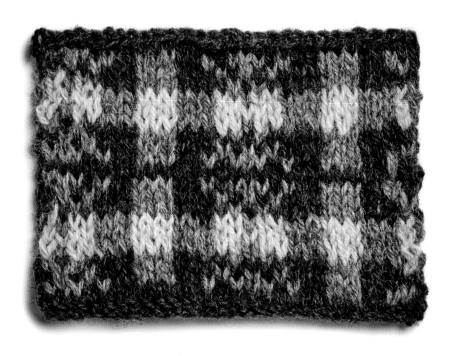

ANCHOR

This would make a perfect overall pattern for a sweater. Changing the colours in the way I have done here gives it a fun feel, but if you wish you could simplify the colours slightly by making the anchor one colour, the 'embellishments' around it another, the motifs in the border bands a third colour and the borders a fourth shade. The pattern repeat is over 24 stitches.

CHART

- Yarn A (Copper)
- Yarn B (Eggshell)
- Yarn C (Leprechaun)
- Yarn D (Damask)
- Yarn E (Lagoon)
- Yarn F (Scarlet)
- Yarn G (Cornfield)

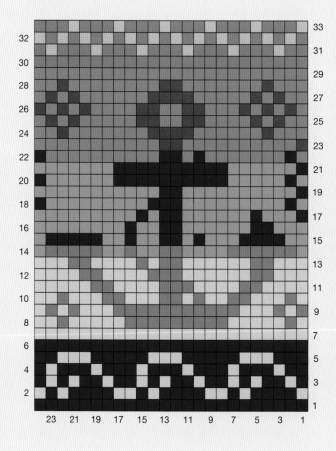

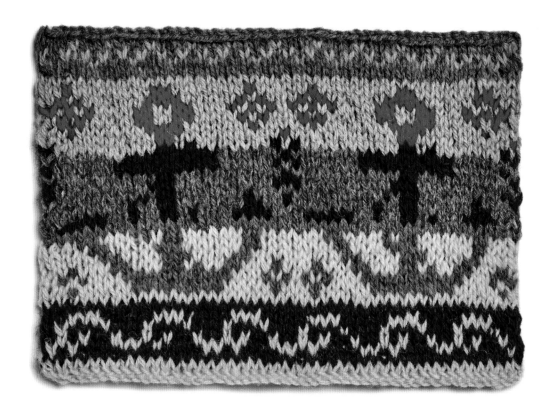

Row 1: using yarn A, knit.

Row 2: p1B, p1A, p1B, p4A, p2B, p1A, p1B, p4A, p2B, p1A. p1B, p4A, p1B.

Row 3: k1A, k1B, k2A, k1B, k1A, k1B, k2A, k1B, k2A, k1B, k1A, k1B, k2A, k1B, k2A, k1B, k1A, k1B, k1A.

Row 4: p1A, p1B, (p3A, p1B) five times, p2A.

Row 5: k3A, (k3B, k5A) two times, k3B, k2A.

Row 6: using yarn A, purl.

Row 7: using yarn B, knit.

Row 8: p2B, p1C, p5B, p9C, p5B, p1C, p1B.

Row 9: k1C, k1B, k1C, k3B, k11C, k3B, k1C, k1A, k1C, k1A.

Row 10: p2B, p1C, p3B, p2C, p3B, p2C, p1B, p1C, p2B, p2C, p3B, p1C, p1B.

Row 11: k4B, k2C, k4B, k3C, k4B, k2C, k5B.

Row 12: p4B, p2C, p4B, p3C, p6B, p2C, p3B.

Row 13: k3B, k2C, k6B, k2C, k1B, k1C, k4B, k2C, k3B.

Row 14: p1D, p5C, p2D, p1C, p2D, p2C, p4D, p6C, p1D.

Row 15: k2D, k4A, k3D, k1A, k1D, k2A, k2D, k1A, k2D, k5A, k1D.

Row 16: p8D, p1A, p2D, p2A, p6D, p2A, p3D.

Row 17: k1A, k3D, k1A, k6D, k2A, k1D, k1A, k9D.

Row 18: p1A, p9D, p3A, p9D, p1A, p1D.

Row 19: k1A, k10D, k2A, k11D.

Row 20: p1A, p6D, p10A, p5D, p1A, p1D.

Row 21: k1A, k6D, k10A, k7D.

Row 22: p1A, p10E, p2A, p1E, p1A, p7E, p1A, p1E.

Row 23: k1F, k10E, k2F, k11E.

Row 24: p2E, p1F, p7E, p4F, p6E, p1F, p3E.

Row 25: k2E, k1F, k1E, k1F, k4E, k2F, k2E, k2F, k5E, k1F, k1E, k1F, k1E.

Row 26: (p1F, p1E) three times, p3E, p2F, p2E, p2F, p3E, (p1F, p1E) three times.

Row 27: k2E, k1F, k1E, k1F, k5E, k4F, K6E, (k1F, k1E) two times.

Row 28: p2E, p1F, p8E, p2F, p7E, p1F, p3E.

Row 29: using yarn E, knit.

Row 30: using yarn C, purl.

Row 31: k2C, (k1G, k3C) five times, k1G, k1C.

Row 32: * p1C, p1G, rep from * to end.

Row 33: * k1G, k3C, rep from * to end.

GREEK COLUMNS

This Fair Isle pattern is made by combining two border-like patterns and five colours. The chart pattern is 12 stitches across and worked over fourteen rows. The knitted swatch below shows three pattern repeats.

CHART

○ *Yarn A (Pebble)*

◐ *Yarn B (Buttercup)*

◐ *Yarn C (Pumpkin)*

● *Yarn D (Admiral Navy)*

◐ *Yarn E (Leprechaun)*

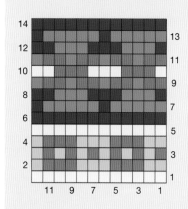

Row 1: using yarn A, knit.

Row 2: p1B, p3C, p3B, p3C, p2B.

Row 3: * k1C, k1B, rep from * to end.

Row 4: as row 2.

Row 5: using yarn A, knit.

Row 6: using yarn D, purl.

Row 7: * k5E, k1D, rep from * to end.

Row 8: p2D, p3E, p3D, p3E, p1D.

Row 9: * k2C, k1E, rep from * to end.

Row 10: p2A, p3C, p3A, p3C, p1A.

Row 11: as row 9.

Row 12: as row 8.

Row 13: as row 7.

Row 14: as row 6.

COLOUR VARIATION

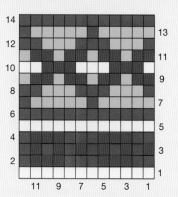

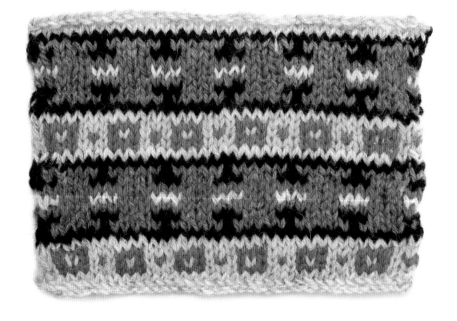

EGYPT

This is a simple geometric pattern inspired by Egyptian motifs, and I love the possibilities this clean design could offer for an overall knitted pattern – especially if bold colours were used. The pattern is repeated over 16 stitches.

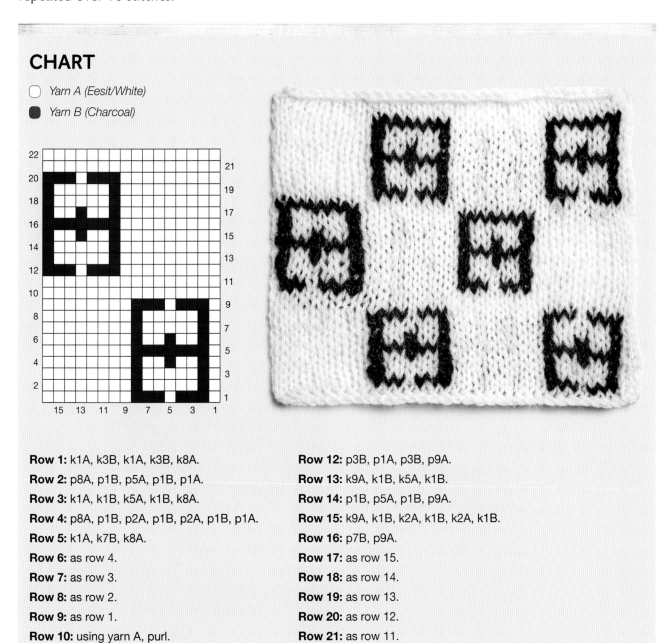

CHART

○ *Yarn A (Eesit/White)*
● *Yarn B (Charcoal)*

Row 1: k1A, k3B, k1A, k3B, k8A.

Row 2: p8A, p1B, p5A, p1B, p1A.

Row 3: k1A, k1B, k5A, k1B, k8A.

Row 4: p8A, p1B, p2A, p1B, p2A, p1B, p1A.

Row 5: k1A, k7B, k8A.

Row 6: as row 4.

Row 7: as row 3.

Row 8: as row 2.

Row 9: as row 1.

Row 10: using yarn A, purl.

Row 11: using yarn A, knit.

Row 12: p3B, p1A, p3B, p9A.

Row 13: k9A, k1B, k5A, k1B.

Row 14: p1B, p5A, p1B, p9A.

Row 15: k9A, k1B, k2A, k1B, k2A, k1B.

Row 16: p7B, p9A.

Row 17: as row 15.

Row 18: as row 14.

Row 19: as row 13.

Row 20: as row 12.

Row 21: as row 11.

Row 22: as row 10.

PROJECT:
Retro Pillow

This is a simple Fair Isle pattern that uses a traditional Scottish yarn. I have used a bright green against a subtle, variegated grey-brown to give this pillow a modern touch, and the square buttons add to the Mid-century flavour of the design. The pillow itself would look great on a solid-colour armchair or sofa, using complementary or contrasting shades to suit your taste.

Yarn

- New Lanark Chunky Wool, or equivalent chunky (bulky) weight 100% pure wool yarn; 100g/132yd/120m; manufacturer's tension 14 sts x 18 rows using 6mm (UK 4; US 10) needles –
 - ~ 2 balls of Gritstone, or grey-brown yarn (A)
 - ~ 2 balls of Verdi, or lime green yarn (B)

Needles

- One pair of 6mm (UK 4; US 10) straight knitting needles
- Tapestry needle

Extras

- Four buttons
- Pillow pad, 44.5 x 44.5cm (17½ x 17½in)

Pattern tension

18 sts x 16 rows on 6mm (UK 4; US 10) needles

Completed size

To fit a 44.5 x 44.5cm (17½ x 17½in) pillow pad

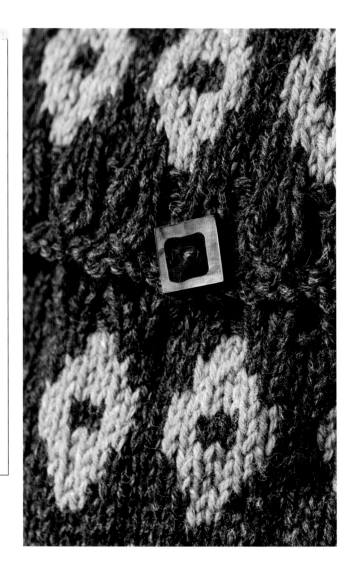

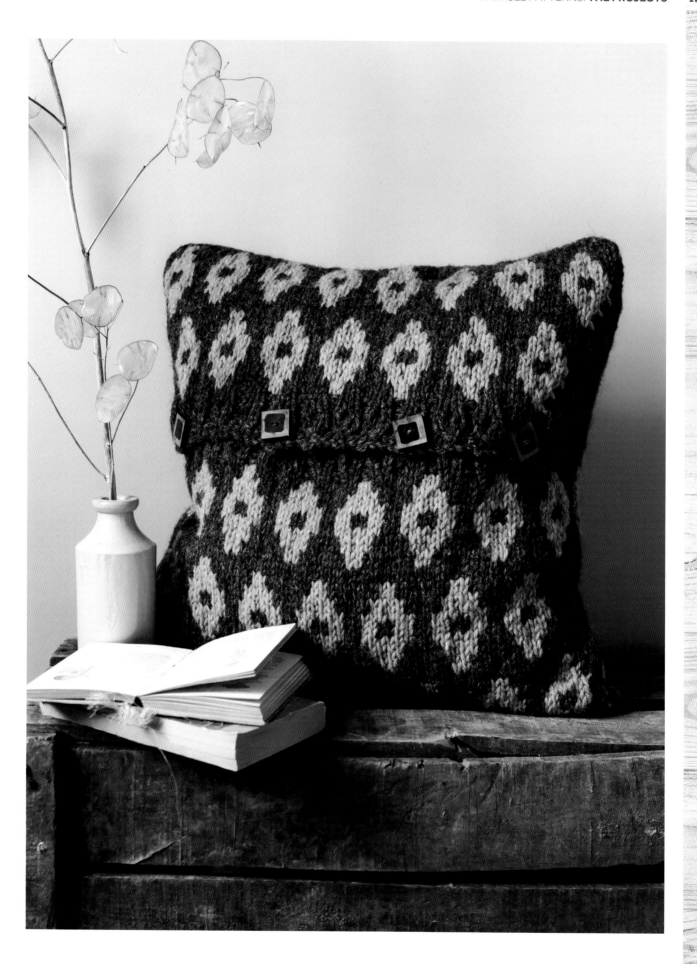

CHART

● *Yarn A (Gritstone, or grey-brown)*

● *Yarn B (Verdi, or lime green)*

○ *Repeat*

Row 1 (RS): k4A, k2B, * k6A, k2B, rep from * to last 4 sts, k4A.

Row 2 (WS): p4A, * p2B, p6A, rep from * to last 6 sts, p2B, p4A.

Row 3: k3A, k4B, * k4A, k4B, rep from * to last 3 sts, k3A.

Row 4: p3A, p4B, * p4A, p4B, rep from * to last 3 sts, p3A.

Row 5: * k2A, k6B, rep from * to last 2 sts, k2A.

Row 6: * p2A, p2B, rep from * to last 2 sts, p2A.

Row 7: * k2A, k2B, rep from * to last 2 sts, k2A.

Row 8: * p2A, p6B, rep from * to last 2 sts, p2A.

Rows 9 and 10: as rows 3 and 4.

Rows 11 and 12: as rows 1 and 2.

Row 13: using yarn A, knit.

Row 14: using yarn A, purl.

Row 15: k8A, * k2B, k6A, rep from * to last 2 sts, k2A.

Row 16: p8A, * p2B, p6A, rep from * to last 2 sts, p2A.

Row 17: k7A, * k4B, k4A, rep from * to last 3 sts, k3A.

Row 18: p7A, * p4B, p4A, rep from * to last 3 sts, p3A.

Row 19: k6A, * k6B, k2A, rep from * to last 4 sts, k4A.

Row 20: p6A, * p2B, p2A, rep from * to last 4 sts, p4A.

Row 21: k6A, * k2B, k2A, rep from * to last 4 sts, k4A.

Row 22: p6A, * p6B, p2A, rep from * to last 4 sts, p4A.

Rows 23 and 24: as rows 17 and 18.

Rows 25 and 26: as rows 15 and 16.

Rows 27 and 28: as rows 13 and 14.

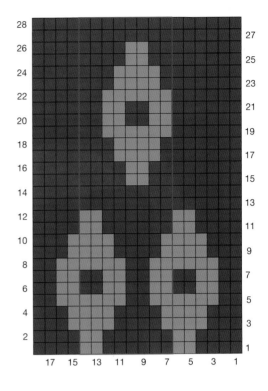

PATTERN

Front panel

Using yarn A, cast on 66 sts.

Foundation row: knit each stitch tbl to end.

Next row (WS): purl.

Row 1 (RS): work row 1 of Chart, working 8-st repeat seven times across the row.

Cont to work from Chart until row 28 is complete, noting that RS (odd numbered) rows are knitted and WS (even numbered) rows are purled.

Repeat rows 1–28 once more, and then repeat rows 1–12 once more.

Fasten off yarn B.

Next row: using yarn A, knit.

Cast off.

Lower Back panel

Work as Front until 40 rows have been worked.

Fasten off yarn B and cont in yarn A only.

Knit 1 row.

BUTTONHOLE BAND

Base Row (WS): k2, * p2, k2, rep from * to end.

Row 1 (RS): p2,* k2, p2, rep from * to end.

Row 2: k2, * p1A, YO, p1, k2, rep from * to end.

Row 3: p2, * k3, p2, rep from * to end.

Row 4: k2, * p3, k2, rep from* to end.

Row 5: p2, k3, then pass the first of these sts over the last 2 sts and drop it, p2, * k3, then pass the first of these sts over the last 2 sts and drop it, p2, rep from * to end.

Cast off.

Upper Back panel

Work as Front until 28 rows have been worked.

Now work as Buttonhole band, this time omitting the buttonholes by working a 2x2 rib for 6 rows.

Cast off.

To make up

Block pieces to measure 47cm (17¾in) square when pieced together (see pages 40–41).

Use mattress stitch (see page 39) to join the following pieces: sew lower Back panel to bottom edge of Front panel. Sew side seams. Sew upper Back panel to top edge of Front panel, overlapping lower Back panel. Sew side seams.

Space your buttons evenly across lower Buttonhole band to correspond with gaps for buttonholes, then sew into place (see page 43).

Weave in any remaining ends (see page 38).

PROJECT: Lerwick Waistcoat

This waistcoat uses a combination of patterns to create a new, all-over Fair Isle design. This is an example of how, by taking apart existing patterns in the swatch gallery and using the motifs within them, you can create entirely new patterns for your own knitwear! Here, I use a line from Dotty (page 108) and the shields from Shields & Crosses (page 109), in conjunction with a new and larger cross motif. The dotted lines are bordered on either side to break up the different motifs in the pattern, and give the overall design more interest. The buttonholes could be reversed for a women's version.

Yarn

- Wensleydale DK yarn, or equivalent DK (light worsted) weight 100% pure wool yarn; 100g/257yd/235m; manufacturer's tension 22 sts x 30 rows on 3.75mm (UK 9; US 5) needles –
 - ~ 2(3:3:3) balls of Storm, or dark-grey yarn (A)
 - ~ 1 ball of Mizzle, or light-grey yarn (B)
 - ~ 1(1:1:2) balls of Dusk, or slate-blue yarn (C)
 - ~ 1(1:1:2) balls of Fennel, or mint green yarn (D)
 - ~ 1 ball of Denim, or royal blue yarn (E)

Needles

- Two pairs of straight knitting needles –
 - ~ 4mm (UK 8; US 6)
 - ~ 3.25mm (UK 10; US 3)
- Tapestry needle

Extras

- Stitch holders

Pattern tension

25 sts x 28 rows on 4mm (UK 8; US 6) needles

Size chart

		SIZE 1	SIZE 2	SIZE 3	SIZE 4
TO FIT CHEST	CM	86	91	96	101
	IN	34	36	38	39¾
ACTUAL WIDTH	CM	91	96	100	105
	IN	36	38	39¼	41¼
LENGTH TO SHOULDER	CM	56	58	59	60
	IN	22	22¾	23¼	23½
SIDE SEAM	CM	30	32	33	34
	IN	11¾	12½	13	13½

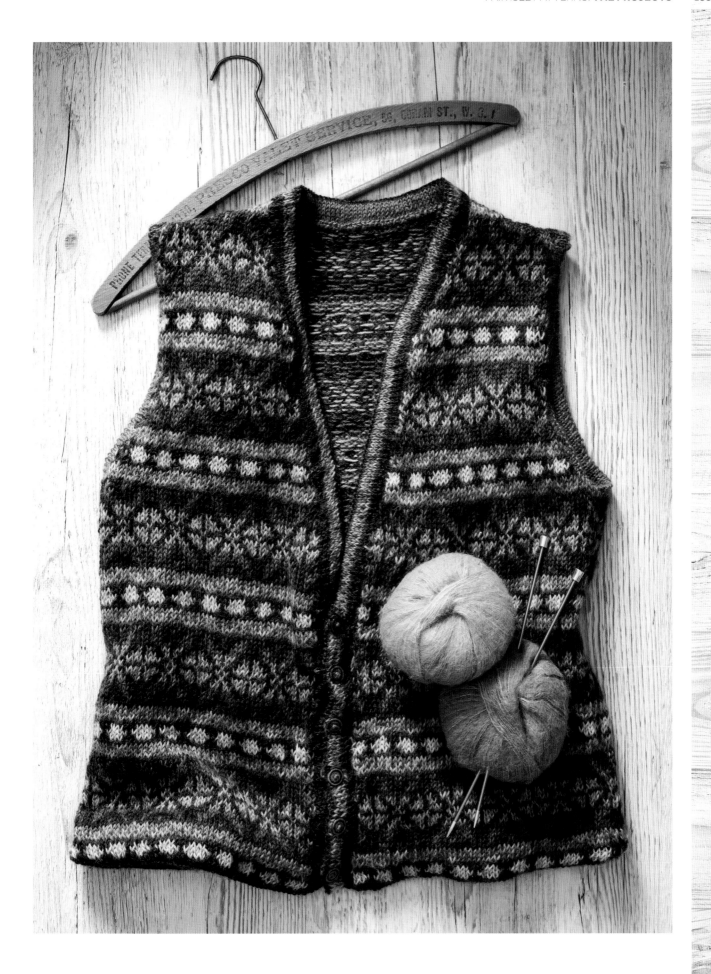

CHARTS

Note: for better readability, yarn colours slightly differ.

○ *Yarn A (Storm, or dark-grey)*
● *Yarn B (Mizzle, or light-grey)*
● *Yarn C (Dusk, or slate-blue)*
● *Yarn D (Fennel, or mint green)*
■ *Yarn E (Denim, or royal blue)*

○ *Size 1 ONLY*
○ *Size 2 ONLY*
○ *Size 3 ONLY*
○ *Size 4 ONLY*
○ *Repeat*

Chart A: Back

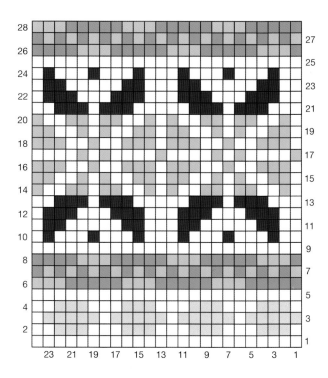

Chart C: Buttonhole band

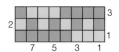

Chart B: Front

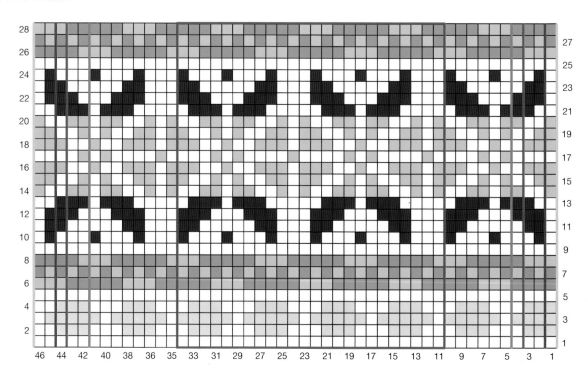

PATTERN

Back

Using 3.25mm (UK 10; US 3) needles and yarn A, cast on 124(130:136:142) sts.

Foundation row: knit each st tbl to end.

Next row (WS): purl.

Beginning with a RS knit row, work 9 rows in St st.

Next row (WS): knit. (**Note:** this creates a garter stitch row for the hemline fold.)

Change to 4mm (UK 8; US 6) needles.

Row 1 (RS): using yarn A, knit (this counts as row 1 of Chart A).

Following the correct instructions for your size, establish edge stitches and Chart A as follows:

SIZE 1 ONLY

Row 2 (WS): p1B, p1A, work row 2 of Chart A five times, p2A.

Row 3: k2A, work next row of Chart A five times, k1A, k1B.

SIZE 2 ONLY

Row 2 (WS): p1A, p3B, p1A, work row 2 of Chart A five times, p2A, p3B.

Row 3: k3B, k2A, work next row of Chart A five times, k1A, k3B, k1A.

SIZE 3 ONLY

Row 2 (WS): p1B, p3A, p3B, p1A, work row 2 of Chart A five times, p1B, p3A, p3B, p1A.

Row 3: k1A, k3B, k3A, k1B, work next row of Chart A five times, k1A, k3B, k3A, k1B.

SIZE 4 ONLY

Row 2 (WS): p1A, p3B, p3A, p3B, p1A, work row 2 of Chart A five times, p1A, p3B, p3A, p3B, p1A.

Row 3: k1A, k3B, k3A, k3B, k1A, work next row of Chart A five times, k1A, k3B, k3A, k3B, k1A.

ALL SIZES AGAIN

(**Note:** weave yarn ends in as you go (see page 38) to avoid this being a huge task when the garment is finished.)

Working Chart A and edge stitches as set by last 2 rows for your size, cont working from Chart A, repeating rows 1–28, until Back measures 31(32:33:34)cm / 12¼(12½:13:13½)in from hemline fold, ending with a WS row.

PM at each end of row to denote start of armhole shaping.

SHAPE ARMHOLES

Cast off 5(6:7:8) sts at beg of next 2 rows (114(118:122:126 sts).

Now dec 1 st at each end of next six rows, then on 8(9:10:11) foll alternating rows (86(88:90:92) sts).

Cont straight in patt until Back measures 56(58:59:60)cm / 22(22¾:23:23¾)in from hemline fold, ending with a WS row.

SHAPE SHOULDERS AND DIVIDE FOR NECK

Cast off 6 sts at beg of next 2 rows (74(76:78:80) sts).

Next row (RS): cast off 6 sts, patt until there are 21 sts on right-hand needle, cast off 20(22:24:26) sts, patt to end.

Next row (WS): cast off 6 sts, patt to neck edge and turn, leaving rem sts on stitch holder and cont on these 21 sts only for left shoulder.

Next row: cast off 4 sts, patt to end (17 sts).

Next row: cast off 6 sts, patt to end (11 sts).

Next row: cast off 4 sts, patt to end (7 sts).

Cast off.

With WS facing, rejoin yarn to held sts and complete to match left shoulder, reversing shaping.

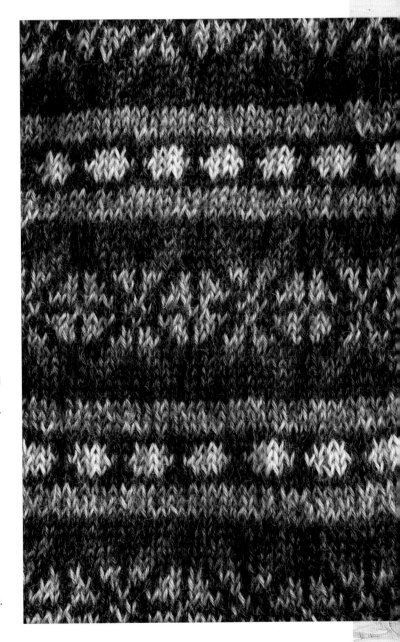

Left Front

Using yarn A and 3.25mm (UK 10: US 3) needles, cast on 62(65:68:71) sts.

Foundation row: knit each st tbl to end.

Next row (WS): purl.

Beginning with a RS knit row, work 9 rows in St st.

Next row (WS): knit. (**Note:** this creates a garter stitch row for the hemline fold.)

Change to 4mm (UK 8; US 6) needles.

Next row (RS): beginning and ending at the correct place for your size, and working 24-st repeat twice across the row, work row 1 of Chart B.

Cont to work from Chart B as set, repeating rows 1–28, until 7(11:13:15) fewer rows have been worked than the Back to armhole shaping, ending with a WS row.

SHAPE NECK AND ARMHOLES

Cont to maintain Chart B pattern as set and dec 1 st at the end (neck edge) of next row and every foll fourth row; at the same time, when Front measures 31(32:33:34)cm / 12¼(12½:13:13½)in from hemline fold row, and ending with a WS row, shape the armhole as foll:

Cast off 5(6:7:8) sts at the beginning (armhole edge) of next row.

Dec 1 st at armhole edge of next WS row, then dec 1 st at armhole edge of foll 8(9:10:11) RS rows.

After armhole shaping is complete, work straight at armhole edge and cont to dec at neck edge every fourth row as set until 35(34:34:35) sts rem, then dec 1 st at neck edge on every foll third row until 25 sts rem.

Cont straight until Front matches Back to shoulder, ending with a WS row.

SHAPE SHOULDER

Cast off 6 sts at beg of next and 2 foll alternating rows (7 sts).

Work 1 row.

Cast off.

Right Front

Work as for Left Front, reversing all shaping.

To make up

Block each piece to your required measurements (see pages 40–41).

Join shoulder seams using mattress stitch (see page 39). Fold Back and Front bottom edges to the WS, along hemline fold, and overcast stitch into place.

ARMBANDS (BOTH ALIKE)

With RS facing, using yarn A and 3.25mm (UK 10; US 3) needles, pick up and knit 108 sts around armhole.

Row 1 (WS): purl.

Rows 2–4: knit. (**Note:** row 3 creates a garter stitch row for the hemline fold.)

Rows 5–7: beginning with a WS row, work 3 rows in St st.

Cast off.

Join side seams using mattress stitch (see page 39). Fold the armhole edges to the WS, along hemline fold, and overcast stitch into place.

BUTTONHOLE BAND

With RS facing, using yarn A and 4mm (UK 8; US 6) needles and beginning at bottom of Right Front, pick up and knit 70 sts up Right Front edge to beg of neck shaping, 72(76:80:84)sts up Right Front neck, 37(39:41:43) sts along Back neck, 72(76:80:84) sts down Left Front neck and 70 sts down Left Front edge to end (321(331:341:351) sts).

Row 1 (WS): purl.

Row 2: using yarn C, K1(2:5:5), work row 1 of Chart C to last 0(1:0:2) sts; change to yarn D, K0(1:0:2).

(**Note:** when casting off and on for the buttonholes, use both yarns held together.)

Row 3: cont in St st, working edge sts and next row of Chart C as set, patt across 263(273:283:293) sts, (cast off 2 sts, patt across 8 sts including st remaining on needle after cast off) five times, cast off 2 sts, patt to end.

Row 4: * patt to cast-off gap, cast on 2 sts, rep from * six times, patt to end.

Fasten off yarns C and D.

Row 5: using yarn A, purl.

Rows 6 and 7: using yarn A, knit. (**Note:** row 7 creates a garter stitch row for the hemline fold.)

Fasten off yarn A and cont in yarn C only.

Row 8: k6, (cast off 2 sts, k8 including st remaining on needle after cast off) six times, knit to end.

Row 9: * purl to cast-off gap, cast on 2 sts, rep from * six times, purl to end.

Row 10: knit.

Row 11: purl.

Cast off.

Fold the buttonhole band to the WS, along hemline fold, and overcast stitch into place, making sure that the buttonholes match up on both sides. Neaten up the buttonholes by sewing around the edges to give them a perfect finish.

Sew on buttons to correspond with buttonholes (see page 43). Weave in any remaining ends (see page 38).

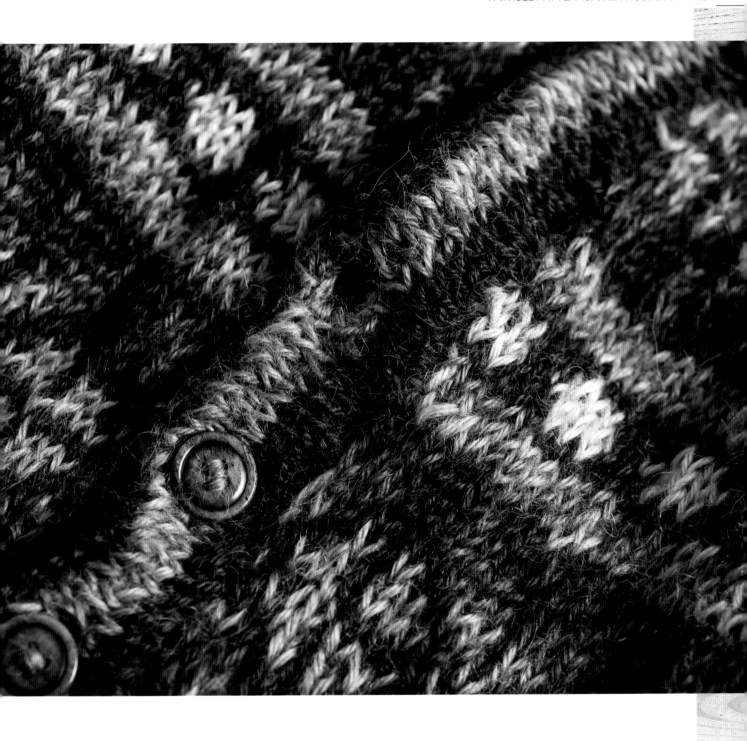

PROJECT: Dogtooth Bag

I wanted a simple project that would use this famous pattern, and decided that a bag would be the perfect item to knit with it. The bag is both functional and fun, and really simple to make. Lining your bag is optional, but does add a touch of class. If you are not comfortable with sewing, but would like to include lining, find a friend to help you as I did.

Yarn

- Jamieson's Shetland Marl Chunky, or equivalent chunky (bulky) weight 100% pure wool yarn; 100g/132yd/120m; manufacturer's tension 5 sts x 22 rows on 6mm (UK 4; US 10) needles –
 - ~ 2 balls of Charcoal 126, or grey-black yarn (A)
 - ~ 1 ball of Topaz 251, or pale orange-blue speckled yarn (B)

Needles

- Three pairs of straight knitting needles –
 - ~ 5.5mm (UK 5; US 9)
 - ~ 6mm (UK 4; US 10)
 - ~ 8mm (UK 0; US 11)
- Tapestry needle

Extras

- Two large buttons
- Two pieces of fabric for the lining, both measuring 30 x 30cm (11¾ x 11¾in) – this should be approx. the same size as the Front/Back bag pieces, plus a seam allowance of 1cm (½in)
- One strip of fabric for the gusset, measuring 89 x 6cm (35 x 2½in)
- Sewing needle with matching thread
- Optional: sewing machine with matching thread

Pattern tension

18 sts x 16 rows on 6mm (UK 4; US 10) needles

Completed size

Including handle, approx. 61 x 66cm (24 x 26in)

CHART

- ● Yarn A (Charcoal 126, or grey-black yarn)
- ○ Yarn B (Topaz 251, or pale orange-blue speckled)

Row 1 (RS): * k2A, k1B, k1A, rep from * to end.

Row 2 (WS): * p1A, p3, rep from * to end.

Row 3: * k1A, k3B, rep from * to end.

Row 4: * p2A, p1B, p1A, rep from * to end.

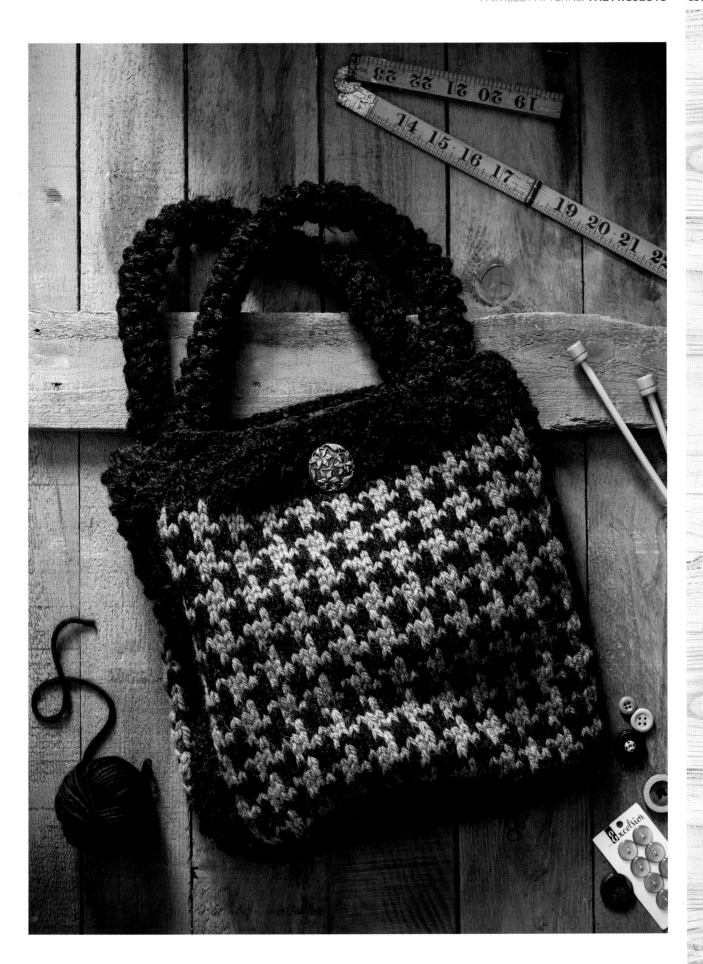

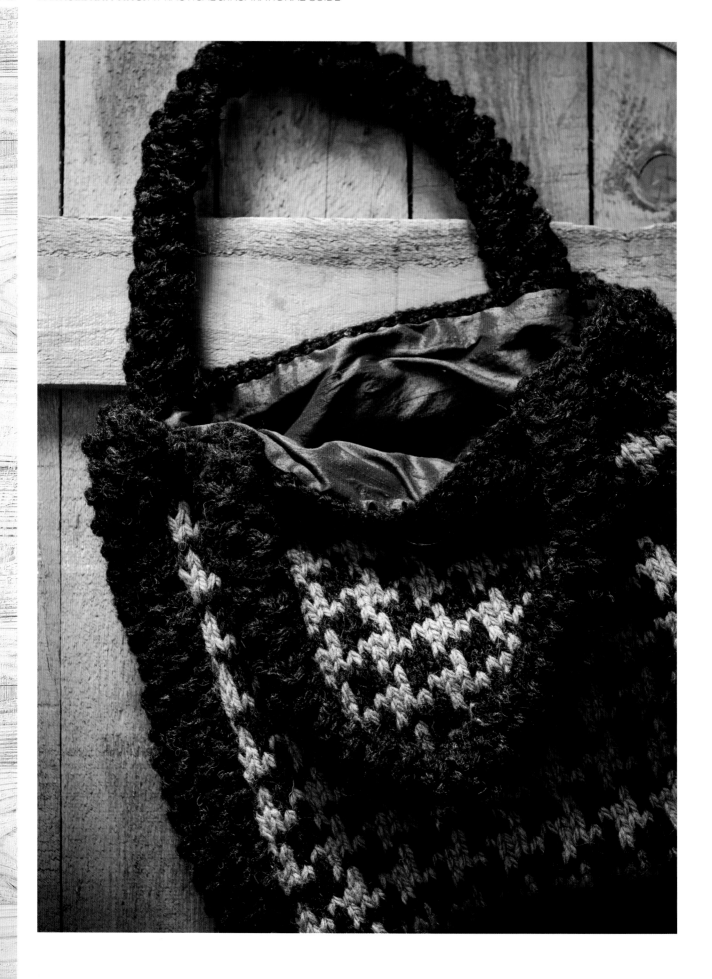

PATTERN

Bag Front

Using 5.5mm (UK 5; US 9) needles and yarn A, cast on 40 sts.

Rows 1 and 2: * k2, p2, rep from * to end.

Rows 3 and 4: * p2, k2, rep from * to end.

Rep rows 1–4 once more.

Row 9 (WS): p1, M1, p13, M1, p13, M1, p12, M1, p1 (44 sts).

Change to 6mm (UK 4; US 10) needles.

Beginning with row 1, joining yarn B when necessary and working the 4-st repeat eleven times across the row, work from Chart until rows 1–4 have been worked a total of nine times.

Work should measure approx. 27cm (10½ in) from cast-on edge).

Cast off sts.

Bag Back

Work as Bag Front.

Side and Bottom Band

(**Note:** yarn is held double throughout to add body to the bag.)

Using 8mm (UK 0; US 11) needles and with yarn A held double, cast on 5 sts.

Foundation row: knit each st tbl to end for a neat edge.

Row 1: k1, p1, k1, p1, k1.

Rep row 1 until the piece measures 82cm (32in) from cast-on edge or is sufficiently long enough to go down the side, bottom edge and opposite side of Bag Front.

Cast off sts.

Handles

MAKE TWO

(**Note:** yarn is held double throughout to make the handles thick and strong.)

Using 8mm (UK 0; US 11) needles and with yarn A held double, cast on 3 sts.

Foundation row (RS): knit each st tbl to end for a neat edge.

Next row (Inc): k1, M1, k1, M1, k1 (5 sts).

Row 2: k1, p1, k1, p1, k1.

Rep row 2 until piece measures 15in (38cm) from cast-on edge.

Next row (Dec): k2tog, k1, k2tog (3 sts).

Cast off sts.

To make up

HANDLES

Fold handle in half widthways and join the seam together using mattress stitch (see page 39). Start after Inc row and end at a Dec row.

BAG BODY

Block pieces (see pages 40–41). Starting at the top of the bag, attach one long edge of the Side and Bottom Band to the Bag Front using mattress stitch (see page 39). Ease it gently into place down one side, across the bottom and up the opposite side. Repeat to sew the Back piece to the opposite edge of the Side and Bottom Band. Weave in any remaining ends (see page 38).

TO LINE THE BAG (OPTIONAL)

Step 1: using a 1cm (½in) seam allowance, attach one long edge of the fabric strip (gusset piece) to one of the lining pieces, RS together, sewing down one long side, across the short bottom edge and up the opposite long side.

Step 2: repeat step 1 to attach the other lining piece to the opposite edge of the gusset piece.

Step 3: sew a button to either RS of the knitted Bag Front and Bag Back.

Step 4: fold over the top edge of the lining to WS of the fabric, pin (or press, depending on the fabric) and sew in place. This not only forms a nice neat hem, it stops the lining from fraying too.

Step 5: using a 5mm (¼in) seam allowance, sew the top of your lining to the inside of the bag.

– If you're **sewing by hand**, overcast stitch is a good one to use as it is secure and allows the knitting to stretch.

– If you're using a **sewing machine**, work steadily and use a long, wide stitch to accommodate the chunky (bulky) yarn. A walking foot will be useful too, to help the bag move under the needle more easily.

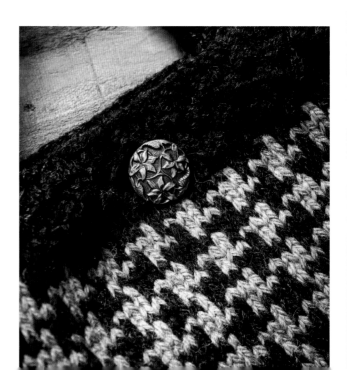

PROJECT:
Rose Shawl

This shawl pattern was inspired by the range of colours I saw in my garden. I took a photo of a flower and used it as inspiration for the main flower motif; I then chose yarn colours that reflected the ones I saw, to create a unique design. The shawl is knitted in a luxuriously soft yarn that feels wonderful next to the skin.

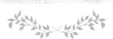

Yarn

- Fyberspates Cumulus 2-ply, or equivalent 2-ply (laceweight) alpaca/silk blend yarn; 25g/164yd/150m; manufacturer's tension 24 sts x 40 rows on 3.75mm (UK 9; US 5) needles –
 - ~ 6 balls of Slate 913, or grey-blue yarn (A)
 - ~ 1 ball of Sea Green 910, or mint yarn (B)
 - ~ 1 ball of Rust 902, or dark-orange yarn (C)
 - ~ 1 ball of Camel 912, or beige yarn (D)
 - ~ 1 ball of Teal 904, or teal yarn (E)
 - ~ 1 ball of Silver 911, or white-grey yarn (F)
 - ~ 1 ball of Magenta 907, or magenta yarn (G)

Needles

- One pair of 4mm (UK 8; US 6) straight knitting needles
- Tapestry needle

Pattern tension

25 sts x 28 rows on 4mm (UK 8; US 6) needles

Completed size

48 x 167cm (19 x 66in)

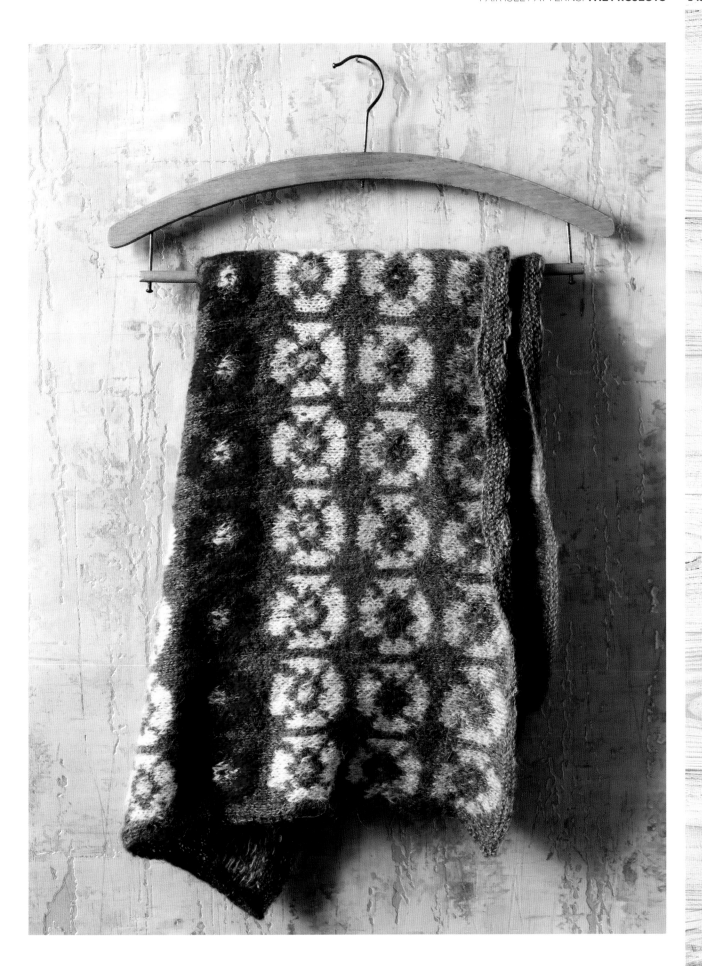

CHART

- 🔘 *RS: Knit with yarn A (Slate 913, or grey blue)*
 WS: Purl with yarn A (Slate 913, or grey blue)

- 💠 *RS: Purl with yarn A (Slate 913, or grey blue)*
 WS: Knit with yarn A (Slate 913, or grey blue)

- 🔘 *Yarn B (Sea Green 910, or mint)*

- ⬛ *Yarn C (Rust 902, or dark orange)*

- ⬜ *Repeat*

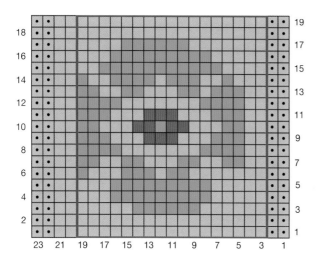

Row 1 (RS): using yarn A, knit.

Row 2 (WS): using yarn A, k2, purl to last 2 sts, k2.

Row 3: k2A, * k6A, k6B, k5A, rep from * to last 4 sts, k4A.

Row 4: k2A, p2A, * p3A, p9B, p5A, rep from * to last 2 sts, k2A.

Row 5: k2A, * k5A, k9B, k3A, rep from * to last 4 sts, k4A.

Row 6: k2A, p2A, * p1B, p3A, p3B, p1A, p2B, p7A, rep from * to last 2 sts, k2A.

Row 7: k2A, * k2A, k2B, k2A, k2B, k3A, k2B, k2A, k2B, rep from * to last 4 sts, k4A.

Row 8: k2A, p2A, * p4B, p7A, p4B, p2A, rep from * to last 2 sts, k2A.

Row 9: k2A, * k2A, k3B, k3A, k3C, k3A, k3B, rep from * to last 4 sts, k4A.

Row 10: k2A, p2A, * p2B, p3A, p2C, p1B, p2C, p3A, p2B, p2A, rep from * to last 2 sts, k2A.

Row 11: as row 9.

Row 12: as row 8.

Row 13: k2A, * k2A, k3B, k1A, k2B, k3A, k2B, k2A, k2B, rep from * to last 4 sts, k4A.

Row 14: k2A, p2A, * p1B, p2A, p4B, p1A, p3B, p2A, p1B, p3A, rep from * to last 2 sts, k2A.

Row 15: k2A, * k4A, k11B, k2A, rep from * to last 4 sts, k4A.

Row 16: as row 4.

Row 17: k2A, * k7A, k6B, k4A, rep from * to last 4 sts, k4A.

Row 18: using yarn A, k2, purl to last 2 sts, k2.

PATTERN

Using yarn A, cast on 414 sts.

Foundation row (RS): knit each stitch tbl to end for a neat edge.

Next four rows: knit.

Row 1 (RS): work row 1 of Chart to end, working 17-st pattern repeat twenty-four times across the row.

Cont to work from the chart until row 18 is complete.

Repeat rows 1–18 of Chart in the following colour combinations:

Rows 19–36: use yarn D instead of B, and E instead of C.

Rows 37–54: use yarn F instead of B, and B instead of C.

Rows 55–72: use yarn G instead of B, and F instead of C.

Rows 73–90: use yarn F instead of B, and B instead of C.

Rows 91–108: use yarn D instead of B, and E instead of C.

Rows 109–126: rep rows 1–18 using yarns B and C.

Rows 127–130: knit.

Cast off.

To make up

Block shawl (see pages 40–41).

Weave in ends (see page 38).

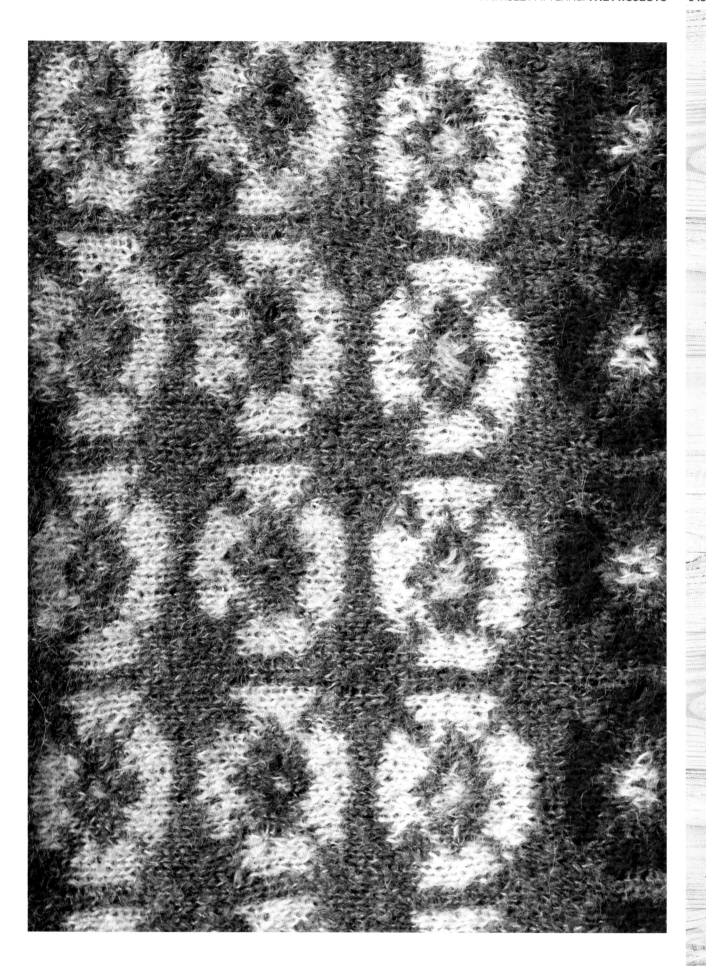

PROJECT:
Shetland Dress

Knitting Fair Isle gives one a real opportunity to work with a range of colours, as there is a freedom and flexibility with the designs. With this in mind, I decided to knit an adult dress using a mixture of bold and subtle colours. The dress can be worn on its own or over leggings or trousers, and I have added pockets to make it practical! The pattern repeat is simple as it is worked over 4 stitches and then repeated in different colours. The dress sits just above the knee but could be lengthened easily if desired: if you are longer in the waist, simply add the four-row, 48-stitch repeat before the shaping for the armhole; if you are longer in the leg, add the extra repeat after the ribbing.

Yarn

- Jamieson's Spindrift 2-ply (knits as 4-ply), or equivalent 4-ply (fingering) weight 100% pure wool yarn; 25g/115yd/105m; manufacturer's tension 30 sts x 32 rows on 3.25mm (UK 10; US 3) needles –
 - ~ 5(6:6:7:7) balls of Nighthawk 1020, or dark cyan yarn (A)
 - ~ 5(6:6:7:7) balls of Mantilla 517, or red-purple yarn (B)
 - ~ 2(2:2:3:3) balls of Pebble 127, or cream yarn (C)
 - ~ 3(3:4:4:4) balls of Wood Green 318, or variegated blue-green yarn (D)
 - ~ 2(3:3:4:4) balls of Scotch Broom 1160, or ochre yarn (E)
 - ~ 3(4:4:5:5) balls of Prairie 812, or variegated green yarn (F)
 - ~ 2 ball of Rust 578, or dark orange yarn (G)

Needles

- Two pairs of straight knitting needles –
 - ~ 2.75mm (UK 12; US 2)
 - ~ 3.25mm (UK 10; US 3)
- Tapestry needle

Extras

- Stitch holders

Pattern tension

28 sts x 30 rows on 3.25mm (UK 10; US 3) needles

Size chart

		SIZE 1	SIZE 2	SIZE 3	SIZE 4	SIZE 5
TO FIT BUST	CM	81–86	91–97	102–107	112–117	122–127
	IN	32–34	36–38¼	40½–42	44–46	48–50
LENGTH TO ARMHOLE	CM	63	65	66	67	68
	IN	25	25½	26	26½	26¾
ARMHOLE DEPTH	CM	17.5	18.5	19.5	20.5	21.5
	IN	6⅞	7¼	7¾	8	8½
SLEEVE LENGTH	CM	36	37	38	38	38
	IN	14¼	14½	15	15	15
LENGTH OF DRESS	CM	82	83.5	85.5	87.5	89.5
	IN	32¼	32⅞	33¾	34½	35¼

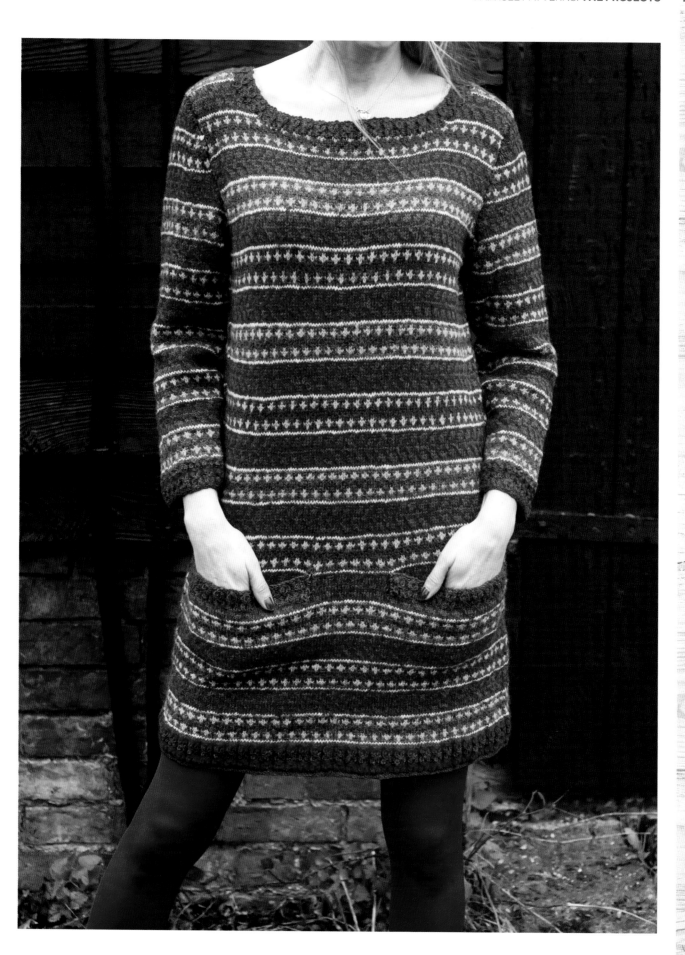

CHART

● *Yarn A (Nighthawk 1020, or dark cyan)*

● *Yarn B (Mantilla 517, or red-purple)*

○ *Yarn C (Pebble 127, or cream)*

● *Yarn D (Wood Green 318, or variegated blue-green)*

● *Yarn E (Scotch Broom 1160, or ochre)*

● *Yarn F (Prairie 812, or variegated green)*

● *Yarn G (Rust 578, or dark orange)*

Row 1 (RS): using yarn C, knit.

Row 2 (WS): using yarn D, purl.

Row 3: * k2D, k1E, k1D, rep from * to end.

Row 4: * p3E, p1D, rep from * to end.

Row 5: * k2D, k1E, k1D, rep from * to end.

Row 6: * p1D, p1A, p2D, rep from * to end.

Row 7: * k1D, k1A, rep from * to end.

Row 8: * p3D, p1A, rep from * to end.

Row 9: * k1E, k3D, rep from * to end.

Row 10: * p1E, p1D, p2E, rep from * to end.

Row 11: * k1E, k3D, rep from * to end.

Row 12: using yarn D, purl.

Row 13: as row 1.

Row 14: using yarn B, purl.

Row 15: * k1B, k2F, k1B, rep from * to end.

Row 16: * p3F, p1B, rep from * to end.

Row 17: * k2B, k2F, rep from * to end.

Row 18: * p3B, p1F, rep from * to end.

Row 19: using yarn F, knit.

Row 20: as row 18.

Row 21: as row 17.

Row 22: as row 16.

Row 23: as row 15.

Row 24: as row 14.

Row 25: as row 1.

Rows 26–36: rep rows 2–12, but use yarn A instead of D and yarn G instead of A.

Rows 37–48: rep rows 13–24.

PATTERN

Back

Using 2.75mm (UK 12; US 2) needles and yarn A cast on 154(170:190:206:226) sts.

Foundation row: knit each st tbl to end.

Next row (WS): purl.

Change to yarn B.

(**Note:** the stitch count will fluctuate as you work the rib pattern.)

Row 1 (RS): p2, * k2, p2, rep from * to end.

Row 2 (WS): k2, * p1, YO, p1, k2, rep from * to end.

Row 3: p2, * k3, p2, rep from * to end.

Row 4: k2, * p3, k2, rep from * to end.

Row 5: p2, * k3 then pass the first of these sts over the last 2 sts and drop it, p2, rep from * to end.

Rows 6–9: change to yarn A and repeat rows 2–5.

Rows 10–13: change to yarn B and repeat rows 2–5.

Row 14 (WS): k2B, * p2B, k2B, rep from * to end.

Change to 3.25mm (UK 10; US 3) needles.

SIZE 1 ONLY

Next row (RS): change to yarn C and knit to end (this counts as row 1 of the Chart) and at the same time inc 2 sts evenly across the row (156 sts).

SIZES 2–5 ONLY

Next row (RS): change to yarn C and knit to end (this counts as row 1 of the Chart) and at the same time dec 2 sts evenly across the row (–(168:188:204:224) sts).

ALL SIZES AGAIN

Beginning with row 2 and working the 4-st repeat 39(42:47:51:56) times across the row, work from Chart for a further 27 rows, ending with a WS row. **

Cont in pattern as set, dec 1 st at each end of next and foll eighth row, then dec 1 st at each end of 10(13:13:13:13) foll sixth rows (132(138:158:174:194) sts).

*** Work a further 23(23:25:25:27) rows without shaping, ending with a WS row.

Inc 1 st at each end of next and 2 foll eighteenth rows, taking these increases into your pattern (138 (144:164:180:200) sts).

Cont straight in pattern until Back measures 63(65:66:67:68)cm / 25(25¾:26:26½:26¾)in, or your desired length to armhole, ending with a WS row.

SHAPE ARMHOLES

Keeping pattern correct as set, cast off 5 (4:7:8:10) sts at beg of next 2 rows (128(136:150:164:180) sts).

Keeping pattern correct as set, dec 1 st at each end of next 5(7:9:11:13) rows, then on 3(3:4:5:6) foll alternating rows (112(116:124:132:142) sts).

Cont straight in pattern until armhole measures 17.5(18.5:19.5:20.5:21.5)cm / 6¾(7¼:7¾:8:8½)in), ending with a WS row.

SHAPE BACK NECK

Patt 25(28:31:35:39) sts and turn, leaving rem 87(88:93:97:103) sts on stitch holder.

Work each side of the neck separately.

Dec 1 st at neck edge of next 6 rows (19(22:25:29:33) sts).

Work 1 row.

(**Note:** for the following section, the yarn colour will depend on where you have finished on the chart.)

If the next row of the chart is:

Row 1, 13, 25 or 37: cont in yarn C only.

Rows 2–12: cont in yarn D only.

Rows 14–24 or 38–48: cont in yarn B only.

Rows 26–36: cont in yarn A only.

SHAPE SHOULDER

Cast off 6(7:8:9:10) sts at the beg of next row (13(15:17:20:23) sts).

Work 1 row.

Rep last 2 rows once more.

Cast off rem 7(8:9:11:13) sts.

With RS facing, leaving centre 62(60:62:62:64) sts for Back neck on stitch holder, rejoin yarn to rem 25(28:31:35:39) sts and work in patt to end.

Complete second side to match first, side, reversing shaping.

Pocket linings
MAKE TWO

Using 3.25mm (UK 10; US 3) needles and yarn A, cast on 36(36:36:36:40) sts.

Foundation row: knit each st tbl to end.

Beg with a WS purl row work in St st until piece measures 15cm (6in), ending with a WS row.

SIZES 1–4 ONLY

Next row (RS): k3(3:3:3:–), M1, (k6, M1) five times, k3(3:3:3:–) (42(42:42:42:–) sts).

SIZE 5 ONLY

Next row (RS): k2, M1, (k7, M1) five times, k3 (46 sts).

Cut yarn and leave sts on stitch holder.

Front

Work as for Back to **.

Keeping pattern correct as set, dec 1 st at each end of next and following eighth row, then dec 1 st at each end of 5 foll sixth rows, ending with a RS row (142(154:174:190:210) sts).

PLACE POCKETS

Patt across 15(17:19:21:23) sts and place next 42(42:42:42:46) sts on stitch holder. Slip one set of pocket lining sts onto the left needle and cont in patt across these 42(42:42:42:46) pocket lining sts.

Patt across next 28(36:52:64:72) sts, and place next 42(42:42:42:46) sts on stitch holder. Slip second set of pocket lining sts onto the left needle and cont in pattern across these 42(42:42:42:46) pocket lining sts. Patt across rem 15(17:19:21:23) sts.

Keeping pattern correct as set, dec 1 st at each end of 5(8:8:8:8) foll sixth rows (132(138:158:174:194)sts).

Now cont as for Back from *** until 22(22:24:24:24) fewer rows have been worked than on the Back to beg of shoulder shaping, ending with a WS row (112(116:124:132:142) sts).

SHAPE FRONT NECK

Next row (RS): patt across 30(33:37:41:46) sts and turn, leaving rem 82(83:87:91:96) sts on stitch holder.

Work each side of the neck separately.

Keeping patt correct as set, dec 1 st at neck edge of next 10 rows, then at neck edge of 1(1:2:2:3) foll alternating rows (19(22:25:29:33) sts).

Work straight in patt until Front measures the same as the Back to the beg of shoulder shaping, ending with a WS row.

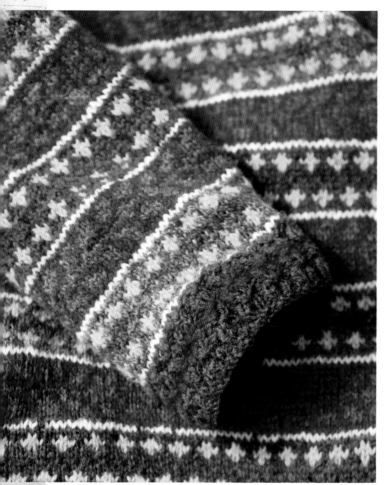

SHAPE SHOULDER

Cast off 6(7:8:9:10) sts at the beg of next row (13(15:17:20:23) sts).

Work 1 row.

Rep last 2 rows once more.

Cast off rem 7(8:9:11:13) sts.

With RS facing, leaving centre 52(50:50:50:50) sts on stitch holder for Front neck, rejoin yarn to rem 30(33:37:41:46) sts and pattern to end.

Complete second side to match first side, reversing shaping.

Sleeves

Using 2.75mm (UK 12; US 2) needles and yarn A, cast on 70(74:74:74:78) sts.

Foundation row: knit each st tbl to end.

Next row (WS): purl.

Change to yarn B.

(**Note:** the stitch count will fluctuate as you work the rib pattern.)

Row 1 (RS): p2, * k2, p2, rep from * to end.

Row 2 (WS): k2, * p1, YO, p1, k2, rep from * to end.

Row 3: p2, * k3, p2, rep from * to end.

Row 4: k2, * p3, k2, rep from * to end.

Row 5: p2, * k3, then pass the first of these sts over the last 2 sts and drop it, p2, rep from * to end.

Rows 6–9: change to yarn A and repeat rows 2–5.

Rows 10–13: change to yarn B and repeat rows 2–5.

Row 14: k2B, * p2B, k2B, rep from * to end.

Next row (RS): change to yarn C and knit to end (this counts as row 1 of the Chart) and at the same time inc 2 sts evenly across the row (72(76:76:76:80) sts).

Beginning with row 2 and working the 4-st repeat 18(19:19:19:20) times across the row, work from Chart and at the same time inc 1 st at each end of foll fourth row and then every foll sixth(sixth:fourth:fourth:fourth) row to 92(102:110:102:110) sts and then every foll eighth(eighth:zero:sixth:sixth) row to 100(106:110:118:124) sts, taking inc sts into pattern.

Work straight in pattern until work measures 36(37:38:38:38)cm / 14¼(14½:15:15:15)in, ending with RS facing for next row.

SHAPE TOP

Keeping patt correct as set, cast off 3(5:7:9:11) sts at beg of next 2 rows (94(96:96:100:102) sts).

Dec 1 st at each end of next eleven rows, then on every foll alternating row until there are 54 sts remaining.

Now dec 1 st at each end of next 7 rows, ending with a WS row (40 sts).

Work 2 rows without shaping.

Cast off 4 sts at beg of next 4 rows (24 sts).

Cast off rem sts.

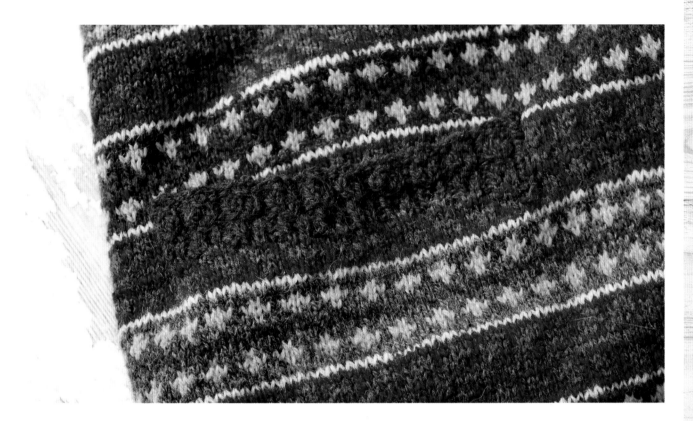

To make up

Block each piece to required size (see pages 40–41).

Join right shoulder seam using mattress stitch (see page 39).

NECKBAND

With RS facing, using 2.75mm (UK 12; US 2) needles and yarn A, beginning at the top left of Front neck, pick up and k17(19:22:22:23) sts down left side of Front neck, knit across 52(50:50:50:50) held Front sts, pick up and k17(19:22:22:23) sts up right side of Front neck, and 11 sts down right side of Back neck, knit across 62(60:62:62:64) held Back sts, then pick up and knit 11 sts up left side of Back neck (170(170: 178:178:182) sts).

(**Note:** the stitch count will fluctuate as you work the rib pattern.)

Row 1 (WS): k2, * p1, YO, p1, k2, rep from * to end.

Row 2: p2, * K3, p2, rep from * to end.

Row 3: k2, * p3, k2, rep from * to end.

Row 4: p2, * k3, then pass the first of these sts over the last 2 sts and drop it, p2, rep from * to end.

Row 5: k2, * p3, k2, rep from * to end.

Cast off sts.

POCKET TOPS (BOTH ALIKE)

With RS facing, place held 42(42:42:42:46) sts onto 2.75mm (UK 12; US 2) needles and rejoin yarn A.

(**Note:** the stitch count will fluctuate as you work the rib pattern.)

Row 1 (RS): p2, * k2, p2, rep from * to end.

Row 2 (WS): k2, * p1, YO, p1, k2, rep from * to end.

Row 3: p2, * k3, p2, rep from * to end.

Row 4: k2, * p3, k2, rep from * to end.

Row 5: p2, * k3, then pass the first of these sts over the last 2 sts and drop it, p2, rep from * to end.

Rows 6–9: rep rows 2–5.

Cast off.

MAKING UP

Use overcast stitch to sew pocket linings in place on the WS of work, and to sew down ends of pocket tops.

Use mattress stitch (see page 39) to join the following pieces: join left shoulder. Set in sleeves by matching the centre of the sleeve head to the shoulder seam, easing the sleeve to fit the armhole. Join underarm, sleeve seams and the sides of the dress together, using the pattern to help you place pieces accurately.

Weave in any remaining ends (see page 38).

FAIR ISLE
ANIMAL
MOTIFS

Who says Fair Isle has to be in a classic style? These animal motifs, made using the Fair Isle technique, can be placed on many of your own projects as well as the ones included in this book. Everyone has a favourite animal, and I hope that I have included one of yours! Why not experiment with one of them by working it as a border on a plain hat? In whichever design you choose, just be careful to the use correct spacing of stitches.

All of the swatches are made using Jamieson's of Shetland Spindrift yarn and 3.25mm (UK 10; US 3) needles.

Note: *for the projects, written instructions for the charts have been included where possible. However, where written instructions may have proven too cumbersome, only charts are featured for ease in pattern reading.*

ELEPHANT

This small, simple Fair Isle pattern is knitted in two contrasting colours and would be fun for a baby or child's item of clothing. The pattern is repeated over 10 stitches.

CHART

● Yarn A (Wren)
○ Yarn B (Eesit/White)

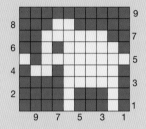

Row 1: k1A, k1B, k3A, k1B, k4A.

Row 2: p4B, p1B, p3A, p1B, p1A.

Row 3: k1A, k5B, k4A.

Row 4: p1A, p2B, p1A, p5B, p1A.

Row 5: k8B, k1A, k1B.

Row 6: p2A, p1B, p1A, p5B, p1A.

Row 7: k2A, k6B, k2A.

Row 8: p3A, p2B, p5A.

Row 9: using yarn A, knit.

COLOUR VARIATIONS

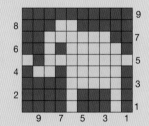
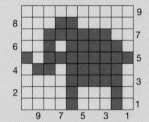

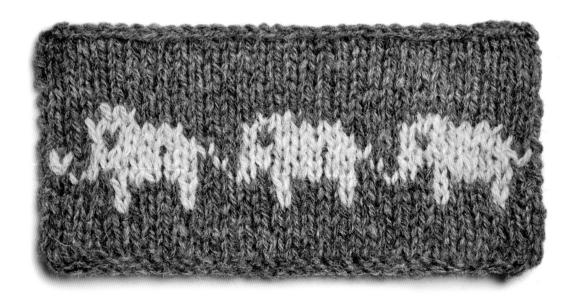

SQUIRREL

Squirrels are great motifs for knitting projects, whether they are for an adult's hat or a child's sweater. Change the colours to suit your taste – perhaps create a tribute to the red squirrels you can still see in Scotland and some northern parts of the British Isles. This pattern is repeated over 28 stitches.

CHART

- ● Yarn A (Lomond)
- ○ Yarn B (Pebble)
- ● Yarn C (Charcoal)

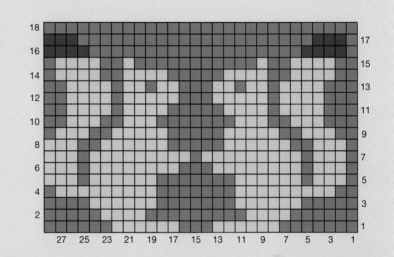

Row 1: k7A, k6B, k3A, k6B, k6A.

Row 2: p5A, p4B, p9A, p4B, p6A.

Row 3: k5A, k6B, k7A, k6B, k4A.

Row 4: p1A, p9B, p7A, p9B, p2A.

Row 5: k1A, k3B, k1A, k6B, k7A, k6B, k1A, k3B.

Row 6: p3B, p1A, p8B, p3A, p8B, p1A, p3B, p1A.

Row 7: k1A, k3B, k1A, k9B, k1A, k9B, k1A, k3B.

Row 8: p3B, p2A, p6B, p5A, p6B, p2A, p3B, p1A.

Row 9: k2A, k3B, k2A, k5B, k5A, k5B, k2A, k3B, k1A.

Row 10: p2A, p3B, p2A, p3B, p7A, p3B, p2A, p3B, p3A.

Row 11: k3A, k4B, k1A, k4B, k5A, k4B, k1A, k4B, k2A.

Row 12: p2A, p4B, p1A, p5B, p3A, p5B, p1A, p4B, p3A.

Row 13: k3A, k4B, k1A, k2B, k1A, k2B, k3A, k2B, k1A, k2B, k1A, k4B, k2A.

Row 14: p1A, p4B, p2A, p4B, p5A, p4B, p2A, p4B, p2A.

Row 15: k2A, k4B, k2A, k1B, k11A, k1B, k2A, k4B, k1A.

Row 16: p4C, p19A, p4C, p1A.

Row 17: k1A, k3C, k21A, k3C.

Row 18: using yarn A, knit.

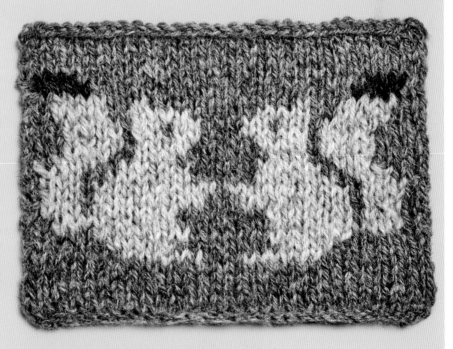

ALPACA

Alpacas produce amazingly soft fibres for wool. This border motif would be great for a sweater, tea cosy or hat. I have added snowflakes to make the alpacas here more festive, but these could be omitted if a plainer pattern is preferred. The pattern is knitted over 16 stitches.

CHART

- Yarn A (Lagoon)
- Yarn B (Mooskit)
- Yarn C (Natural White)

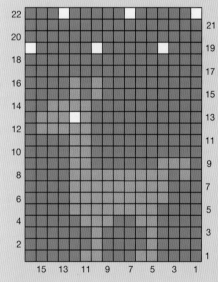

Row 1: k4A, k2B, k3A, k2B, k5A.

Row 2: p6A, p1B, p4A, p1B, p4A.

Row 3: k4A, k1B, k4A, k1B, k6A.

Row 4: p5A, p3B, p2A, p2B, p4A.

Row 5: k4A, k8B, k4A.

Row 6: p4A, p9B, p3A.

Row 7: k3A, k9B, k4A.

Row 8: p4A, p9B, p1A, p1B, p1A.

Row 9: k1A, k3B, k6A, k2B, k4A.

Row 10: p4A, p2B, p10A.

Row 11: k10A, k2B, k4A.

Row 12: p1A, p5B, p10A.

Row 13: k10A, k1B, k1C, k3B, k1A.

Row 14: p2A, p4B, p10A.

Row 15: k9A, k1B, k1A, k1B, k4A.

Row 16: p4A, p1B, p1A, p1B, p9A.

Row 17: using yarn A, knit.

Row 18: using yarn A, purl.

Snowflakes (optional)

Row 19: k3A, k1C, * k5A, k1C, k5A, k1C, rep from * to end.

Row 20: using yarn A, purl.

Row 21: using yarn A, knit.

Row 22: p3A, p1C, * p5A, p1C, p5A, p1C, rep from * to end.

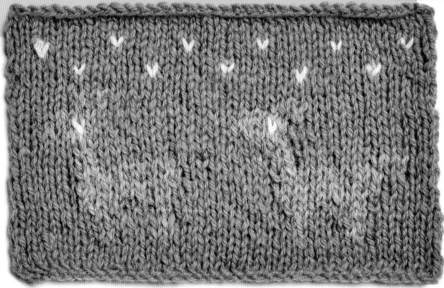

RABBIT

As a single motif on a pocket or scarf, or as a border on a sweater or cardigan, rabbits make a lovely spring-themed addition to a knitted item. The pattern is knitted over 15 stitches.

CHART

○ *Yarn A (Lavender)*
○ *Yarn B (Eesit/White)*

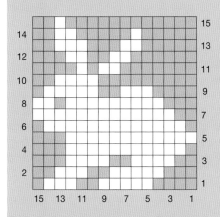

Row 1: k4A, k5B, k2A, k3B, k1A.
Row 2: p2A, p3B, p2A, p5A, p3A.
Row 3: k2A, k4B, k2A, k4B, k3A.
Row 4: p3A, p11B, p1A.
Row 5: k12B, k3A.
Row 6: p1A, p13B, p1A.
Row 7: k2A, k13B.
Row 8: p2B, p1A, p9B, p3A.

Row 9: k4A, k3B, k2A, k5B, k1A.
Row 10: p2A, p4B, p9A.
Row 11: k7A, k2B, k1A, k1B, k4A.
Row 12: p3A, p2B, p2A, p2B, p6A.
Row 13: k5A, k2B, k3A, k3B, k2A.
Row 14: p2A, p2B, p5A, p1B, p5A.
Row 15: k12A, k1B, k2A.

COLOUR VARIATION

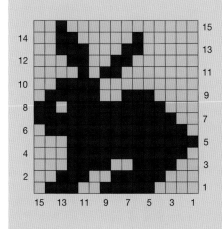

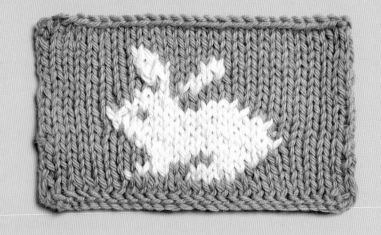

SCOTTISH TERRIER

Dogs are said to be man's best friend, so knit some onto your garment or accessory as a thank you! It is easy to incorporate a dog motif into many knitted items: use the pattern as a border on hats, tea cosies and sweaters; or, for fun, use as an overall pattern on a pillow cover or blanket. The pattern is knitted over 19 stitches.

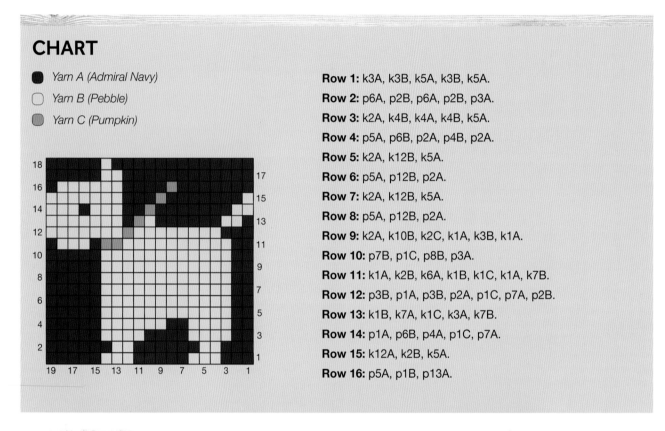

CHART

⚫ Yarn A (Admiral Navy)
⚪ Yarn B (Pebble)
🔘 Yarn C (Pumpkin)

Row 1: k3A, k3B, k5A, k3B, k5A.
Row 2: p6A, p2B, p6A, p2B, p3A.
Row 3: k2A, k4B, k4A, k4B, k5A.
Row 4: p5A, p6B, p2A, p4B, p2A.
Row 5: k2A, k12B, k5A.
Row 6: p5A, p12B, p2A.
Row 7: k2A, k12B, k5A.
Row 8: p5A, p12B, p2A.
Row 9: k2A, k10B, k2C, k1A, k3B, k1A.
Row 10: p7B, p1C, p8B, p3A.
Row 11: k1A, k2B, k6A, k1B, k1C, k1A, k7B.
Row 12: p3B, p1A, p3B, p2A, p1C, p7A, p2B.
Row 13: k1B, k7A, k1C, k3A, k7B.
Row 14: p1A, p6B, p4A, p1C, p7A.
Row 15: k12A, k2B, k5A.
Row 16: p5A, p1B, p13A.

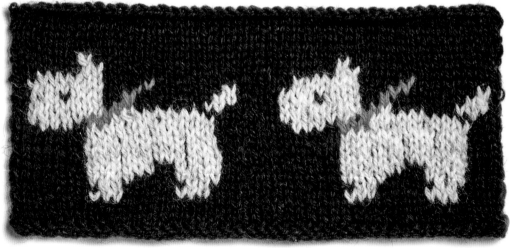

CAT

Cats are always popular so I felt that this motif was a must for the collection. This motif could be used as a border for any of your knitting projects whether they be large or small. The pattern is knitted over 19 stitches.

CHART

○ Yarn A (Eesit/White)
● Yarn B (Charcoal)

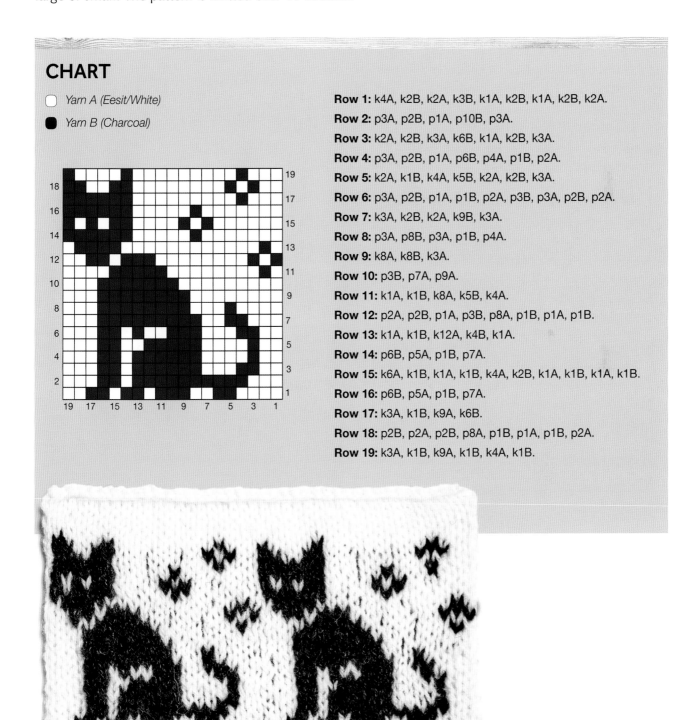

Row 1: k4A, k2B, k2A, k3B, k1A, k2B, k1A, k2B, k2A.

Row 2: p3A, p2B, p1A, p10B, p3A.

Row 3: k2A, k2B, k3A, k6B, k1A, k2B, k3A.

Row 4: p3A, p2B, p1A, p6B, p4A, p1B, p2A.

Row 5: k2A, k1B, k4A, k5B, k2A, k2B, k3A.

Row 6: p3A, p2B, p1A, p1B, p2A, p3B, p3A, p2B, p2A.

Row 7: k3A, k2B, k2A, k9B, k3A.

Row 8: p3A, p8B, p3A, p1B, p4A.

Row 9: k8A, k8B, k3A.

Row 10: p3B, p7A, p9A.

Row 11: k1A, k1B, k8A, k5B, k4A.

Row 12: p2A, p2B, p1A, p3B, p8A, p1B, p1A, p1B.

Row 13: k1A, k1B, k12A, k4B, k1A.

Row 14: p6B, p5A, p1B, p7A.

Row 15: k6A, k1B, k1A, k1B, k4A, k2B, k1A, k1B, k1A, k1B.

Row 16: p6B, p5A, p1B, p7A.

Row 17: k3A, k1B, k9A, k6B.

Row 18: p2B, p2A, p2B, p8A, p1B, p1A, p1B, p2A.

Row 19: k3A, k1B, k9A, k1B, k4A, k1B.

PROJECT:
Duck Nursery Blanket

This is a lovely soft baby blanket, knitted in subtle pastel colours with a duck motif. The beak and feet are embroidered once the blanket has been knitted. The beauty of this pattern is that it has been knitted on circular needles; these are used in the same way as straight ones, which makes it much easier to knit such a large project as it doesn't strain your wrists. I have made this with superwash yarn, making it a perfect blanket for your little one.

Yarn

- Rooster Almerino Aran, or equivalent aran (worsted) weight alpaca/merino blend yarn; 50g/103yd/94m; manufacturer's tension 19 sts x 23 rows on 4.5mm (UK 7; US 7) needles –
 - ~ 7 balls in Silver 320, or light grey-blue yarn (A)
 - ~ 2 balls in Sandcastle 322, or pale yellow yarn (B)
 - ~ 1 ball in Cornish 301, or cream (C)
 - ~ 1 ball in Coral 318, or pink-orange yarn (D)

Needles

- Two pairs of circular knitting needles –
 - ~ 4.5mm (UK 7; US 7), 80–100cm (32–40in) long
 - ~ 5mm (UK 6; US 8), 80–100cm (32–40in) long
- Tapestry needle

Pattern tension

20 sts x 24 rows on 4.5mm (UK 7; US 10) needles

Completed size

82 x 85cm (32¼ x 33½in)

Pattern notes

During the colourwork motif, strand the yarn not in use loosely across the WS of the work. Avoid long strands by twisting unused yarn colours with those in use every few stitches as you work (see page 29).

CHARTS

⬤ *Yarn A (Silver 320, or light grey-blue)*

◯ *Yarn B (Sandcastle 322, or pale yellow)*

◯ *Yarn C (Cornish 301, or cream)*

Chart A

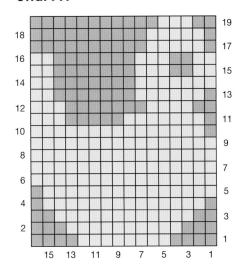

Row 1 (RS): k4A, k7B, k5A.

Row 2 (WS): p4A, p9B, p3A.

Row 3: k2A, k12B, k2A.

Row 4: p1A, p14B, p1A.

Row 5: k15B, k1A.

Row 6: using yarn B, purl.

Row 7: using yarn B, knit.

Rows 8 and 9: rep rows 6 and 7.

Row 10: p15B, p1A.

Row 11: k1A, k7B, k5A, k3B.

Row 12: p3B, p7A, p4B, p2A.

Row 13: k1A, k6B, k7A, k2B.

Row 14: p2B, p7A, p7B.

Row 15: k2B, k2A, k3B, k7A, k2B.

Row 16: p2B, p7A, p3B, p2A, p2B.

Row 17: k1A, k5B, k10A.

Row 18: p10A, p5B, p1A.

Row 19: k2A, k3B, k11A.

Chart B

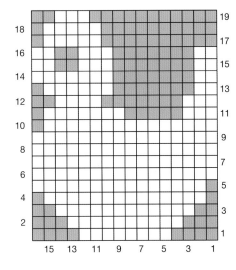

Row 1 (RS): k5A, k7B, k4A.

Row 2 (WS): P3A, p9B, p4A.

Row 3: k2A, k12B, k2A.

Row 4: p1A, p14B, p1A.

Row 5: k1A, k15B.

Row 6: using yarn C, purl.

Row 7: using yarn C, knit.

Rows 8 and 9: rep rows 6 and 7.

Row 10: p1A, p15C.

Row 11: k3C, k5A, k7C, k1A.

Row 12: p2A, p4C, p7A, p3C.

Row 13: k2C, k7A, k6C, k1A.

Row 14: p7C, p7A, p2C.

Row 15: k2C, k7A, k3C, k2A, k2C.

Row 16: p2C, p2A, p3C, p7A, p2C.

Row 17: k10A, k5C, k1A.

Row 18: p1A, p5C, p10A.

Row 19: k11A, k3C, k2A.

PATTERN

Using 4.5mm (UK 7; US 7) needles and yarn A, cast on 168 sts.

Rows 1–10: knit.

Row 11 (RS): knit.

Row 12 (WS): k7, purl to last 7 sts, k7.

Rep rows 11 and 12 twice more.

Change to 5mm (UK 6; US 8) needles.

(**Note:** on every following WS row, the first 7 and the last 7 sts are knitted to form a garter stitch border.)

Row 17 (RS): k11A, work row 1 of Chart A once, * k10A, work row 1 of Chart A once, rep from * to last 11 sts, k11A.

Row 18 (WS): k7A, p4A, work next row of Chart A once, * p10A, work next row of Chart A once, rep from * to last 11 sts, p4A, k7A.

Rows 19–35: cont to work as set until Chart A has been completed. Fasten off yarn B.

Rows 36–46: using yarn A, beginning with a WS and maintaining garter stitch border as set, work in St st for 11 rows.

Rows 47–65: join yarn C and repeat rows 17–35, working from Chart B instead of Chart A. Fasten off yarn C.

Rows 66–76: rep rows 36–46.

Repeat rows 17–76 once more, then rows 17–65 only once.

Cont in yarn A only.

Next row: k7, purl to last 7 sts, k7.

Next row: knit.

Rep last 2 rows once more.

Next row: k7, purl to last 7 sts, k7.

Change to 4.5mm (UK 7; US 7) needles.

Knit 10 rows.

Cast off.

To make up

Block the blanket (see pages 40–41) then weave in all loose ends (see page 38).

Embroider on beak and feet using yarn D. Begin by cutting a long length of yarn D, approx. three times the width of the blanket.

For the beak, take your tapestry need threaded with yarn D up through the back of the blanket and then work a diagonal stitch over the knit stitch adjacent to the duck's head. Take the needle up again at the same point and work another diagonal stitch upwards to finish the sideways 'V'.

Place feet at either end of the duck's base using the same method as the beak, this time with an upside-down 'V'.

Work the rest of the beaks and feet with the same length of yarn, by weaving the yarn around the stranding at the back of the blanket to help you 'travel' to the next duck.

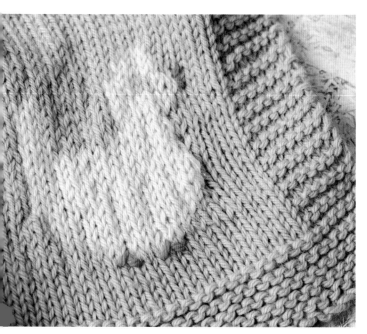

PROJECT:
Sheep Pillow

Where would Fair Isle knitting be without sheep! The Shetland Isles sheep are renowned for their wool, and generations of farmers here have lived out in their crofts to tend them. So, it seemed only right to pay my respects with this fun pillow cover. I have added a moss stitch border to add a little textural interest, which makes this cover really special.

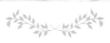

Yarn

- Rooster Almerino Aran, or equivalent aran (worsted) weight alpaca/merino blend yarn; 50g/103yd/94m; manufacturer's tension 19 sts x 23 rows on 4.5mm (UK 7; US 7) needles –
 - ~ 3 balls in Gooseberry 306, or moss green yarn (A)
 - ~ 1 ball in Caviar 325, or black-blue yarn (B)
 (**Note:** only short lengths of this shade are needed. You may find it helpful to cut 2.5m (2¼yd) lengths for rows 1–8 of Chart and 1.5m (1½yd) lengths for rows 11–16 of Chart, as this will make the twisting of yarns easier.)
 - ~ 1 ball in Cornish 301, or cream (C)

Needles

- One pair of 5mm (UK 6; US 8) straight knitting needles
- Tapestry needle

Extras

- Four buttons
- Pillow pad, 30 x 30cm (12 x 12in)

Pattern tension

20 sts x 24 rows on 4.5mm (UK 7; US 10) needles

Completed size

To fit a 30.5 x 30.5cm (12 x 12in) pillow pad; actual measurements 32 x 32cm (12½ x 12½in)

Pattern notes

During the colourwork motif, strand the yarn not in use loosely across the WS of the work. Avoid long strands by twisting unused yarn colours with those in use every few stitches as you work (see page 29).

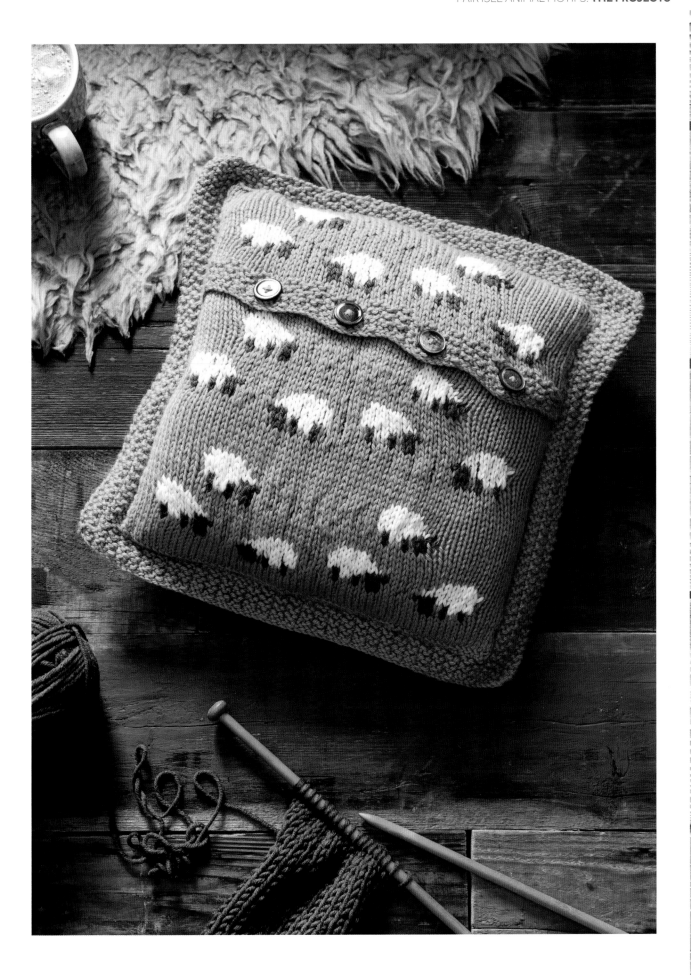

CHART

● Yarn A (Gooseberry 306, or moss green)

● Yarn B (Caviar 325, or black-blue)

○ Yarn C (Cornish 301, or cream)

○ Repeat

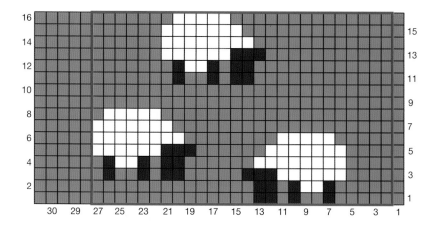

Row 1 (RS): k1A, * k5A, k1B, k2A, k1B, k1A, k2B, k14A, rep from * to last 5 sts, k5A.

Row 2 (WS): p5A, * p14A, p2B, p1A, p1B, p2C, p1B, p5A, rep from * to last st, p1A.

Row 3: k1A, * k4A, k6C, k3B, k5A, k2B, k1A, k1B, k2A, k1B, k1A, rep from * to last 5 sts, k5A.

Row 4: p5A, * p1A, p1B, p2C, p1B, p1A, p2B, p6A, p8C, p4A, rep from * to last st, p1A.

Row 5: k1A, * k4A, k7C, k6A, k3B, k6C, rep from * to last 5 sts, k5A.

Row 6: p5A, * p8C, p8A, p5C, p5A, rep from * to last st, p1A.

Row 7: k1A, * k19A, k7C, rep from * to last 5 sts, k5A.

Row 8: p5A, * p1A, p5C, p20A, rep from * to last st, p1A.

Row 9: using yarn A, knit.

Row 10: using yarn A, purl.

Row 11: k1A, * k12A, k2B, k1A, k1B, k2A, k1B, k7A, rep from * to last 5 sts, k5A.

Row 12: p5A, * p7A, p1B, p2C, p1B, p1A, p2B, p12A, rep from * to last st, p1A.

Row 13: k1A, * k11A, k3B, k6C, k6A, rep from * to last 5 sts, k5A.

Row 14: p5A, * p6A, p8C, p12A, rep from * to last st, p1A.

Row 15: k1A, * k13A, k7C, k6A, rep from * to last 5 sts, k5A.

Row 16: p5A, * p7A, p5C, p14A, rep from * to last st, p1A.

PATTERN

Front panel

Using yarn A, cast on 70 sts.

Rows 1–7: * k2, p2, rep from * to last 2 sts, k2.

Row 8 (WS): k2, p2, k2, purl to last 6 sts, k2, p2, k2.

Row 9 (RS): k2, p2, k2, knit to last 6 sts, k2, p2, k2.

Rows 10–12: rep rows 8 and 9 once, then row 8 only once.

** Begin colourwork pattern while maintaining the moss stitch edging as follows:

Row 1 (RS): k2A, p2A, k2A, work row 1 of Chart to last 6 sts, working 26-st repeated section twice across the row, k2A, p2A, k2A.

Row 2 (WS): k2A, p2A, k2A, work next row of Chart to last 6 sts, k2A, p2A, k2A.

Cont to work from Chart, maintaining moss stitch edges, until row 16 is complete. Fasten off yarns B and C.

Cont in yarn A only.

Next row: k2, p2, k2, knit to last 6 sts, k2, p2, k2.

Next row: k2, p2, k2, purl to last 6 sts, k2, p2, k2.

Repeat last 2 rows twice more. **

Repeat from ** to ** twice more.

Next six rows: * k2, p2, rep from * to last 2 sts, k2.

Cast off all sts.

Lower Back panel

Using yarn A, cast on 58 sts.

Row 1 (RS): knit.

Row 2 (WS): purl.

Rows 3–6: rep rows 1 and 2.

*** Begin colourwork pattern as follows:

Row 1 (RS): work row 1 of Chart to end, working 26-st repeated section twice across the row.

Row 2 (WS): work next row of Chart to end.

Cont to work from Chart until row 16 is complete.

Fasten off yarns B and C.

Cont in yarn A only.

Next row: knit.

Next row: purl.

Repeat last 2 rows twice more. ***

Repeat from *** to *** once more.

Cast off all sts.

Upper Back panel

Using yarn A, cast on 58 sts.

BUTTONHOLE BAND

Rows 1–4: * k2, p2, rep from * to last 2 sts, k2.

Row 5: * work next 10 sts in established rib pattern, cast off 1 st, rep from * to last 10 sts, work last 10 sts in established rib pattern.

Row 6: work in established rib pattern, casting on 1 st over each cast off st from the previous row.

Row 7: as row 1.

Row 8: purl.

Rows 9–30: work as for Lower Back panel from *** to ***.

Cast off all sts.

To make up

Block pieces (see pages 40–41) so that the Front panel measures 32 x 32cm (12½ x 12½in) and the Back panels fit within the moss stitch border of the Front panel when pieced together.

Use mattress stitch (see page 39) to join the following pieces: sew Lower Back panel to bottom edge of Front panel, above the moss stitch border. Sew Lower Back panel to Front panel at side seams within the moss stitch border. Sew Upper Back panel to top edge of Front panel below the moss stitch border, overlapping the Lower Back panel. Sew Upper Back panel to Front at side seams within the moss stitch border.

Sew on buttons to correspond with buttonholes (see page 43). Weave in any remaining ends (see page 38).

PROJECT:
Ptarmigan Child's Cardigan with Hat

This set features a classic, drop/set-in sleeved, all-season cardigan and matching hat to keep your little one cosy during the colder months! This is a great outfit to knit for beginner to intermediate Fair Isle knitters, and the alpaca/merino wool blend makes it wonderfully soft and luxurious – perfect for a child's sensitive skin.

Yarn

- UK Alpaca Super Fine DK, or equivalent DK (light worsted) weight alpaca/merino blend yarn; 50g/122yd/112m; manufacturer's tension 25 sts x 34 rows using 3.75mm (UK 9; US 5) needles –
 - ~ 2(2:3:3:3:3) balls of Rust, or dark orange yarn (A)
 - ~ 2 balls of Parchment, or cream yarn (B)
- UK Alpaca Superfine Alpaca Speckledy DK, or equivalent DK (light worsted) weight wool blend yarn; 50g/122yd/112m; 25 sts x 34 rows using 3.75mm (UK 9; US 5) needles –
 - ~ 3(3:3:3:3:4) balls of Speckledy Grey, or variegated brown-grey yarn (C)

Needles

- Two pairs of straight knitting needles –
 - ~ 3.75mm (UK 9; US 5)
 - ~ 4.5mm (UK 7; US 7)
- Two pairs of circular needles –
 - ~ 3.25mm (UK 10; US 3), 40cm (16in) long
 - ~ 4.5mm (UK 7; US 7), 40cm (16in) long
- Five 4.5mm (UK 7; US 7) DPNs
- Tapestry needle

Extras

- 5(6:6:6:7:7) buttons
- Stitch holders
- Stitch markers

Pattern tension

24 sts x 30 rows on 4.5mm (UK 7; US 7) needles

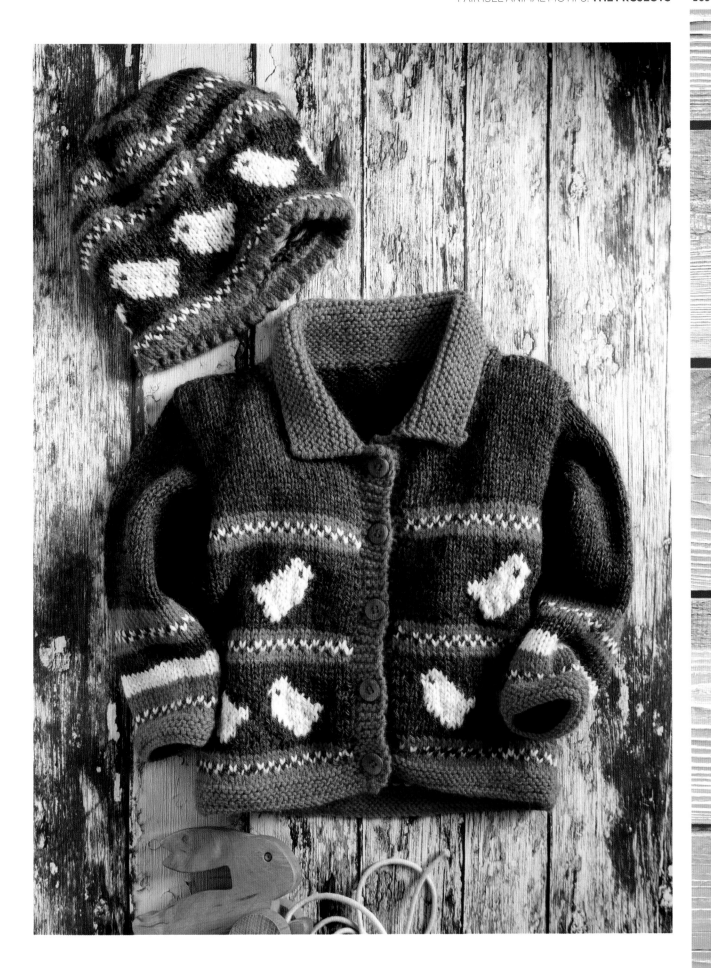

Pattern notes

During the colourwork motif, strand the yarn not in use loosely across the WS of the work. Avoid long strands by twisting unused yarn colours with those in use every few stitches as you work (see page 29).

The collar is shaped with short rows using the 'wrap and turn' method (W&T). See 'Knitting Abbreviations' on page 37 for instructions on how to do this.

Use straight knitting needles for the cardigan; circular needles and DPNs for the hat.

Size chart

		SIZE 1: 0–3 MONTHS	SIZE 2: 3–6 MONTHS	SIZE 3: 6–9 MONTHS	SIZE 4: 9–12 MONTHS	SIZE 5: 1–2 YEARS	SIZE 6: 2–3 YEARS
ACTUAL CHEST	CM	49	53	56	59	60	65
	IN	19¼	20⅞	22	23¼	23½	25½
ACTUAL LENGTH TO SHOULDER	CM	21	24	26	28	32	34
	IN	8¼	9½	10¼	11	12½	13½
ACTUAL SLEEVE LENGTH	CM	13	15	17	19	24	25
	IN	5⅛	6	6¾	7½	9½	10
UPPER ARM CIRCUM.	CM	15	17	19	20.5	21	22
	IN	6	6¾	7½	8	8¼	8¾

CHARTS

◯ *Yarn B (Parchment, or cream)*

⬤ *Yarn C (Speckledy Grey, or variegated brown-grey)*

Chart A

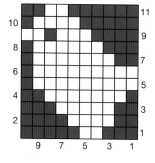

Row 1 (RS): k3C, k2B, k5C.

Row 2 (WS): p4C, p4B, p2C.

Row 3: k2C, k5B, k3C.

Row 4: p2C, p7B, p1C.

Row 5: k9B, k1C.

Row 6: p1C, p9B.

Row 7: k2C, k7B, k1C.

Row 8: p1C, p6B, p3C.

Row 9: k4C, k3B, k1C, k2B.

Row 10: p1C, p4B, p5C.

Row 11: k6C, k2B, k2C.

Chart B

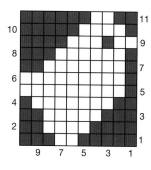

Row 1 (RS): k5C, k2B, k3C.

Row 2 (WS): p2C, p4B, p4C.

Row 3: k3C, k5B, k2C.

Row 4: p1C, p7B, p2C.

Row 5: k1C, k9B.

Row 6: p9B, p1C.

Row 7: k1C, k7B, k2C.

Row 8: p3C, p6B, p1C.

Row 9: k2B, k1C, k3B, k4C.

Row 10: p5C, p4B, p1C.

Row 11: k2C, k2B, k6C.

PATTERN

CARDIGAN

Back

Using yarn A and 3.75mm (UK 9; US 5) needles, cast on 51(55:59:63:67:71) sts.

Rows 1–6: knit.

Change to 4.5mm (UK 7; US 7) needles.

Work 2 rows is St st, starting with a RS knit row.

Join in yarns B and C.

Row 9: * k1B, k1C, rep from * to last st, k1B.

Row 10: * p1C, p1B, rep from * to last st, p1C.

Work 2 rows in St st using yarn A, starting with a RS knit row.

Work 2 rows in St st using yarn C, starting with a RS knit row.

Row 15: k3(3:5:3:3:3)C, * work row 1 of Chart A across next 10 sts, k2(3:3:2:3:3)C, rep from * 2(2:2:3:3:3) more times, work row 1 of Chart A across next 10 sts, k2(3:5:2:2:6)C.

Row 16: p2(3:5:2:2:6)C, * work row 2 of Chart A across next 10 sts, p2(3:3:2:3:3)C, rep from * 2(2:2:3:3:3) more times, work row 2 of Chart A across next 10 sts, p3(3:5:3:3:3)C.

Cont to work as set until row 11 of Chart A is completed.

Work 3 rows in St st using yarn C, starting with a WS purl row.

Work 2 rows in St st using yarn A, starting with a WS purl row.

Row 31: * k1B, k1C, rep from * to last st, k1B.

Row 32: * p1C, p1B, rep from * to last st, p1C.

Work 2 rows in St st using yarn A, starting with a RS knit row.

Work 2 rows in St st using yarn C, starting with a RS knit row.

(**Note:** read the following instructions carefully, as you will be working two sets of instructions at the same time.)

SIZE 1 ONLY

Cut off yarns A and B. Cont in St st using yarn C only throughout the remainder of Back.

SIZES 2, 3, 4, 5 AND 6 ONLY

Row 37: k–(10:12:10:10:10)C, * work row 1 of Chart B across next 10 sts, k–(3:3:2:3:3)C, rep from * –(2:2:3:3:3) more times, k–(6:8:5:5:9)C.

Row 38: p–(6:8:5:5:9)C, * p–(3:3:2:3:3), work row 2 of Chart B across next 10 sts, rep from * –(2:2:3:3:3) more times, p–(10:12:10:10:10)C.

Cont to work as set until row 11 of Chart A is completed.

Row 48: using yarn C, purl.

Work 2 rows in St st using yarn A, starting with a RS knit row.

Next row: * k1B, k1C, rep from * to last st, k1B.

Next row: p1C, p1B, rep from * to last st, p1C.

Work 2 rows in St st using yarn A, starting with a RS knit row.

Fasten off yarns A and B. Cont in St st using yarn C only throughout remainder of Back.

ALL SIZES AGAIN

SHAPE ARMHOLES

When Back measures 12(14:15:16:18:21)cm / 4¾(5½:6:6¼:7:8¼)in from cast-on edge, ending with a WS row, shape armholes as follows:

Cast off 4 sts at beg of next 2 rows (43(47:51:55:59:63) sts).

Cont in patt as set until Back measures 21(24:26:28:32:34)cm / 8¼(9½:10¼:11:12½:13½)in from cast-on edge ending with a WS row.

SHAPE SHOULDERS

Cast off 10(11:13:14:16:17) sts at beg of next 2 rows.

Cast off rem 23(25:25:27:27:29) sts.

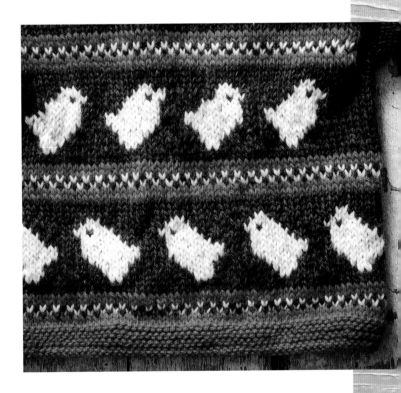

Left Front

Using yarn A and 3.75mm (UK 9; US 5) needles, cast on 28(30:32:34:36:38) sts.

Rows 1–6: knit.

Change to 4.5mm (UK 7; US 9) needles.

Row 7 (RS): knit.

Row 8 (WS): k5A; purl to end.

This sets the 5-st garter stitch border for the Front buttonhole band that is continued in yarn A throughout.

Join in yarns B and C.

Row 9: * k1B, k1C, rep from * to last 6 sts, k1B, k5A.

Row 10: k5A, * p1C, p1B, rep from * to last st, p1C.

Row 11: using yarn A, knit.

Row 12: k5A, * p1B, rep from * to end.

Row 13: * k1C, rep from * to last 5 sts, k5A.

Row 14: k5A, * p1C, rep from * to end.

Row 15: k1(2:2:3:4:5)C, * work row 1 of Chart A, k1(1:2:3:3:3)C, rep from * once, k0(1:1:0:1:2)C, k5A.

Row 16: k5A; p0(1:1:0:1:2)C, * p1(1:2:3:3:3)C, work row 2 of Chart A, rep from * once, p1(2:2:3:4:5)C.

Cont to work as set until row 11 of Chart A is complete.

Work 2 rows in St st using yarn C, maintaining garter stitch buttonhole band in yarn A and starting with a WS purl row.

Work 2 rows in St st using yarn A, maintaining garter stitch buttonhole band.

Row 31: * k1B, k1C, rep from * to last 6 sts, k1B, k5A.

Row 32: k5A, * p1C, p1B, rep from * to last st, p1C.

Row 33: using yarn A, knit.

Row 34: k5A, * p1B, rep from * to end.

Work 2 rows in St st using yarn C, maintaining garter stitch buttonhole band in yarn A.

(**Note:** read the following instructions carefully as you may be working two sets of instructions at the same time.)

SIZE 1 ONLY

Cut off yarn B. Cont in St st throughout rem of Front, using yarn C and maintaining the garter stitch buttonhole band in yarn A.

SIZES 2, 3, 4, 5 AND 6 ONLY

Row 37: k8(9:9:10:11)C, work row 1 of Chart B across next 10 sts, k7(8:10:11:12)C, k5A.

Row 38: k5A, p7(8:10:11:12)C, work row 2 of Chart B across next 10 sts, p8(9:9:10:11)C.

Cont to work as set until row 11 of Chart B is completed.

Work 3 rows in St st using yarn C, starting with a WS purl row and maintaining garter stitch buttonhole band in yarn A.

Work 2 rows in St st using yarn A, maintaining garter stitch buttonhole band.

Next row: * k1B, k1C, rep from * to last 6 sts, k1B, k5A.

Next row: k5A, * p1C, p1B, rep from * to end.

Next row: using yarn A, knit.

Next row: k5A, pB to end.

Cut off yarn B. Cont in St st throughout rem of Front, using yarn C and maintaining garter stitch buttonhole band in yarn A.

ALL SIZES AGAIN

SHAPE ARMHOLES

When Front measures 12(14:15:16:18:21)cm / 4¾(5½:6:6¼:7:8¼)in from cast-on edge, ending with a WS row, shape armholes as follows at the same time:

Cast off 4 sts at beg of next row (24(26:28:30:32:34) sts).

Cont straight in pattern as set until Front measures 17.5(20.5:21.5:23.5:26.5:28.5)cm / 6⅞(8:8½:9¼:10½:11¼) in from cast-on edge, ending with a WS row.

SHAPE NECK

Next row: knit to last 7(7:8:8:9:9) sts, turn and leave rem sts on a stitch holder for the collar. Dec 1 st at neck edge on every row until 10(11:13:14:16:17) sts rem.

Cont straight in pattern as set until Left Front measures same as Back to shoulder, ending with working yarn at armhole edge.

Cast off sts.

Mark position for 4(5:5:5:5:6) buttons, the first placed 1cm (½in) below neck edge, and the last placed in the middle of the garter stitch border. The rem 2(3:3:3:3:4) buttons are spaced evenly between them.

Right Front

Using yarn A and 3.75mm (UK 9; US 5) needles, cast on 28(30:32:34:36:38) sts.

Rows 1–4: knit.

Row 5 (RS) (buttonhole): k1, k2tog, YO, knit to end. This begins the spacing of the buttonholes.

Row 6: knit.

Change to 4.5mm (UK 7; US 7) needles.

Row 7: knit.

Row 8: purl last 5 sts, k5A.

The 5-st buttonhole band is continued in garter stitch throughout.

Cont in pattern as set for Left Front, reversing all shaping and placing the buttonholes to match button markers.

Sleeves

Using yarn A and 3.75mm (UK 9; US 5) needles, cast on 29(3133:35:35:37) sts.

Rows 1–6: knit.

Change to 4.5mm (UK 7; US 7) needles.

Cont in St st as outlined below, AT THE SAME TIME Inc 1 st at each end of next and every foll sixth row, until there are 37(41:45:49:51:53) sts:

Work 2 rows in St st, starting with a RS knit row.

Join in yarn B and C.

Row 3: k1B, * k1C, k1B, rep from * to end.

Row 4: p1C, * p1B, p1C, rep from * to end.

Work 4 rows in St st using yarn A.

Work 4 rows in St st using yarn B.

Work 4 rows in St st using yarn C.

Work 2 rows in St st using yarn A.

Rows 17 and 18: as rows 3 and 4.

Work 4 rows in St st using yarn A.

Cont in yarn C until sleeve measures 13(15:17:19:22:24)cm / 5¼(6:6¾:7½:8¾:9½)in from cast-on edge, ending with a WS row.

Mark each end of last row with contrasting coloured scraps of yarn.

Work 6 rows in St st.

Cast off.

Collar

Using 3.75mm (UK 9; US 5) needles and yarn A, and with RS facing, k7(7:8:8:9:9) sts from Right Front neck, pick up and k13(13:15:15:17:17) sts up Right Front neck, pick up and k29(31:31:33:33:35) from Back neck edge, pick up and k13(13:15:15:17:17) sts down Left Front neck, k7(7:8:8:9:9) sts from Left Front (69(71:77:79:85:87) sts).

Next 2 rows: knit to last 20 sts, W&T.

Next 2 rows: knit to last 16 sts, W&T.

Next 2 rows: knit to last 12 sts, W&T.

Next 2 rows: knit to last 8 sts, W&T.

Next row (WS): knit.

Cast off 3 sts at beg of next 2 rows (63(65:71:73:79:81) sts).

Cont to work in garter stitch pattern until collar measures 5(5:5:6:6:7)cm / 2(2:2:2½:2½:2¾)in, ending with WS row.

Cast off.

To make up

Block each piece to your required measurements (see pages 40–41).

Use mattress stitch (see page 39) to join the following pieces: sew in sleeves to correspond with armholes, joining row ends above coloured scraps of yarn to cast-off edges at underarm. Join side and sleeve seams.

Sew on buttons to correspond with buttonholes (see page 43). Weave in any remaining ends (see page 38).

HAT

Using yarn A and 3.25mm (UK 10; US 3) needles, cast on 72(78:84:90) sts. Join to work in the round, being careful not twist sts. Place marker for beginning of round.

Rounds 1–4: knit.

Round 5: * k2tog, YO, rep from * to end.

Last round forms the fold for the picot edge.

Change to 4.5mm (UK 7; US 7) needles.

Rounds 6 and 7: knit.

Join in yarns B and C.

Round 8: * k1B, k1C, rep from * to end.

Round 9: * k1C, k1B, rep from * to end.

Rounds 10 and 11: using yarn A, knit.

Rounds 12–14: using yarn C, knit.

Following Chart A, place the bird motif on the next round as follows (**Note:** as you are knitting in the round, all rows in Chart A are now knitted. Read each row in the chart from right to left; if you are using the written instructions, read the even rows in reverse):

Round 15: * work row 1 of Chart A across next 10 sts, K2(3:2:5)C, rep from * to end.

Rounds 16–25: cont in pattern as set by last round, working next row of Chart A each time.

Round 26: using yarn C, knit.

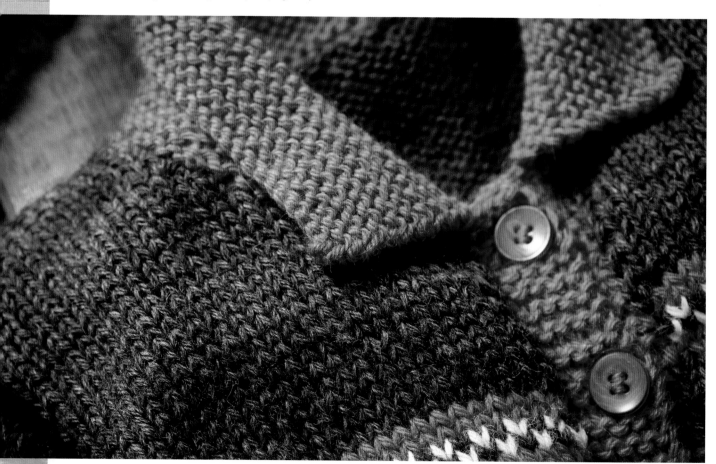

Round 27: using yarn C, * k1, kfb into next st, k1, rep from * to end (96(104:112:120) sts).

Round 28: using yarn C, knit.

Round 29: using yarn A, knit.

SIZES 1, 2, 3 and 4 ONLY

Round 30: using yarn A, purl.

SIZES 5 and 6 ONLY

Round 30: using yarn A, knit.

ALL SIZES AGAIN

Rounds 31 and 32: rep rounds 8 and 9.

Round 33: using yarn A, knit.

SIZES 1, 2, 3 and 4 ONLY

Round 34: using yarn A, knit.

SIZES 5 and 6 ONLY

Round 34: using yarn A, purl.

ALL SIZES

Rounds 35 and 36: using yarn C, knit.

Begin to shape crown as follows:

Round 37: * k2togtblC, k8(8:9:9:10:11)C, k2togC, rep from * to end (80(80:88:88:96:104) sts).

Round 38: using yarn C, knit.

SIZES 1, 2, 3 and 4 ONLY

Round 39: * k2togtblA, k6(6:7:7)A, K2togA, rep from * to end (64(64:72:72) sts).

Round 40: using yarn A, knit.

Rounds 41 and 42: rep rounds 8 and 9.

Cut yarns B and C and cont with yarn A only.

Round 43: * k2togtbl, k4(4:5:5), k2tog, rep from * to end (48(48:56:56) sts).

Round 44: knit.

Round 45: * k2togtbl, k2(2:3:3), k2tog, rep from * to end (32(32:40:40) sts).

Round 46: knit.

Round 47: * k2togtbl, K0(0:1:1), k2tog, rep from * to end (16(16:24:24) sts).

Round 48: knit.

Round 49: * k2tog, rep from * to end (8(8:12:12) sts).

Cut yarn and thread through rem sts, pull tight and fasten off.

SIZES 5 and 6 ONLY

Rounds 39 and 40: using yarn A, knit.

Rounds 41 and 42: rep rounds 8 and 9.

Round 43: * k2togtblA, k8(9)A, k2togA, rep from * to end (80(88) sts).

Round 44: using yarn A, knit.

Round 45: * k2togtblC, k6(7)C, k2togC, rep from * to end (64(72) sts).

Rounds 46–48: using yarn C, knit.

Round 49: * k2togtblC, k4(5)C, k2togC, rep from * to end (48(56) sts).

Round 50: using yarn A, knit.

Round 51: * k2togtblA, k2(3)A, k2togA, rep from * to end (32(40) sts).

Rounds 52 and 53: using yarn A, knit.

Cut yarn A. Cont in yarn C only.

Round 54: * k2togtbl, k0(1), k2tog, rep from * to end (16(24) sts).

SIZE 5 ONLY

Round 55: knit.

Round 56: * k2tog, rep from * to end (8 sts).

Cut yarn and thread through rem sts, pull tight and fasten off.

SIZE 6 ONLY

Round 55: * k2togtbl, K1, rep from * to end (16 sts).

Round 56: knit.

Round 57: * k2tog, rep from * to end (8 sts).

Cut yarn and thread through rem sts, pull tight and fasten off.

To make up

Turn up hem on picot row and overcast stitch into place on the WS. Weave in any remaining ends (see page 38).

INDEX

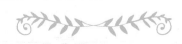